Christopher Allen
received his PhD from the University of Sydney
in 1992. He has worked at the Universities of New South
Wales and Sydney, and the Collège de France in Paris, and
has been a well-known art critic in Australia since the late
eighties. He currently teaches at the
National Art School in Sydney.

WORLD OF ART

This famous series
provides the widest available
range of illustrated books on art in all its aspects.
If you would like to receive a complete list
of titles in print please write to:
THAMES AND HUDSON
30 Bloomsbury Street, London WC1B 3QP
In the United States please write to:
THAMES AND HUDSON INC.
500 Fifth Avenue, New York, New York 10110

Printed in Singapore

CHRISTOPHER ALLEN

Art in Australia

From Colonization to Postmodernism

183 illustrations, 58 in color

THAMES AND HUDSON

I would like to dedicate this book to
my father and mother, and to
my wife Belinda and my daughter Rebecca

Frontispiece: Russell Drysdale *The Rabbiters* 1947 (detail)

First published in the United States of America in 1997 by
Thames and Hudson Inc., 500 Fifth Avenue, New York, New York 10110

Library of Congress Catalog Card Number 96-61173
ISBN 0-500-20301-6

Printed and bound in Singapore

Contents

Preface and Acknowledgments

'Pleased to be back?' This is the question that Australians inevitably ask returning compatriots. It is asked more urgently if you have been away a long time, or living in one of the three or four great capitals of Western culture. As most of this book was drafted between two academic appointments in Paris, and a good part of it in France, I have been subjected to this anxious interrogation countless times over the last couple of years.

Home-coming, the end to wandering or exile or foreign war, is one of the greatest of human themes. But no one asks Odysseus if he is pleased to be home. For that matter, is the Parisian pleased to be back in Paris? He may hate the city, but that is not the point: he knows that it is the centre of the world. That is the difference with Australia – we have never been able to think that we were at the centre of the world. Hence the question: are you really happy to have come back from the centre to the periphery?

Today, of course, I return with a collection of e-mail addresses all over Europe. It is as easy to send a message to Paris or Cambridge or Boston as to another building at the University of Sydney. Not surprisingly, Australians have a particular affinity for the electronic geography of the internet. But this virtual abolition of distance remains a mirage. It is not the old world made accessible, but a new one which more subtly internalizes the famous tyranny of distance.

The two centuries of Australia's existence have seen almost every fundamental development in the technologies of transportation and communication since Antiquity. The meaning of our geographical position has changed continuously, but we have always been, and remain, a European nation established on the other side of the world, in a land very different from the one in which our inherited culture evolved. These are fundamental facts in any study of Australia, and they are only two of several respects in which our experience is to be distinguished from that of the United States, the first of the new European societies. For the North American continent, unlike the Australian, is neither extremely distant nor particularly foreign.

In asking me to write this book, Nikos Stangos made me think about Australia systematically for the first time. Though my family came to Australia soon after the middle of the nineteenth century, I had grown up in Europe and Asia. I arrived here as an adolescent, with painfully mixed feelings of belonging and foreignness. My compatriots had attractive personal qualities, but the cultural life of the Sydney bourgeoisie in the early seventies seemed appallingly materialistic, narrow-minded and intolerant, grossly hostile to things of the mind or spirit. It was a world in which one clung to the few kindred spirits that could be found, simultaneously dreaming of revolution and of mandarin transcendence. It is easy to forget that Sydney's present sophistication and cosmopolitanism are an achievement of the eighties, and that this infinitely more civilized surface is still often skin-deep. It is a symptom of the superficiality that even the tolerance and broad-mindedness that began to appear in the seventies have somehow turned into the new prudery of political correctness. The old wolf of intolerance and narrow-mindedness, it seems, had merely re-equipped itself with a more up-to-date sheepskin. And outside the centres of urban culture, there are still wolves that disdain such precautions.

One of the great Australian illusions is that it is a young country. But the youthful qualities of idealism, curiosity, passion and innocence are not common or much admired. Realism, laconic courage and loyalty to comrades are the traditional virtues, born of adversity; wry melancholy is the contemplative stance; laziness, cynicism, gross incuriosity, indulgence of appetite and insensitivity to others are the vices. Intellectual life often seems to be dominated by inarticulate anxieties about identity. The expressions 'cultural cringe', 'coming-of-age', 'republic' and 'flag', among others, are like buoys marking dangerous reefs: they are inevitably surrounded by ridiculous and embarrassing displays of chauvinistic or promotional verbiage.

As a result I, and no doubt many others of my generation, developed a profound distaste for any talk of 'Australian identity'. Essentially turned towards Europe and Asia, I was equally indifferent to shearers, Aborigines and explorers. The Australian landscape tradition left me cold – Ned Kelly, the Eureka Revolt, the gold rushes were provincial folklore. This attitude was unaffected by spending most of the eighties closely involved with contemporary art and especially performance. It began to change when, towards the end of the decade, I started to write as a critic. Over the last couple of years, as I have worked on this book, I have developed a new regard for the

Australian experience, inevitably composed of uprooting, displacement and resettling; and have found that it was also, in this respect, my own after all.

This book is concerned with art made by Europeans in Australia for reasons discussed in the final chapter (another volume in the World of Art series deals with Aboriginal art). It is an attempt to chart the way that art has imagined the place called Australia and the relation of the new European population to this place. It is, in other words, about successive ideas of inhabitation. The book is therefore in no way a compilation of biographies – it starts rather from a consideration of the questions that underlie Australian art, from a search for the currents of thought and feeling it embodies, for the characteristic dynamic and tensions that define periods. But because ideas do not exist in a void, and because they can be given a particular inflection by important individual artists, a closer study of significant individuals provides the necessary corrective to general historical hypotheses.

I have, of course, greatly benefited from the work of many scholars and critics who have written about Australian art and history, especially over the last half-century: Bernard Smith, Richard Haese, Robert Hughes, Andrew Sayers, Tim Bonyhady, Ian Burn, Jane Clark, Mary Eagle, Virginia Spate, Terry Smith, James Gleeson, Patrick McCaughey, James Mollison, Nancy Underhill, Geoffrey Dutton, Daniel Thomas, Ron Radford, Deborah Edwards, Gary Catalano, Alan McCulloch, Graham Sturgeon, Manning Clark, Geoffrey Blainey, Richard White, Tim Flannery. I have had many useful discussions with a number of friends and colleagues, including Frances Muecke, Yasmin Haskell and John McDonald. The book was read in draft by Jacques Delaruelle, Belinda Allen, Karen Pearlman and Tim Bonyhady. I am grateful to all and it goes without saying that errors and omissions are my own responsibility. I would particularly like to thank Professor Jacques Thuillier, of the Collège de France, and Professor Kevin Lee and Ms Frances Muecke, of the Department of Classics at the University of Sydney, for their generous hospitality and support during the writing of this book. Finally, I want to thank Nikos Stangos for his warm encouragement and fruitful criticism.

Introduction

haec loca non tauri spirantes naribus ignem
invertere satis immanis dentibus hydri
nec galeis densisque virum seges horruit hastis...

this land no fire-breathing bulls have ploughed
to sow with a monstrous dragon's teeth;
no crop of men has bristled with massed spears and helms...

Virgil, *Georgics*, II, 140–42

Does Australian art have a history? The question is not entirely rhetorical, for the two most common views of the subject imply a negative answer. It may appear, for example, that every style practised in the new continent was imported from Europe or America, usually long after it had ceased to be current in its place of origin. From this perspective, Australian art looks like little more than a series of colonial footnotes to developments in the West over the last two centuries.

On the other hand, there is the view accredited by the Australian 'Impressionists' and their supporters, not so much in their heyday around 1890, but with hindsight in the early decades of the twentieth century. The particularity of Australian art lies in the unfamiliarity of the physical environment, and especially the difficulty of rendering the twisted forms of the gum tree and the glare of brilliant sunlight. Colonial painters, you will still hear visitors to art galleries telling each other, tried in vain to impose European models on these phenomena. Then the Impressionists, known as the Heidelberg School from the name of a locality near Melbourne, learnt to see the new world as it really was, and the beauty of Australia was revealed. On this account, there is a history of Australian art, but only because of the mistakes of earlier generations. It is the story of attempts to apply inappropriate cultural models. At last these are jettisoned, the truth is

made visible, and history comes to an end. Aesthetics here tends to justify a nationalistic account of settlement and to conceal the real historical processes at work.

The fact is that everything in Australian art initially came from elsewhere, but that everything acquired a new meaning when translated to the unfamiliar continent. Australia is a case-study in the development of a relatively autonomous, or at least local and specific art history. No significant work can be explained adequately as a by-product of contemporary European developments. And Australia also tells us much about the relation of the artist to the historical experience of a society. In the early years, all those whom we now consider 'Australian' artists arrived in the colonies as adults and established painters, and they came from very different backgrounds. Many stayed for a time and then returned home. Three of the most important figures in the nineteenth century, John Glover, Eugène von Guérard and Abram Louis Buvelot, were born respectively in England, Austria and Switzerland; and yet they very soon came to speak for and to the new society. It was not simply that they adapted to the conditions of an unfamiliar physical environment; in each case they articulated a new relationship with the land, and in each case that relationship was founded in the social realities of their time. Their works became factors in the development of an 'Australian' culture, and they themselves grew to be better and more important artists for responding to what was tacitly asked of them. Artists work not alone but in relation to social reception, apprehending, anticipating and in turn shaping the experience of a community.

The basis of Australian historical experience was the problem of inhabiting a strange and distant land. No less important than the material obstacles to settlement was the imaginative difficulty of feeling at home in a place that lacked all the references of familiarity. In Europe, mountains and rivers, trees and flowers were charged with the associations of myth or history or literature, and had long been absorbed almost as lexical elements in the language of painters and poets. Australia had no *meaning* for the new arrivals: neither land ploughed by fire-breathing bulls nor flora that matched a contemporary literature increasingly marked by sensitivity to nature; later generations of schoolchildren would not immediately know what Keats meant by a 'plot of beechen green and shadows numberless'. In due course, they would read May Gibbs's Australian fairy tales of gumnut children and then, at school, learn 'I love a sunburnt country...' before reading Patrick White's evocation of exploration in the desert.

Intangible as such considerations may appear, they are crucial to morale, and morale to the ability to resolve material problems. And the tangible and the intangible, especially as the artist encounters them, are not always easy to keep apart. Bright light, for example, is not just a technical problem for the painter; it is first of all something experienced corporeally. Glare makes us squint. We cannot stare into the distance or enjoy the sense of space in a view. We are forced back on ourselves. At the same time, something as apparently abstract as the immense distance separating us from 'home' in the mother country, or later the great centres of contemporary Europe and America, or even other parts of the continent, follows like a hollow echo after our foot-steps. The spatial experience of Australia, at its most hostile, alternates between claustrophobia and agoraphobia.

Australia has often been represented as the place of such contradic-tions. The last continent to be discovered by the Europeans had been imagined by geographers even in Antiquity, when it was believed to be impossible to sail south through the Torrid Zone around the Equator. *Terra Australis* was a virtual place long before the age of exploration. The earliest landfalls were made in the lifetimes of Shakespeare and Caravaggio, and seventeenth-century maps show a vast and uncertain outline extending from Java to the Antarctic and sometimes as far east as Chile. Gradually the familiar profile of the continent emerges, and such labels as *Terra Australis Nondum Cognita* are replaced by the sober and incongruous appellation *New Holland*. By the middle of the eighteenth century, the northern, western and southern coasts had all been mapped, but the Pacific shores remained a huge blank. No settlements were established in the incomplete continent. Cook charted the eastern coastline in 1770, discovering far more promising land than Australia had previously seemed to offer, and also the famous pines and flax plants of Norfolk Island from which the Royal Navy hoped to make masts and sailcloth. Within a few years, in 1788, the first colony was founded in Sydney, with convicts from the desperately overcrowded gaols of Great Britain.

The new colony was not at first intended to become an auto-nomous society, far less to grow into a nation. In London, Sydney was not thought of as a potential city, although very early on the colonists themselves, and their Governors, conceived ambitions which can be measured by the progress of architecture, urbanism, civil institutions and proposals for schools and universities. They knew, instinctively, that the answer to the question of inhabiting this new land lay not just

in opening their eyes to a world whose strangeness was only too obvious, not just in clearing away the debris of imported cultural habits; but in constructing or adapting a set of practices, of ideas, of social, political and imaginary models and values that would make it possible to live in the new environment.

Two points must be emphasized. First of all, such a process of construction cannot be accomplished in isolation. It is necessarily a collective, and therefore a political and historical enterprise. To inhabit is to found a polity in a place. Secondly, in the formation of this polity, practice – or what the French sociologist Pierre Bourdieu calls *habitus*, the generative principle of practice – takes precedence over theory. Consciousness appears first in practice, but without self-consciousness; theory tries to catch up, to impose its own interpretations and to simplify the ambiguities of practice. The importance of this for our purposes is that art is a form of practice, or rather a simulation of practice (an imitation of action, in Aristotle's terms). It articulates the consciousness of practice in concrete form, ahead of theory. That is why we have to be wary of taking contemporary accounts of pictures at face value – the best art says things that cannot yet be put into words. Those who write about art almost always, though in varying degrees, see the work through a prevailing theory or ideology, and often seem to misinterpret it. Strictly speaking, of course, every reading of a work of art involves theoretical simplifications and reorientations, but that does not mean that they are gratuitous, or that there cannot be a dialectical progression over time towards a more comprehensive account.

The construction of a polity founded in a new land is the subject of Australian history. It takes place, inevitably, against the ambivalent background of the Aboriginal presence: a people whose seemingly nomadic habits were so foreign to European custom that the land was thought to be technically uninhabited, and yet who were manifestly at home in it. In some respects the settlers were far more nomadic than the natives, for European culture had long ago adapted itself to the practices of travel, exploration and resettlement in strange lands; Aboriginal culture was and remains rooted in particular places; a rigidity which is also, necessarily, fragility. The Aborigines recur throughout Australian art, more often at some periods than at others, but almost always with the sense of a 'natural' belonging which serves as a benchmark to our historical efforts at settlement.

In the following chapters, I will try to show first of all how the earliest arrivals, as explorers or colonists, were protected by what one

may call the personae they brought with them. The explorer knows that his voyages are to end in a return home. The colonist confidently imposes an imported culture, underwritten by the authority of his far-away home. The full problem of inhabitation posed itself for those who came as settlers, with the intention of remaining permanently, and who had no choice but to make Australia their home. These successive personae, although to some extent ideal types, are also involved in the movement of European ideas in the Romantic period: the Enlightenment belief in universal rational norms was being over-taken by the new awareness of culture and cultural differences. Culture was formed by a people living in a place, and to this 'organic' relationship to place could be added the organic development through time that is history. Such ways of thinking, inherent in the formation of Australia, are of course completely different from the beliefs that underlay the settlement of the United States in the seventeenth century, and the development of the colonies into a nation at the height of the Enlightenment.

What is usually called later colonial art I have therefore considered to be the first attempt at a 'settler' art. The result was paradoxical – a kind of belonging-in-alienation, based on the spectacle of the sublime. It is only with the Heidelberg School, the Australian 'Impressionists' at the end of the century, whose great subject was the rural work of the settler and the relationship with the bush, that an unambiguous sense of home was achieved.

Why does Australian art history continue after Heidelberg? For much the same reason that Heidelberg had succeeded the previous style: if the early settler vision had been paradoxical, the Heidelberg model was unstable, relying excessively on a mythical image of life in the bush. Most Australians, by the end of the century, lived in large coastal cities, and advances in technology were decisively changing the balance of power between settler and nature. I have called the subsequent period 'Unsettlement', because it represents the dissolution of Heidelberg confidence and energy and the rise of a competing, but still tentative modernism. It is a long aftermath, from one point of view, coinciding with a long prelude, from the other. A truly motivated and extremely vigorous modernism arose in the years immediately before, during and after the Second World War. The art of the Angry Penguins, as they came to be known, was riven with tensions that recall those of early settler art in a new idiom and at a far more acute emotional pitch. It was the paradox of living in the 'Uninhabitable'.

13

The period that followed the Second World War seems to have been dominated by the desire to escape from these intolerable tensions, and so I have called it 'Escape routes', even though many of the artists discussed do discreetly find an accommodation with Australia. Finally I have called the last period 'Homeless', not to suggest that the whole enterprise ends in failure, but rather that the expectation of home and inhabitation has waned in the generation of postmodernism. Of course, this is only taken as a dominant current; the reality is naturally more complex. It is, however, probably true to say that art in Australia has developed from beginnings that were concerned with local problems to a present in which the local environment serves to give a particular perspective to the common concerns of contemporary Western culture. But if the initial colonial problem has been largely eroded, it would be a mistake to conclude that the physical nature of Australia has lost its central place in the cultural imagination.

The breakdown into periods is roughly chronological, but the main attempt has been to locate the effective tensions within each period. Considerations of 'style' have been subordinated to this search for historical shape (thus different styles may be taken as 'Escape routes'). Of course, in a book of this size there could be no question of mentioning every artist worthy of consideration, and even the length of discussion given to various individuals is determined primarily by their historical importance, or their suitability to stand as examples of different qualities. Because it is more useful to look closely at images than to generalize in the abstract, I have deliberately chosen a few works or artists in each period to stand as paradigms for styles and movements.

The important thing, in an historical survey, is to identify movement and direction. This is especially true in such a relatively brief study, and it forces one to confront the relationship between intrinsic aesthetic worth and historical importance. In the Heidelberg period itself there are quite a number of interesting or attractive artists, but only a small number who matter historically. Perhaps this is a way of defining canonicity: that an artist has made a significant difference to the way we think and see. Such a criterion would be irrelevant in a non-historical society, based on subsistence and stability through time, but European culture is essentially historical and dynamic, constantly defining itself in relation to the achievements of the past and to conceptions of the future. This question has a bearing on the genres and even the art-forms to be considered. At certain times and in certain

places particular genres are culturally central. In the Renaissance, 'history' paintings and religious subjects were fundamental, and land-scape as an independent genre virtually non-existent. The reverse is true in Australian art: landscape is the central genre, even up to the Second World War, and Australian abstraction, since that time, has often remained close to the landscape tradition. The portrait has been a minor genre, and so has hardly been discussed except where it is part of a landscape. Sculpture is an art-form that had few exponents of any importance before the mid-twentieth century. I have not attempted to discuss the many lesser though often very able artists in the smaller centres.

It is a good thing, in some respects, to write an historical survey that runs up to your own time. It instils a sense of responsibility for the whole narrative. But I have been struck by the very different access that one has to periods of the past and present. The remoter periods have been worked over by predecessors in the field; standard views have emerged, sometimes competing interpretations. One can choose to agree or disagree or to propose a new approach. The hardest peri-ods are the last and the penultimate. The last period, obviously, is the one in which the author has lived and perhaps played some part. It is harder to be detached, hard not to continue, in some sense, to inter-vene in the questions discussed. In this way even the last chapters of Bernard Smith's two fundamental books, *Place, Taste and Tradition* (1945) and *Australian Painting* (1962), including the new section added to the 1971 edition of the second work, are also documents of their respective times. The penultimate period presents problems of a dif-ferent order: it is a time of which the author cannot have first-hand knowledge, and yet one which has not been properly written about either, because many of the individuals concerned are still alive, and many remain active as teachers, critics, trustees of galleries or other-wise entrenched in some position of power that has hindered dispas-sionate assessment.

Can we ever be quite dispassionate, though? We recall Baudelaire's injunction to the critic to be 'personal, passionate and political'. The critic who turns historian, like the barrister who goes to the bench, must aspire to impartiality. But he is still required to judge; and art his-tory written without a critical perspective has no sense of direction. We cannot rely simply on the 'facts'; in art history, as in the study of any other human creation, the primary facts are ideas. Works, first of all, speak for themselves; knowledge of the circumstances does not give us the meaning of a work, but it serves to restrict or specify that

meaning. And quantitative or statistical studies are of limited interest because in the qualitative world of ideas it is not the average that is typical, but the exceptional.

In trying to determine the shape of Australian art history, and in finding my formal principle in the inhabitation of Australia, I do not mean that Australian art is about nothing else. The point is to look for those questions that are distinctive in Australian art, that arise out of the specific historical circumstances, and that form its characteristic structure and dynamism. Thus the theme of agrarian work in the Heidelberg School has general affinities with some contemporary or earlier European artists, but in Australia it takes on a specific meaning and historical significance which is completely different. History deals with the shape of experience; it does not claim to exhaust its content; we can discuss what changes, but it is much harder to see into the darkness of what remains so obstinately the same.

There is a Zen saying, I believe, that a butcher who perfectly understood the structure of the ox could cut the whole beast up with a single continuous stroke of the cleaver. In writing we sometimes have the sensation of forcing, of trying to cut through solid bone and then we intuitively feel that we have found a natural join when the cleaver seems to pass through effortlessly. I cannot claim that this ox has been dissected with a single stroke, but then history is even more complicated than an ox, since it keeps on developing and, as I suggested at the outset, has no conclusion.

Colonization

> ...this fifth part of the Earth,
> Which should seem an after-birth,
> Not conceiv'd at the Beginning
> (For GOD bless'd his work at first,
> And saw that it was good),
> But emerg'd at the first sinning,
> When the ground was therefore curst; —
> And hence this barren wood!
>
> Barron Field, 'The Kangaroo', 1819

When the first British fleets came to this continent, they faced urgent questions both of material and of moral survival: supplies of food and other provisions had to be assured, housing built, services provided, and some form of social order established among the transported convicts and their warders. The early years were harder than anticipated, but gradually the penal colonies developed into towns, and the convicts into colonists. Voluntary immigration soon exceeded transportation, and then transportation ceased altogether. Within less than a century not only courts and legislative assemblies, but also schools, universities, art galleries and museums had developed. The colonists were turning into citizens, and had achieved a large measure of autonomy. From early in the nineteenth century there had been debate about the nature of the new nation and the new people that were emerging in the southern continent.

Everyone agreed that three factors were crucial: British ethnic stock, the specific history of the colonies, and the qualities of the Australian environment. The virtues of British stock were constantly extolled: unfortunately, Australia had not been founded by the emigration of the finest specimens, but by the transportation of a criminal rabble. Of course free settlers had soon outnumbered the convicts and their descendants, but the fear of bad blood remained. In the

twentieth century, the characteristically Victorian biological imagery was replaced by an equally characteristic psychological representation, and the convict past became, for many authors, a repressed memory of suffering and guilt lurking beneath the surface of a prosperous modern nation.

In the nineteenth century the problem was eventually resolved by reference to the environment in which the new race was emerging. The struggle with the new land was breeding a strong and – this was a central metaphor – a *clean* race. The achievement of settlement will be the subject of the next chapter; the purpose of this one will be to consider the early responses to the new environment.

The Australian experience is often compared with the American. There is some justification for this, if only because the United States were often looked to by the colonists themselves as the model of a British colony which had matured and become independent. But it is important to begin by recognizing the very considerable differences. Three of the most salient are the circumstances of foundation; the date of constitution as a nation; and the nature of the land itself. For the present purposes, the relation between the last two is particularly interesting, and I shall come back to it. But the first thing to emphasize is that Australia is far more remote from Europe and far more foreign and strange to European eyes. New England is the Home Counties compared to Australia's profusion of unfamiliar flora and fauna, some so bizarre as to have been, like the platypus, initially thought a hoax.

The flora and fauna, in turn, are adaptations to a particularly difficult and unpredictable natural environment. Australia is physically the most ancient land on earth, unaffected by more recent geological events that rebuilt the mountains of the northern hemisphere, and by the ice ages which enriched the soil there and rejuvenated the plant and animal life. The land is old, poor and fragile. In addition, it is the only continent in the world whose climate is dominated by a non-seasonal cycle, the El Niño Southern Oscillation (ENSO), which causes prolonged and unpredictable droughts and flooding. ENSO makes farming in Australia, even with massive applications of modern technology, a matter of constant uncertainty, and has been convincingly cited as the reason why the Aborigines never developed agriculture. Together, these conditions explain the peculiar forms of animal and plant life, the 'living fossil' survivals, the fragile endemic populations and the finely tuned co-adaptations that can so easily be shattered.

It may seem surprising that early explorers and colonists, in spite of their material difficulties in Australia, were often delighted by the beauties they encountered, and that it was later arrivals who complained of its strangeness. But Australian art in the nineteenth century was not all made by (or on behalf of) people who understood their presence in the new continent in the same way. As I have already suggested, there were different, roughly successive conceptions of what it meant to be in Australia, phases that correspond to historical personae – each of these personae allows certain things to be seen or experienced, makes certain experiences endurable, and shields the subject from others. The first of these personae, that of 'explorer', is like a carapace designed to support material hardships and to protect the sense of self from the tides and undertows of strangeness. The 'colonist' comes to live but brings his prefabricated home with him; only the 'settler' is obliged to make a home out of the unfamiliar environment.

The very earliest images belong to this phase of exploration – indeed the list should begin with the topographical views of coastlines made as aids to navigation, the views and the scientific documentation produced by the artists who accompanied Cook on his voyages. For our purposes, however, the first artists in the new colony will adequately represent these concerns. There was new land to survey, and there were new forms of plant, animal and even human life to catalogue. The aesthetic is one of detail, concentrating on unfamiliar forms; the focus is not on the general experience of living in the new environment, for the good reason that hardly anyone assumes they will live there indefinitely. Australia might be a punishment, an ordeal or an adventure, but it was not yet home, nor was it expected to be.

What is touching about these early pictures, especially the depictions of the Aboriginal people made during the first years of Sydney Town, is that for all their utilitarian or anthropological intentions, they cannot help expressing a spontaneous humanity. These are some of the few images of Aborigines ever produced in Australia to be free of prejudice, guilt or self-consciousness. In general it is the innocence of this 'explorer' art that is striking. The Port Jackson Painter's study of *A Native Going to Fish* ... is a precise ethnographic document illustrating boats, fishing equipment and the means of carrying fire, but it is also the picture of a family. The Enlightenment faith in common humanity had not yet given way to speculations about race, adaptation and the struggle for life, which would soon grow from the new biological sciences of the nineteenth century in combination with the spread of industrialization and colonization.

1

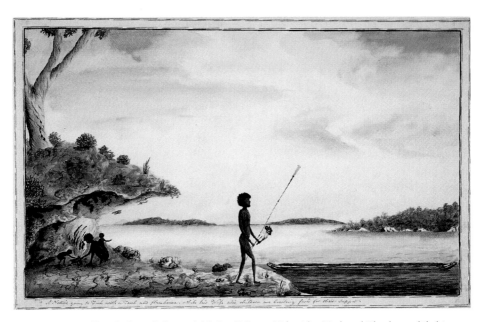

1 Port Jackson Painter *A Native Going to Fish with a Torch and Flambeau while his Wife and Children are Boiling Fish for their Supper c.* 1795

It is appropriate that the first professional artist to come to live in Australia should have been a natural history painter, John Lewin (1770–1819), the author, among many other subjects, of a charming depiction of the kangaroo as well as what is now considered to be Australia's first oil painting, a still-life of the fish of Sydney Harbour. Lewin arrived in Australia in 1800 and remained in the colony for the rest of his life, preparing illustrations for his volumes on the insects and the birds of New South Wales. It is the *experience* of exploration that is depicted, somewhat later, in Augustus Earle's *Bivouac of Travellers in Australia*. The travellers seem incongruous in the exotic setting of the forest, dressed for another world and only provisionally adapted to this one. And yet they suffer no apparent alienation, for they have brought their identity with them, and it is fundamentally impervious to their exotic location. It is significant that the picture was painted around 1830, some years after the artist's stay in Australia; it is an image of adventure, but not of inhabitation. Earle (1793–1838) himself was the first of many artist-adventurers who spent a few years in the colony – in his case from 1825 to 1828 – collecting material that would be worked up into paintings after his return home.

20

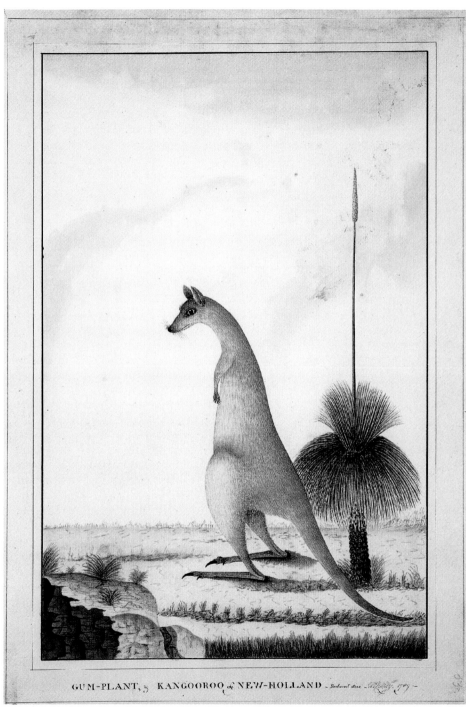

GUM-PLANT, & KANGOOROO of NEW-HOLLAND — *Reduced size* — G. Raper 1789

2 George Raper *Gum-Plant and Kangooroo of New Holland* 1789

Almost from the beginning, too, artists began to paint views of the new colony of Sydney, with roads, houses and fences, and ships at anchor in the harbour – all reassuring signs of a growing township, and of a familiar world re-created at the ends of the earth. In a composition attributed to the convict-artist Thomas Watling (1762–after 1806), we see the sun rising over an already well-established township in 1802. Thus the phase of exploration evolved quickly into one of colonization, dominated by a new historical persona. The explorer comes to investigate, to map and to catalogue; the colonist comes to propagate a new branch of the old society. And if the explorer is protected in his passage through an unknown land by the sense of identity that he carries with him, the colonist reproduces the environment that corresponds to that imported identity.

The view of Governor Philip's house, soon after it was built, by the young officer George Raper (c. 1768–97) is perhaps the first image of colonization. In equally simple, almost diagrammatic, form the basis of the colonial vision is to be seen in *Blighton Farm* (1810) by the surveyor G. W. Evans (1770–1852) or in Joseph Lycett's *Raby, a Farm Belonging to Alexander Riley Esq* (c. 1820). Lycett (1774–1828), who like several other convict-artists had been transported for forgery, arrived

7
8
9

3 John Lewin *Two Kangaroos in Landscape* 1819

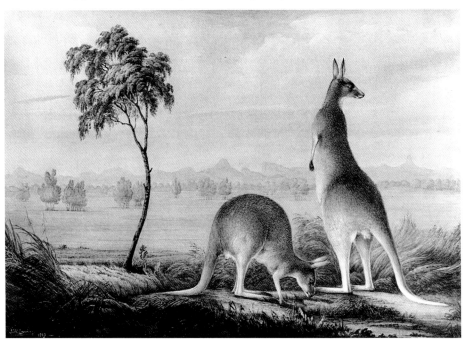

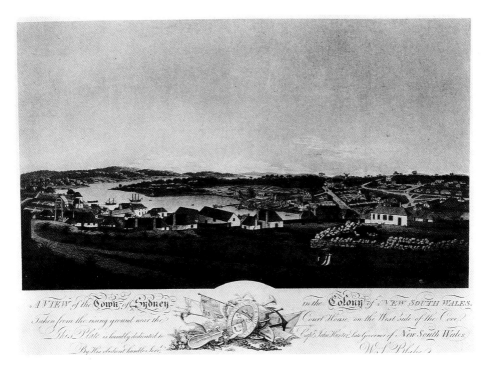

4 William Blake after Thomas Watling *A View of the Town of Sydney in the Colony of New South Wales* 1802

in Sydney in 1814. He painted many pictures of the colony, and on his return to England published *Views in Australia and Van Diemen's Land* (1824–25). His homestead is the image of a model establishment: neatly fenced plots with a road, house, stream, cattle, horses and sheep, cart, plough and harrow; the artist has reproduced the farm machinery with meticulous care, for these are the vital instruments of colonization. Here we can see openly displayed the processes of cutting a piece of land out of the domain of nature and imposing cultural order upon it: clearing, enclosure, cultivation, and everywhere the signs of human activity. The farmer is even seen bringing water up from the stream. This picture was published in *Views in Australia*, where the accompanying text spoke of 'those striking contrasts which agreeably surprise the traveller in the forests of this country, on suddenly coming in view of the vast openings cleared by the industry of man.' In a similar way, many of the early views of Sydney seem –

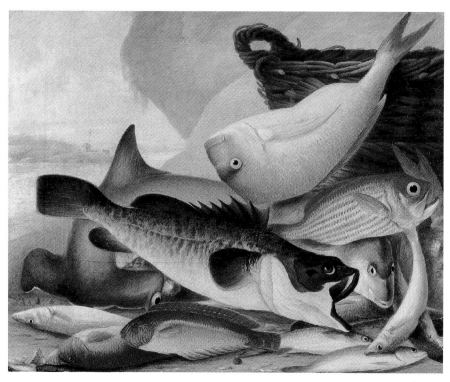

5 John Lewin *Fish Catch and Dawes Point, Sydney Harbour c.* 1813

perhaps especially to our eyes – to emphasize the tree stumps that remain adjacent to houses and fences, as tokens of the recent conquests of civilization.

And yet Lycett's enthusiasm for the cleared landscape is inseparable from his praise of the natural beauties of Australia, which he – or an anonymous collaborator – called, in a moment of lyricism, 'a new Creation!' This effusion appeared, admittedly, in the advertisement for his publication, but the element of personal interest does not invalidate the objective principle. Colonial security provides the vantage-point from which the beauty of the new land may be safely enjoyed; from which we may gaze at *Views in Australia*, in which the artist emphasizes the lucid notation of seen detail rather than the ambience of a dwelt-in environment. And this paradigm – the natural picturesque seen from the safety of colonial order – remains pervasive in the work of such an essentially colonial artist as Conrad Martens and even later in the compositions of a Nicholas Chevalier.

24

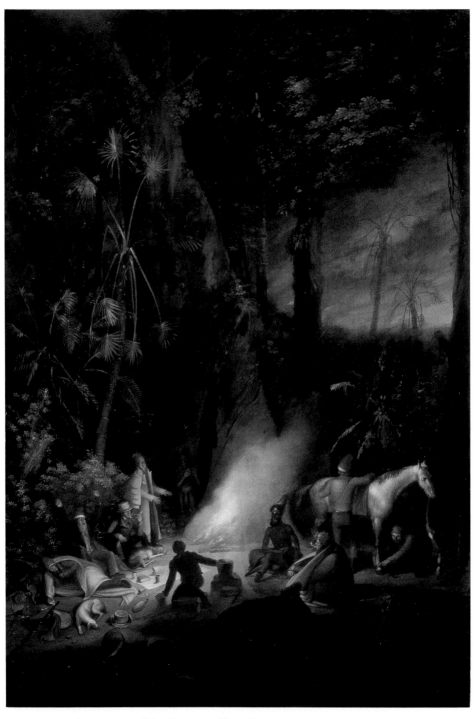

6 Augustus Earle *A Bivouac of Travellers in a Cabbage-Tree Forest* c. 1838

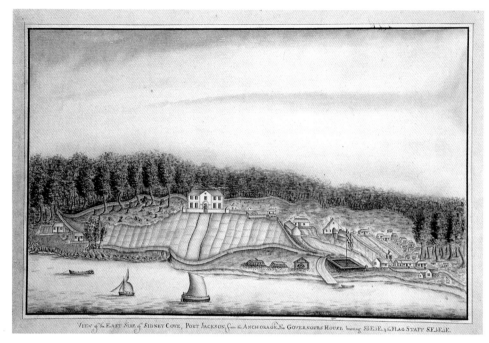

VIEW of the EAST SIDE of SIDNEY COVE, PORT JACKSON, from ye ANCHORAGE, ye GOVERNOURS HOUSE bearing S.E.E., & the FLAG STAFF S.E.E.E.

7 George Raper *View of the East Side of Sydney Cove, Port Jackson c.* 1790

8 G. W. Evans *Blighton Farm* 1810

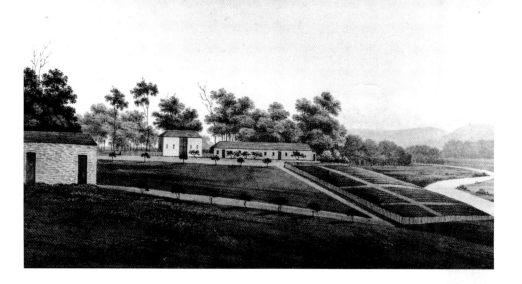

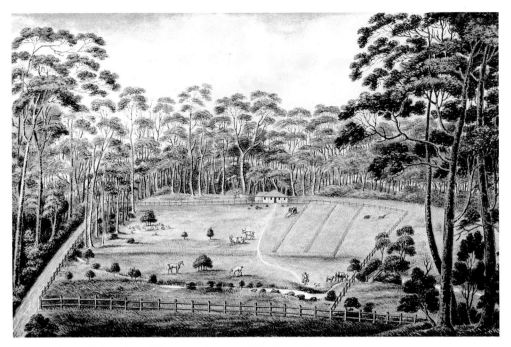

9 Joseph Lycett *Raby, a Farm Belonging to Alexander Riley Esq c.* 1820

10 John Glover *My Harvest Home* 1835

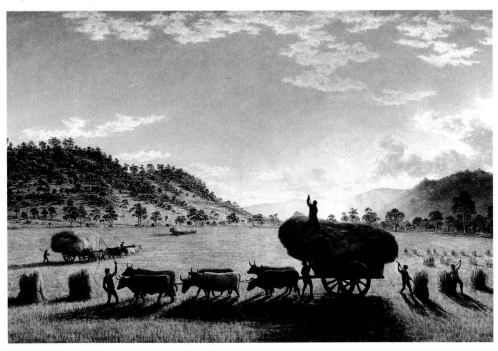

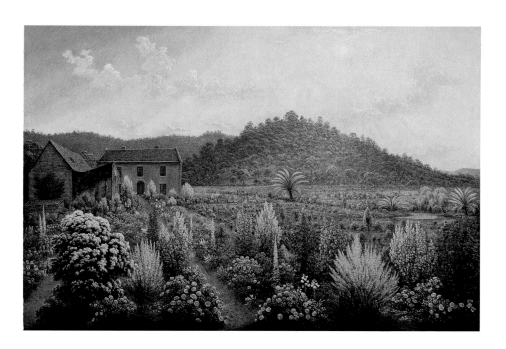

The finest colonial painter is John Glover (1767–1849), the only Australian artist to be a colonist of considerable means. Glover had been a successful artist in Bath, and came to Australia in 1831 to join his sons. He was an acute observer of the Tasmanian landscape, and yet his compositions always balance the explorer's interest in the exotic – he was evidently so struck by the sinuous curves of the eucalyptus that his trees have a strange and rather eerie animation – with an uncomplicated sense of being at home, embodied in the peaceful cattle grazing beneath those trees. This familiarity is striking because it is not found in the artists of a later generation, and indeed does not reappear until the end of the century.

Glover shows that the colonist, who brings his whole world with him, and has the means to realize it in a new environment, may create the sense of being at home relatively quickly. He has not fundamentally adapted to a new land, but largely reproduced the old; this is strikingly clear in two beautiful paintings of Glover's later years: *My Harvest Home* and *A View of the Artist's House and Garden, in Mills Plains, Van Diemen's Land* (both 1835). Glover has, it seems, reconstructed a familiar English world in Tasmania, aided by his wealth and a compatible climate. And yet it would be quite wrong to suggest that he is incapable of seeing the new world: it is rather that, like the persona of

10

28

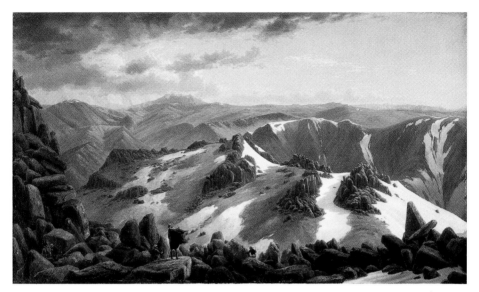

11 *(opposite)* John Glover *A View of the Artist's House and Garden, in Mills Plains, Van Diemen's Land* 1835

12 *(above)* Eugène von Guérard *North-East View from the Northern Top of Mount Kosciusko* 1863

13 *(below)* Eugène von Guérard *Stony Rises, Lake Corangamite* 1857

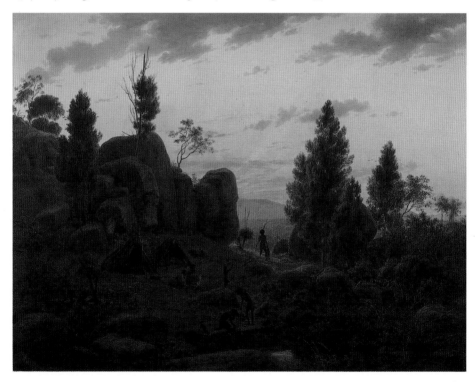

the explorer, that of the colonist protects the subject from being lost in the strangeness of the new. We would fail to appreciate the highest moments in Glover's art if we overlooked the visionary quality of *My Harvest Home*, or the uncanny mixture of the homely and the wildly exotic in the enchanted garden that surrounds the artist's house.

Much more transient – or transitional – is the colonial life depicted by S. T. Gill (1818–80) in his many images of life on the gold-fields near Melbourne during the rush of the 1850s. The townships are improvised assemblages of solid buildings, sheds and tents, where men wander around almost in rags. And yet the gold rush played a vital role in populating Australia. Transportation to Sydney had been stopped in 1840, but free settlers had been slow to take the place of the convicts. With the discovery of gold, the combined population of New South Wales and Victoria grew from a little over 250,000 to 886,393 between 1850 and 1860. After the end of the gold rush, the new arrivals needed to find work, and, although most ended up in cities and towns, many settled as farmers – 'selectors' – on land formerly occupied by the immense sheep-runs of the colonial squatters. The new wealth and expanded population of the colonies hastened the development of self-government and progress towards democratic parliaments, which in turn were the scene of political struggles between competing political interests.

The third phase of engagement with the new land, then, is settlement. Chronological sequence does not always follow logical order, but the principle is clear enough: the settler, unlike the colonist, does not re-create a fully imported world but has to adapt to the land he encounters. Above all, the colonist, even when he actually remains in the new land, sees the new world as an extension of the old and always imagines that he could return home; the settler must find his destiny in the new world. He has come to stay, and even if he continues to call the place of his birth 'home', this gradually becomes little more than a sentimental habit.

With such a commitment to permanence the inhabitation of the new land becomes a matter of renewed urgency, eloquently articulated by Marcus Clarke (1846–81) in two essays he wrote to accompany photographic reproductions of paintings from the collection of the National Gallery of Victoria. Earlier authors had spoken of Australia as a barren wilderness or a desolate waste, often in order to emphasize the progress of material civilization in the new continent. But this is the language of the colonist, who is primarily concerned with the obstacles to setting up commercial operations and social institutions.

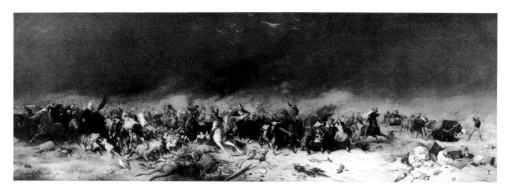

14 William Strutt *Black Thursday, February 6th, 1851* 1862–64

When Clarke wrote of the 'weird melancholy' of the Australian scenery he was speaking from the point of view of the settler, alluding to qualities of the land that seemed resistant to familiarization, and yet which the imagination could transform into a sense of belonging.

The material obstacles themselves were real, and the history of Australian exploration shows that contemporary expeditions were revealing the land to be more inhospitable than had previously been thought. Early expeditions in the 1810s and 1820s had opened promising new country over the Blue Mountains and north and south of Sydney. But from Eyre's expedition in 1840 to the disastrous journey of Burke and Wills in 1860 and those of the next fifteen years, it became clear that vast areas of the continent were uninhabitable. Again, of course, a dramatic contrast with the American experience of westward pioneer progress. As it happens, this experience of the remote outback was not to acquire significance in art until after the Second World War. For most of the first 150 years of Australian art, the natural environment that concerned settlers and painters was that of the coastal plains and the mountain barrier beyond. But the new discoveries demonstrated that what lay beyond was still more strange and hostile.

Even closer to hand, William Strutt's *Black Thursday, February 6th, 1851* (1862–64) commemorates another of the periodic disasters that are typical of the continent: a massive bushfire which destroyed many farms and homes near Melbourne. In the painting he completed after his return to England the bushfire is shown driving before it men,

31

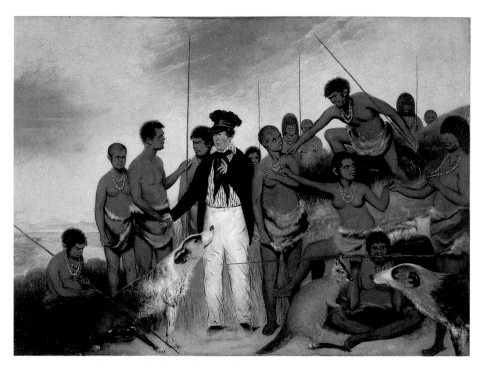

15 Benjamin Duterrau *The Conciliation* 1840

women, cattle and native animals alike. In spite of Strutt's over-eagerness to put expression in all his faces, and even in the eyes of the cattle and sheep, the painting has a kind of emblematic value as an image of the land physically rejecting the new settlers.

Strutt (1825–1915) pictures the anxiety of the settler; but there was a people who did not share such anxieties because they had lived in Australia from time immemorial. All culture is an acculturation of place, but the Aborigines were singularly preoccupied with mapping their environment, defining paths which were at once diagrams of a mythic past that is also the present, and vital notations of the routes between water-holes and camp-sites. Such topographies are the subject of the 'dot-paintings' that have come out of desert communities in recent decades.

By one of those ironies that can in retrospect assume such symbolic weight, the Europeans did not recognize that the Aborigines 'inhabited' the continent in any proper sense at all. Because they built no

towns or permanent dwellings, and appeared to wander at random through the country, living from hunting and gathering, they did not meet any criteria of effective occupation, and the country was assumed to be strictly speaking uninhabited. The consequent legal doctrine of *terra nullius*, only recently revoked, has been the occasion of great indignation and derision. In an historical perspective, however, it must also be seen as a genuine misapprehension arising out of a massive cultural disparity.

The encounter between Enlightenment Europeans and stone-age Aborigines was bound to be a difficult one. In 1698 William Dampier had called them 'the miserablest People in the world.' Cook, in 1770, took a very different view:

> From what I have seen of the Natives of New-Holland, they may appear to some to be the most wretched people upon Earth, but in reality they are far more happier than we Europeans; being wholly unacquainted not only with the superfluous but the necessary Conveniences so much sought after in Europe, they are happy in not knowing the use of them. They live in a Tranquillity which is not disturb'd by the Inequality of Condition: The Earth and sea of their own accord furnish them with all things necessary for life.

Cook's language directly alludes to the ancient idea of the Golden Age, before men separated themselves from a maternal nature that fed them spontaneously by the brutal act of ploughing the earth and forcing her to yield nourishment at their command. From this original sin (the sin of Cadmus and later of Oedipus) follow all the benefits of civilization but also all the evils of a society based on power and inequality. Such ideas ultimately lay behind the eighteenth-century idea of the noble savage, given special currency in Rousseau's *Discours sur les sciences et les arts* (1750). The idealization of the Aborigines as noble savages, however, did not succeed, partly because they so soon became sad fringe-dwellers around the new settlements, but also because the colonists, whose whole attitude was necessarily post-Golden Age, saw little to admire in their way of life. The very idea of a noble savage will always be more appealing in a metropolitan salon than in a colonial outpost.

But there is a more intimate reason for the failure of the noble savage idea in Australia. If the core of the conception was moral, its outward manifestation was aesthetic: the simple virtue of the noble

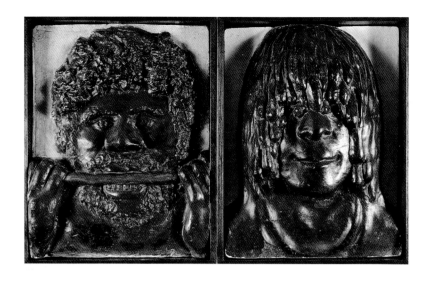

16 Benjamin Duterrau *(left) The Manner of Straightening a Spear; (right) Cheerfulness*
1835

savage was expressed in the beauty of his form and the dignity of his bearing. This was consonant with the late eighteenth-century aesthetic of neo-classicism which put formal perfection before the expressive values of the previous century. Nor was the beauty of the noble savage entirely ideal: as it was an image of physical harmony specifically opposed to Christian views of the body as corrupt, it inevitably implied the enjoyment of sexual pleasure without guilt. This became – and of course remained – the principle reason for European interest in the inhabitants of the South Seas, especially the Polynesians. But it was precisely the overwhelming importance of the aesthetic that disqualified the Aborigines, for they were not beautiful to European eyes. Dampier had found them 'of a very unpleasing aspect; having no one graceful feature in their faces.' Cook, a man for whom the moral substance mattered more than the outward appearance, could ignore the question of beauty; others could not.

All of this makes Benjamin Duterrau's (1767–1851) representation of the Tasmanian Aborigines particularly interesting. By the early 1830s, after a relatively short period of unequal warfare, most of the Tasmanian Aborigines had been killed; a Methodist bricklayer, George Robinson, had undertaken a series of missions to bring the

34

survivors into captivity. He succeeded in this 'conciliation' and the last Aborigines went to live on Flinders Island in Bass Strait, later moving to Oyster Bay on the mainland where they finally died. Duterrau saw in Robinson's mission a suitable subject for a history painting, which he conceived as a 'National Picture'. The subject of *The Conciliation* (1840) may strike us today as highly ambivalent, and yet Duterrau's treatment of the Aboriginal figures is significant. In accordance with the academic theory of expression, most famously articulated in a 1668 lecture by Charles le Brun, Duterrau has attempted to give each of the Aboriginal figures a different expression, as each responds in his own way to Robinson's offer of peace.

A set of plaster reliefs, painted to look like bronze, was apparently part of the artist's preparation for his principal work: they are an exercise in re-creating the images of the passions in Aboriginal features. The academic repertory of the passions is itself so little known today that we may easily miss the importance of Duterrau's work: but it amounts to nothing less than an affirmation of the humanity of the Aborigines and the human expressivity of their features. In the process he is appealing, beyond the neo-classical ideal of formal perfection, to the earlier classical aesthetic of expression founded in the practice of Raphael and Poussin. Indeed it is possible that he thought, following a suggestion in Richard Payne Knight's *Analytical Enquiry*

17, 18 Benjamin Law
(left) Bust of Trucaninny,
Wife of Woureddy 1835;
(right) Bust of Woureddy,
an Aboriginal Chief of Van
Diemen's Land 1836

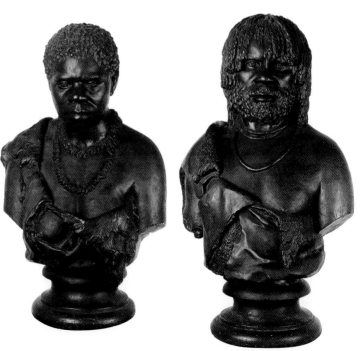

into the Principles of Taste (1801), that savages expressed 'the sentiments of the mind' more clearly and directly than civilized people.

Duterrau was, it should be said, not the only artist to give this kind of attention to the Tasmanian Aborigines. Benjamin Law's (1807–90) busts of the last full-blood survivors of the race, Trucaninny (1835) and her husband Woureddy (1836), are among the few nineteenth-century Australian sculptures worthy of serious consideration as art. The Tasmanian Aborigines, a different race from those of the mainland (long ago driven out of the mainland by the invasion of later arrivals), led a fierce resistance to the settlers, but after their defeat seem to have evoked a particular sympathy. The imminent disappearance of a people must have seemed to some settlers at least a grave and awful thing; the busts are charged with that sense of commemoration.

The settlers committed many crimes against the Aborigines, in spite of the colonial government's avowed policy of protection. Attempts at 'protection' themselves sometimes had disastrous or inhumane consequences. And yet attitudes to the native population were probably more complex than is usually suggested today, and have

19 Augustus Earle *Wentworth Falls c.* 1830

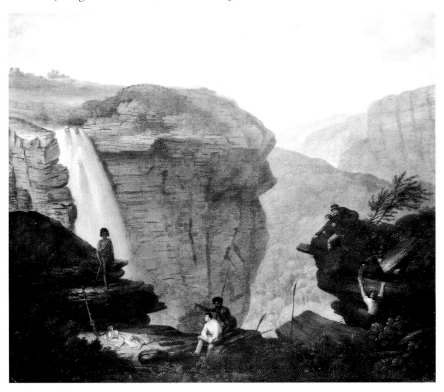

20 Augustus Earle *Natives of New South Wales as seen in the Streets of Sydney* 1830

remained so through the two centuries of Australia's European history. Beside those two Latin words, *terra nullius*, should be placed two others, *ab origine* – the land may have been technically unoccupied, but the people who dwelt in it had done so 'since the beginning'. Often, in the art that has attempted to articulate the European experience of living in the new land, the Aborigine has appeared as the reminder of another way of being, or at least as a marker of the distance that separates us from unselfconscious intimacy with our environment. Even in Earle's *Wentworth Falls* (c. 1830), the Englishmen scrambling up the rocks on the right are contrasted with the perfect poise of the native standing on the left of the composition. The fact that Earle himself could elsewhere represent the native as drunken fringe-dweller is not only evidence that both types of Aborigine existed, but more importantly that conventions of genre affected their treatment in art. In the documentary genre, contemporary urban reality could be revealed; in the genres of high art, the Aborigine became a symbolic figure in the imaginative universe of the European Australian.

Earle described Wentworth Falls from the point of view of the explorer – the principal figure in the composition, presumably a self-portrait, is clearly making topographical sketches. But a generation later such dramatic views became important subjects for artists concerned with the spirit of the new land – with the artists who first articulate the experience of the settler. The landscape painters who worked in Australia during the middle years and especially the third quarter of the century brought a new ambition to their depictions of the continent – unlike the earliest painters in the colony, they did not choose the settlements for their subjects, but scenes of natural beauty and grandeur. And unlike the earliest artists, who tended to concentrate on the detail of topography or botany, they were concerned with the general effect of a location.

In both of these respects, no doubt, they were influenced by the general spirit of romanticism with its belief in nature as a living force with which the human soul could commune; a force with a distinctive local character and yet ultimately expressive of the universal creative power of the divinity. Landscape, therefore, could both describe the qualities of a particular place and hint at the presence of God. In Australia artists appear to have devoted themselves particularly to the careful description of the landscape. But it is significant that they chose to represent not the environment in which most of the settlers actually lived and worked, but apparently distant and spectacular scenes in which the nature of the land could reveal itself in its pristine state.

Conrad Martens (1801–78), who came to Sydney in 1835 and remained there until his death, began as a topographic watercolourist and developed an increasingly Turneresque style, capturing with a fine touch the luminous and atmospheric effects of the harbour. His views are in fact mostly of settled country, and often include the reassuring Georgian forms of a large colonial house, but unlike those early painters of townscapes, Martens takes his point of view from much further off, so that everything is diminished in scale, and instead of lucid notation of the facts of daily life, concentrates on the broad effects of light and weather. Nature is his subject, and the colony is there as a familiar and comforting background. Martens is thus a transitional figure: his aesthetic remains formally colonial, but the early Romantic idea of the picturesque allows him to venture away from the ploughed farm and fenced garden, and to enjoy the beauty of wild, rough and organic things. Still, the picturesque is what lends itself to being pictured – to being captured for exhibition on the walls of one

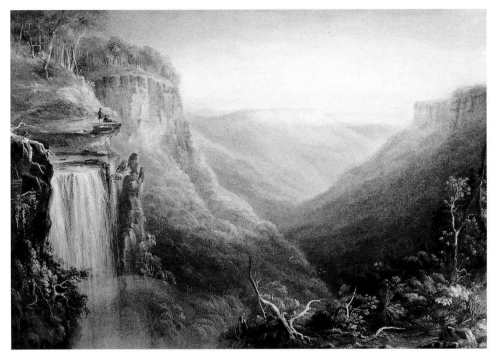

21 Conrad Martens *Fall of the Quarrooille (FitzRoy Falls), near Throsby Park, Bong Bong* 1836

of those elegant Georgian mansions of which Martens was the skilful portraitist, and which so often served to anchor his compositions.

Martens did not venture – figuratively speaking – far enough from the colonial villa to engage with the deeper experience of settlement. The artist who first articulates this new commitment in the encounter with the land is Eugène von Guérard (1811–1901). Like Martens and almost every early Australian artist, von Guérard came from overseas, arriving in Melbourne in 1853. These artists had trained in Europe (but by no means only in Britain), had often lived and worked in other colonial lands, and spent some years in Australia in the course of their travels around the world. Some, like Martens, stayed; von Guérard remained in Melbourne for many years but finally returned to Europe in 1881; others, like Strutt, completed their important 'Australian' works long after their return home. As we have already suggested, however, it is not where artists were born or how long they remained in Australia that matters, but the quality of the relationship

they achieved with their environment and their public. Von Guérard's case in this respect is exemplary: he was a very minor painter in Austria; the new world made him an artist of standing.

Von Guérard painted many colonial pictures – such as *Koort Koort-Nong Homestead, near Camperdown, Victoria* (1860) – but his characteristic subject-matter was wild scenery remote from colonial occupation. It was here, beyond the reach of domestication, that the settler–artist looked for the spirit of the land. Some of von Guérard's most dramatic subjects were encountered on expeditions into the interior: 'exploration', of course, takes on a different character altogether when it is no longer London surveying a distant continent but Sydney or Melbourne trying to understand its own hinterland.

If Martens's aesthetic did not reach beyond the picturesque, von Guérard discovered the sublime of the Australian landscape: the sense of something ancient, vast and irreducibly strange. He defined the difficulty of imaginatively inhabiting Australia. At the same time, the genre of the sublime landscape allowed him to make this discovery intelligible and to convert discomfort into an aesthetic experience (beauty gives pleasure, but the sublime inspires an exaltation inseparable from a sense of fear). His most famous composition in this genre is *North-East View from the Northern Top of Mount Kosciusko* (1863). The minute figure of an explorer stands in the foreground to admire the

12

22 Eugène von Guérard *Koort Koort-Nong Homestead, near Camperdown, Victoria* 1860

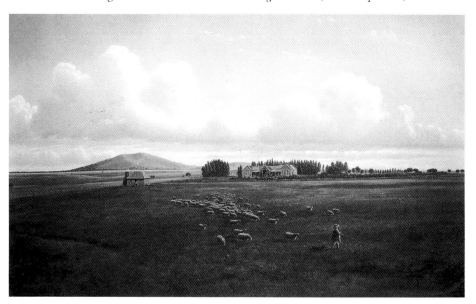

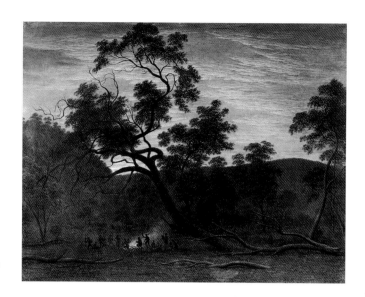

23 John Glover
*A Corrobery of Natives in
Mills Plains* 1832

vista of unpeopled snowy wastes, just as, in the slightly more familiar
and yet self-conscious *Castle Rock* (1865), the cliffs dwarf the few
fishermen and a small party of seaside visitors.

It is von Guérard who most frequently seems to invite comparison
with nineteenth-century American painters of the sublime landscape
such as Thomas Cole or Frederic Church. But beyond the most obvi-
ous level of similarity, such parallels are misleading, and ignore the
very different significance these painters have within their respective
historical contexts. In a word, von Guérard's pictures are involved in a
crucially formative period for early Australian culture, while Cole's
and Church's come long after the definition of what it is to be
American. Their views of romantic wilderness are supplementary to
an established culture, and this remoteness from urgency is translated
into the elevated, distant, self-consciously sublime spirit of their com-
positions. Von Guérard's *North-East View from the Northern Top
of Mount Kosciusko* is characteristically down-to-earth, scrupulous in
its attention to detail. Humility and integrity save him from the perils
of kitsch.

Von Guérard also discovered (though, as we have already seen, this
had been anticipated even by Earle) that the Aborigines were at home
in this seemingly inhospitable environment – these people who did
not appear to occupy the land in any recognized way were natural
dwellers in the sublime. This is in itself paradoxical from our point of
view, since the sublime is something to be admired, but not to be

41

lived in – the experience of the sublime is not reciprocal, not a relationship. But although the Aborigines belong to this order of timeless nature, history is invading their domain. *Stony Rises, Lake Corangamite* (1857) is one of the most moving nineteenth-century images of the Aborigines, because it expresses such intimacy of belonging, but suggests at the same time the doom that hangs over this way of life. The little community is too small, as though reduced to a single family. It is sunset, as it had been significantly in Glover's *A Corrobery of Natives in Mills Plains* (1832), and as it will often be again in Australian landscapes; in Hans Heysen's paintings, many years later, sunset casts a melancholy glow over the world of the Heidelberg School.

If von Guérard gave pictorial articulation to the settler sensibility in its first form – one might almost say in the form of a question, for the 'answer' is provided by the Heidelberg painters in the next period – it was Marcus Clarke who most memorably put this sensibility into words a few years later. The occasion of this important piece of writing was a picture greatly inferior to those we have just mentioned: *The Buffalo Ranges* (1864), by Nicholas Chevalier (1828–1902), a Swiss artist born in St Petersburg, and another of the painters who visited Australia for a time before returning to greater fortunes in Europe.

In 1863, in the newly prosperous city of Melbourne, a Fine Arts Commission was appointed to begin purchasing works for the future National Gallery of Victoria. They announced that they would devote part of their funds to the purchase of a painting (or paintings) by an artist resident in Australia, provided that it should 'compare favourably with the works of eminent living artists in Europe'. Artists were given twelve months to prepare their entries, and in January 1865 the prize was awarded to *The Buffalo Ranges*, which thus became the new Gallery's first specimen of Australian painting. It was, consequently, one of the two Australian pictures (the other was Buvelot's *Waterpool near Coleraine (Sunset)* 1869) chosen for the set of photographic reproductions which the gallery produced in 1874, and to which Marcus Clarke contributed the accompanying essays.

Clarke clearly did not like the picture, although he records that it 'is very popular with visitors to the Gallery, and has been highly spoken of by many persons'. As for the artist, he observes that Chevalier, on arriving in Victoria, 'lent himself readily to satisfy popular taste'. Clarke's essay contains one of his most celebrated and frequently cited passages about the Australian bush, but it is clearly provoked, rather than evoked by the painting before his eyes. There are few mountain ranges, he writes, 'which can be compared with the Australian Alps –

42

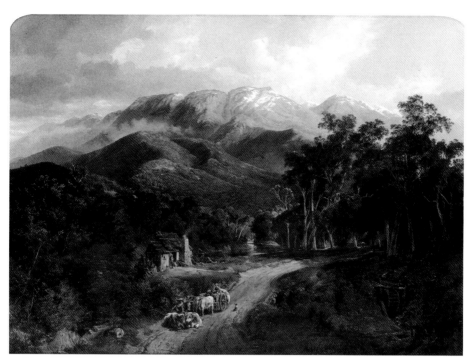

24 Nicholas Chevalier *The Buffalo Ranges* 1864

25 Nicholas Chevalier *Mount Arapiles and the Mitre Rock* 1863

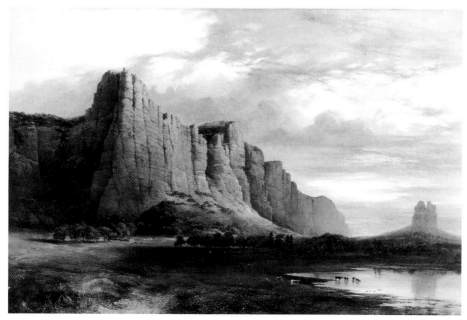

not for magnificence – but for gloom, for greatness of solitude, and for that grandeur which is born of the mysterious and the silent. ... The Australian mountain forests are funereal, secret and stern. Their solitude is desolation. They seem to stifle in their black gorges a story of sullen despair. No tender sentiment is nourished in their shade. In other lands the dying year is mourned, and falling leaves drop lightly on his bier. In the Australian forests, no leaves fall. The savage wind shouts among the rock-clefts. From the melancholy gums, strips of white bark hang and rustle. ... All is fear inspiring and gloomy. No bright fancies are linked with the memory of these mountains. Despairing explorers have named them out of their sufferings – Mount Misery, Mount Dreadful, Mount Hopeless.'

Clarke's writing and Chevalier's painting together give some idea of the range of contemporary sentiment and attitude before Australian nature. Chevalier's composition is made of two distinct parts: in the foreground, there is a road with a little house and a cart – all very European and familiar; in the background is the snow-capped mountain, self-consciously sublime and distant. It is fundamentally chocolate-box, and in its juxtaposition of a reassuringly settled foreground with remote wilderness – safely turned to spectacle – it avoids precisely the experience of involvement in the bush that Clarke has described. Less bold than von Guérard, Chevalier has reproduced on a more pompous scale the colonial formula we have seen in Martens. Turning from this meditation, Clarke writes acidly about the setting of the painting:

'In the townships around the Buckland, however, the tide of modern life flows with its customary dullness. A police-station, a road board, a common school, together with the convenient number of public-houses, give evidence of the progress of civilization. The natives have killed themselves with gin, and immigrants from Berkshire pic-nic on the spurs of Mount Despair. The painting by M. Chevalier represents a view taken on the main road leading through the range, and no doubt faithfully represents the local features of the landscape.'

Chevalier, the adaptable, ultimately vulgar painter, mirrors the general idea of what it is to feel at home in the new land: to gaze at the sublime spectacle of distant wilderness from the vantage-point of comfortable familiarity. This is, indeed, the late colonial compromise. Clarke evidently considers much of the material progress questionable. But above all, he speaks for a closer relationship with the environment: he suggests that we can only truly inhabit this land by

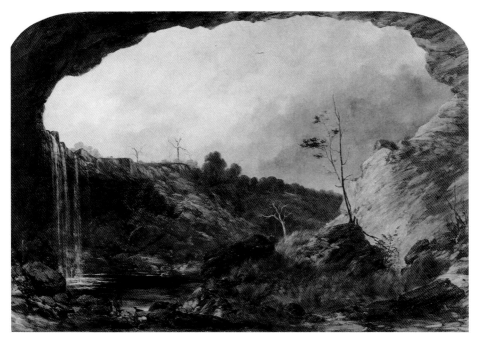

26 Thomas Clark *Falls on the Wannon* 1870

recognizing and even assuming its strangeness; we can only feel at home here, paradoxically, by accepting its unhomeliness.

'In Australia alone is to be found the Grotesque, the Weird – the strange scribblings of Nature learning how to write. Some see no beauty in our trees without shade, our flowers without perfume, our birds who cannot fly, and our beasts who have not yet learnt to walk on all fours. But the dweller in the wilderness acknowledges the subtle charm of this fantastic land of monstrosities. He becomes familiar with the beauty of loneliness. Whispered to by the myriad tongues of the wilderness, he learns the language of the barren and the uncouth, and can read the hieroglyphs of haggard gum-trees blown into odd shapes, distorted with fierce hot winds, or cramped with cold nights, when the Southern Cross freezes in a cloudless sky of icy blue. The phantasmagoria of that wild dreamland called the Bush interprets itself, and he begins to understand why free Esau loved his heritage of desert-sand better than all the bountiful riches of Egypt.'

Closer to Clarke's sense of the Australian environment is a painting by Thomas Clark (*c.* 1814–83), *Falls on the Wannon* (1870). Ten years

45

earlier, Clark had painted the same motif, from a distance which reveals its modest scale; in addition, he had included a couple of middle-class sightseers and their dog, sheep and cattle on the hill above, and two Aboriginal women in cast-off European clothes in the foreground. The scene is picturesque, anecdotal and essentially colonial. In 1870, the whole subject is recast in the mode of the sublime: it is an unspoilt natural scene, dramatic and strange, a vast hollow in the rock forming something like a secret world. A native family, apparently untouched by European contact, is now quite at home in this 'weird' place. Above, however, on the ridge, two minute figures on horseback are visible. Near them are dead trees, while everything in the rocky hollow of the waterfall is wet and lush. The transient but ominous presence of the European is disturbingly, if only implicitly, contrasted with the natural dwelling of the Aborigines in the bush.

The two horsemen are exceptionally small, but the figure in colonial painting is rarely large. In the predominant genre of landscape, the human figure plays a secondary, though still important part – either showing activities typical of the scene, or indicating the appropriate attitude of the viewer. Scenes of Aboriginal life, for example, such as Glover's, animate the landscape and in a sense complete it by illustrating the kind of human life that has grown out of this environment. In many other colonial paintings, particularly of dramatic scenery or the broad vistas of new country, the small figure of an explorer will be included, marking the wonder of new discovery. 'Sublime' landscapes continued to be produced by such artists as W. C. Piguenit (1836– 1914) long after this conception of Australia had been rendered obsolete by the Heidelberg painters. The absence of figures in *The Flood in the Darling* (1890) is perhaps symptomatic of a dated vision.

The small size of the figures is a matter of genre, but the genre practised also tells us about the training of the artist. From the Renaissance onwards, in theory at least, history painting – the representation of substantial narrative subjects – had been considered the highest genre. History painting was based on the human figure, and that became the principal study of art academies. Landscape painters did not have this training, and so could not execute large-scale bodies; they learnt to paint the small figures known as *staffage*. Hence the relation of figure to landscape has not traditionally exhibited a wide range of possibilities: generally, it has been either large figures with a background view, or a landscape animated by small figures.

Of the two genres, it is clear that landscape was more closely related both to the British tradition and to the immediate needs of explorers

27 W. C. Piguenit *The Flood in the Darling* 1890

and colonists. The later eighteenth century and the first half of the nineteenth offered rich opportunities to a class of artist-adventurers, who might come, like Earle, von Guérard and Chevalier, from anywhere in Europe and who sought their fortune accompanying scientific expeditions or simply travelling around the exotic ports of the expanding European empires, collecting picturesque views. Landscapists could be mobile and itinerant in this way; history painting was a more sedentary art, and in any case there was little call for history painters in a new settlement. In the long run, however, if landscape could speak eloquently of the relation of the colonists to their new environment, it was nonetheless limited. Small figures tend to be anonymous; they can stand for the general or the typical, but they are unsuited to representing the individual moral drama or the act of will. If the question of inhabiting the new country was not to be restricted to the registering of passive response or to a level of general documentation, artists had to be competent to use the human figure.

Few such artists came to the Australian colonies in the early days. Duterrau aspired to the great genre, and, in spite of his very modest abilities, produced in *The Conciliation* what has usually been considered the first history painting painted in this continent. Adelaide Ironside (1831–67) was the first Australian-born artist to study

47

28 William Strutt *Bushrangers, Victoria, Australia, 1852* 1887

overseas, but the most significant picture she produced, *The Marriage at Cana* (1861), has no incidence on the history of Australian painting.

One of the very few artists to come to Australia already trained as a figure artist and with the ambition to make history paintings of colonial life was William Strutt, although both his important compositions were painted after his return to England, and many years after the events on which they were based, which occurred in 1851 and 1852 respectively. *Black Thursday, February 6th, 1851* (1862–64), which has already been mentioned, was followed by *Bushrangers, Victoria, Australia, 1852* (1887). The figure is even more important in this picture than in the previous one, and the subject gave him the opportunity to paint a much greater variety of expressions. Nevertheless it epitomizes the banality of a subject that is too close to the artist, and in which the imagination is stifled by circumstantial reconstruction. The fault was not Strutt's alone: for the Victorians, trying to address a broader public, history painting became indistinguishable from genre at one end of the scale, and a prefiguration of Hollywood at the other.

Figure painting began to be taught in Australia with the development of professional academic art education, which dates from the foundation of the National Gallery School in Melbourne in 1870. Before that time art teaching mainly took the form of private lessons given by artists or classes at the various Mechanics' Institutes (the first

14

48

of which was founded in Hobart in 1826), and the object of teaching was primarily landscape. Even the founding of the National Gallery School, however, did not guarantee immediate opportunities to work from the live model, and students in the early eighties, including Tom Roberts and Frederick McCubbin, used to band together to hire models. Nonetheless, the National Gallery School soon began to turn out competent exponents of that peculiarly Victorian fusion of genre and history painting, and the necessary adjunct of an academic training – the travelling scholarship to study abroad – was set up in 1886. John Longstaff (1861–1941) was the first winner, in 1887, for *Breaking the News*. These are pictures seldom looked at today, but they are products of the training that allowed Tom Roberts to produce compositions that demanded an equal mastery of figure and landscape, and without which it would have been impossible to articulate the answers to the questions raised by von Guérard and his successors.

29 John Longstaff *Breaking the News* 1887

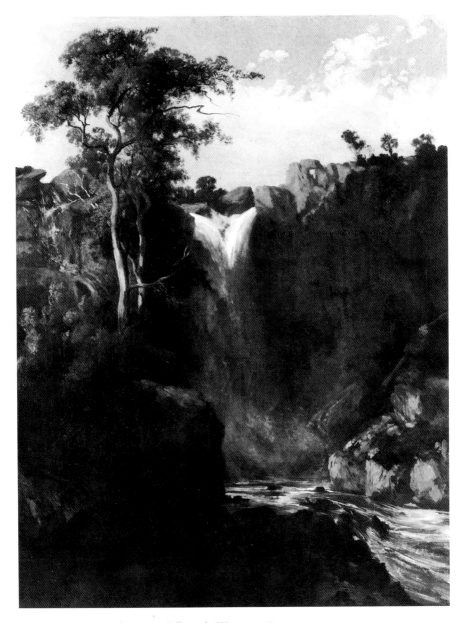

30 Abram Louis Buvelot *Upper Falls on the Wannon c.* 1872

Settlement

The large canvas is divided into three panels to enable the
painter to give pictorial insight to three episodes in the life his-
tory of those strong spirits who opened up this Continent. ...
In the first ... the young, free selector has pushed into the
depths of the bush. ... In the next panel we see that the great
wonder of the bush has been achieved [by] the strong arm of
the man. ... His cottage nestles in the clearing. In the fore-
ground, he sits smoking the pipe of peace on the trunk of·the
last giant to crash before the axe that lies before him. ... The
young wife stands in front of him, a child in her arms.

The Age, 16 August 1905
(on Frederick McCubbin's *The Pioneer*)

Of all the subjects in the repertoire of the sublime, the waterfall was
the most familiar, if not the most facile. It was the natural way to add
movement and sound to a mountainous landscape, to express visible
scale as audible power. Even a painter whose sensibility was more
drawn to the intimacies of the picturesque, like Martens, used the
waterfall to convey an effect of grandeur. But only a few years after
some of the most ambitious attempts at the sublime in Australian
painting, Abram Louis Buvelot's (1814–88) *Upper Falls on the Wannon*
(*c.* 1872), presents a surprisingly sober view of this popular motif.
There are no great heights or depths; this is not the vista discovered by
an explorer at the edge of the known world, but a beauty-spot at the
end of a bushwalk. The falls are modest in scale, close and literally
approachable: the foreground in which we are almost forced to imag-
ine the painter's easel leads directly to the foot of the falls at a little dis-
tance. Buvelot's *Near Fernshaw* (1873) is a similarly domesticated
version of the deep primeval forests so often evoked by the previous
generation. The ground is level, the forest is faced directly, and a broad
track runs through it. And it is not a makeshift track, finding its way as

31 Isaac Whitehead *Gippsland c.* 1870

32 Abram Louis Buvelot *Summer Afternoon, Templestowe* 1866

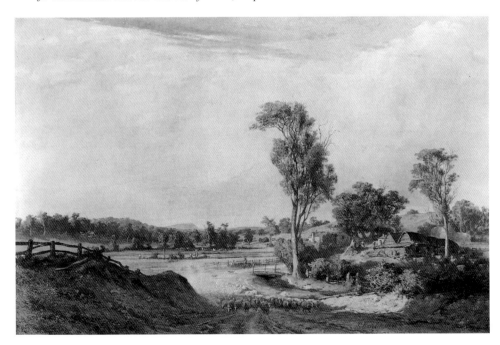

33 Abram Louis Buvelot *Waterpool near Coleraine (Sunset)* 1869

best it can around the giant trees of the forest – as in Isaac Whitehead's
Gippsland painted only three years earlier – but one deliberately
cleared. The fallen logs have been used in the foreground, and a
farmer with his ox-cart suggests the regular traffic along this road.

Buvelot was born in Switzerland and arrived in Australia in 1865 at
the age of 51. He is another example of the unpredictable results that
can come of grafting cultural cuttings onto a foreign stock. Like such
painters as Glover and von Guérard, Buvelot found new material in
Australia and no doubt developed into a better artist than if he had
stayed in Europe. But Buvelot also became – which is not the same
thing – an *influential* artist in Australia. In Europe he could never have
been influential; he was a capable but slightly *retardataire* exponent of
the Barbizon School, once again illustrating the principle that no
innovative European artist ever came to settle in Australia. But that
did not matter at a time when Australian art was dominated by local
problems: Buvelot came at precisely the right moment for Australia,

bringing ideas that were not only still new, but much more importantly, useful and applicable to local artistic and cultural problems.

If the artists of the mid-century and the following decades had begun the imaginative settlement of Australia with attempts to confront the 'weirdness' of their new home, such a strategy could yield only a paradoxical accommodation. Buvelot, on the other hand, perhaps because he was a foreigner, seems to have been indifferent to the weirdness. He brought the compositional formats and the sensibility of Barbizon, with its roots in Millet and the ideology of peasant labour, and began to discover such rural subjects in Australia. He also promoted the Barbizon practice of *plein-air* painting, which tends to produce the effect of closeness to the motif already mentioned, and as a consequence of this closeness, a reduction in overall scale. The *plein-air* painter looks for an interesting group of trees rather than a whole forest. Conversely, the very fact of painting before the motif implies a degree of familiarity and an ease in the environment. It encourages in the artist a freer, less meticulous execution than in a studio painting; the point is to capture the appearance of the subject at a particular moment. Inevitably freedom of handling is preferred to high finish; and just as von Guérard's finish embodies the intensity of the sublime, so the loose, casual handling of Buvelot speaks of a greater detachment and a concern for subjective experience.

Buvelot thus turned Australian painting from its concern with the strangeness of nature – whether beautiful or terrifying or both – to
32 the spectacle of its domestication. In his *Summer Afternoon, Templestowe* (1866) we recognize a new attitude to the country and specifically to the experience of settlement. The artists of the following generation were in no doubt about it: Streeton later called it 'the first fine landscape painted in Victoria'. It is the simple picture of a farmhouse and sheep being driven along a dusty road towards evening. It is not at all the portrait of a gentleman's residence and property, like so many colonial pictures; it is not really about property or ownership at all, but rather about being at home on the land.
33 *Waterpool near Coleraine (Sunset)* (1869) is much more closely reminiscent of Barbizon in style and composition. The image is more ambiguous than it seems: within the frame of reference implied by the style and its original European context, it is a picture of nature – trees, a pond, the red sky of sunset. But this is a frame of reference within which even 'nature' is usually park, cultivated wood or a quiet corner of farmland; transposed into the Australian setting, in which the land had never been settled or cultivated, even the discreet signs of human

presence that Buvelot has left in this composition become very significant. Cattle graze on the left, ducks waddle towards the pond, and once again a track leads into the composition. The whole picture speaks of a familiarity which perhaps came easily to Buvelot, but which is the antithesis of Marcus Clarke's 'weird melancholy'.

Buvelot's historical importance lay in his introducing the idea of familiarity with nature, in demonstrating its possibility. But he had largely brought these formulas with him; he could stimulate the next generation to rediscover this familiarity for themselves, and even give them important hints about how it should be done. In the end, however, the world and the persona of the settler could only be constructed by artists whose own development had taken place in this setting. It was not only a question of knowing the land and the light, the flora and fauna of the new continent, but of sharing the historical experience of the Australian settler, or more precisely the experience of those who would take the settler as their hero.

Buvelot had given one important clue in *Waterpool near Coleraine (Sunset)*: the fallen tree and the axe. The sight of an axe no longer warms the heart of educated Australians – so much irreparable damage to the environment was done by a mixture of ignorance, greed and ambition, sheltering under the ideology of the pioneer. Nonetheless, the axe is certainly endowed with noble, even heroic connotations in the art of the nineteenth century. It is the first tool of the settler, the instrument with which land is cleared before it can be inhabited. J. D. Lang, in his *Historical and Statistical Account of New South Wales* (1834), had already written of the sons of the colony that each, 'on attaining man's estate, goes forth with his axe into the vast forest to extend the limits of civilization, and to fill the wilderness and the solitary place with the habitations of men.'

The axe appears in many later pictures, but never with a clearer significance than in Streeton's *The Selector's Hut: Whelan on the Log* (1890). 35 Streeton's picture is all the more instructive because we can compare it with a very different interpretation of the same motif, at the same time, by Charles Conder, and thus for once see not only what an artist has done, but what he has *not* done. *Under a Southern Sun* 34 (1890) depicts what appear to be the same hut and the same tree (though with some significant modifications), the same settler and the same fallen trunk. But Conder (1868–1909) is more interested in the topography of the place, and also in picturesque detail – above all he introduces notes of sentimentality (the little girl in the foreground) and of domesticity (the clothes hanging on a makeshift line)

which were presumably present in the motif but were removed by Streeton.

Streeton's picture is clearer both compositionally and above all in meaning. It is reduced to tree, hut, selector and trunk, all brought into a taut formal relationship. Narratively, the elements are simplified and concentrated on a single event: the selector sits on the trunk, his axe behind him; he smokes his pipe, resting from his labour. Even the treatment of time is highly significant. Where Conder evokes an indefinite present with hints of past and future, Streeton very deliberately chooses the perfect tense – the aspect of a task just completed, of a past leading up to and culminating in a present which is thereby charged with historical dynamism.

The real subject of Streeton's picture is work. It is through work that the selector has earned the right to sit on the log, smoking his pipe, satisfied and happy even though he lives in a hut with none of

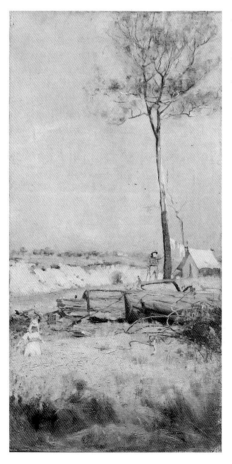

34 *(left)* Charles Conder *Under a Southern Sun* 1890

35 *(opposite)* Arthur Streeton *The Selector's Hut: Whelan on the Log* 1890

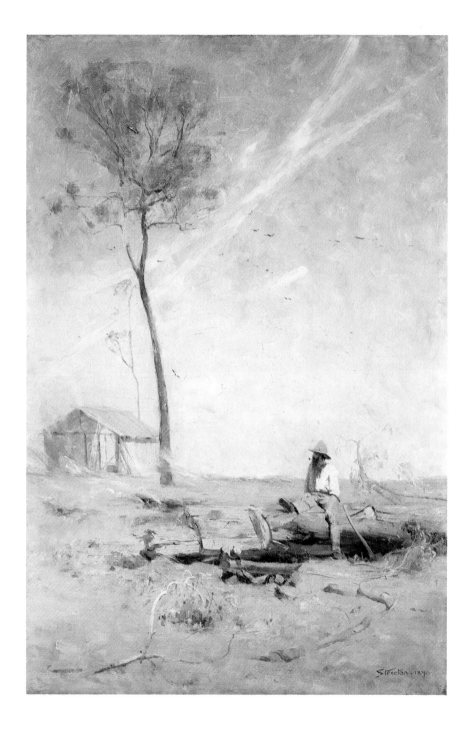

the amenities of modern life. This is still further than Buvelot from the colonial pictures of Georgian farmhouses, with their imported and imposed order, their display of wealth and social rank. Streeton's selector has nothing, but has earned the right to live in this new land; he has earned the evident familiarity which he enjoys. His work is a struggle with nature; the outcome, however, is not conquest but a relationship: the land becomes, for the settler as he is conceived by the Heidelberg Movement, the mirror of his experience. For the first time the dry land, the harsh glare, the scrawny trees appear beautiful, not because painters had finally solved the technical problem of representing them, but because they had discovered the historical and political vision which made it possible to build a home among them.

The Heidelberg Movement effectively began with Tom Roberts's (1856–1931) return from England in 1885. He had been born there and had come to Australia with his widowed mother and his brother and sister in 1869. In Melbourne he had studied art at the National Gallery School from 1875 to 1880, and then returned to London in 1881, where he attended the Royal Academy. Although he acquired some idea of French Impressionism, he was more directly influenced by Jules Bastien-Lepage (1848–84), who painted scenes of rural work inspired by Millet. Roberts was thus exposed to the same movement that influenced the young van Gogh in the early 1880s, although a theme that in Europe could range from the quasi-mystical to bourgeois kitsch acquired quite a different meaning in his hands and in the specific context of Australia. He was also influenced by Whistler, whose aesthetic style appears both in the bohemianism of the Heidelberg artists and in certain details of paint handling which were adapted to their needs, and by the English school of *plein-air* painting.

Returning to Melbourne in 1885, he set up the first *plein-air* painting camp at Box Hill, near Melbourne, with his friends Frederick McCubbin (1855–1917) and Louis Abrahams (1852–1903), and the young painters set out to become intimately familiar with their natural environment. Abrahams had been born in London and come to Australia at the age of eight, McCubbin in Melbourne; they too had studied at the National Gallery School. They invited the somewhat younger Arthur Streeton (1867–1943), also born in Victoria, to join them after meeting him painting on the beach at Beaumaris. Conder, born in London and living in Sydney since 1884, went to Melbourne and joined the group in 1888. The old idea that this group of friends became the first significant Australian artists is untenable, but it is true that they were the first school or movement of importance. The

36 Tom Roberts *The Artists' Camp c.* 1886

earlier artists were solitary figures – the Heidelberg group, as they became known after a place they liked to paint, imply in their own social organization a different relation of the artist to society as a whole.

Roberts's *The Artists' Camp* (*c.* 1886), in which McCubbin and Abrahams are recognizable, evokes those happy days of youthful escapades to the fringes of the bush to which all of them later looked back with nostalgia. At the same time, fortuitous resemblances to *The Selector's Hut* remind us how different the experience of these young city artists really was from that of farmers and pioneers. They were not merely learning to paint *en plein air*, they were beginning to imagine the ideal world that they would elaborate in the guise of realism.

The Heidelberg group did not immediately discover the theme of rural work. Roberts, for example, painted a memorable picture of the city of Melbourne shortly after his return – *Allegro con brio: Bourke Street West* (*c.* 1886), whose high viewpoint and elevated horizon were 39

later used, with modifications, by Conder in his *The Departure of the Orient – Circular Quay* (1888) and by Streeton in *The Railway Station, Redfern* (1893). The recurrence of this viewpoint is significant, and it suggests why urban subjects were peripheral, rather than central, to the Heidelberg style: apart from the fact that no one can be seen to be working, the individual is lost in the bustle of a big city. Roberts's choice of a musical title itself speaks of the distance from which he witnesses this animation – a distance at which men and women are reduced to tiny figures in a counterpoint of movement, considered formally but not purposively. In the Heidelberg view of work, a careful balance is maintained between individuality and anonymity. Individuals are rarely named (Whelan, on his log, is an exception); these are simple people, considered almost as types, and there lies behind all these images an ideology of common effort in the building of a new nation. And yet they are never the anonymous workers of the industrial assembly-line; the Heidelberg artists evoke the ideal of tough individualists joined, perhaps without their fully being aware of it, in a collective effort.

Other early pictures are concerned with leisure rather than work; leisure of course is the corollary of work in a modern economy, just as the weekend is the corollary of the working week. Pictures of city people at the beach, for example, hint by association at the offices they spend their days working in. And even Roberts's *The Sunny South* (*c.* 1887) makes one think of three boys from an office or factory on their day off. A variant on the theme of leisure is the sentimental narrative subject – an attenuated version of Victorian genre – set in the bush: such is Roberts's *A Summer Morning Tiff* or McCubbin's *Lost* (both of 1886). The responses of contemporary reviewers to such pictures show how they appealed to the Victorian fondness for sentimental storytelling: it is not, as was the case with traditional history painting, the pleasure of finding a great story given powerful visual expression, but on the contrary, the pleasure of weaving anecdotal variations around of the banalities of everyday life. Such images, essentially plebeian, are the forerunners of television drama. McCubbin's picture of a little girl lost in the bush (1886) is particularly hard to sympathize with today; in any case, as an image of perfect passivity in relation to the environment, it stands diametrically opposed to the active involvement and struggle of work.

There is nothing surprising in this exploration of leisure before the theme of work has been fully discovered. It is simply a case of artists, as so often, finding their way gradually inwards, from the periphery of

37 Tom Roberts *The Sunny South c.* 1887

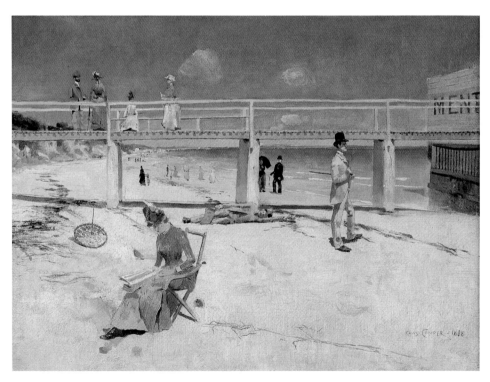

38 Charles Conder *A Holiday at Mentone* 1888

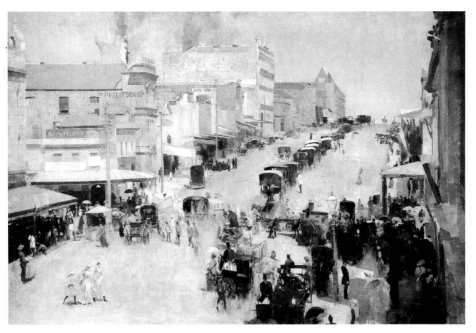

39 *(above)* Tom Roberts *Allegro con brio: Bourke Street West* c. 1886

40 *(below)* Arthur Streeton *The Railway Station, Redfern* 1893

41 *(opposite)* Charles Conder *The Departure of the Orient – Circular Quay* 1888

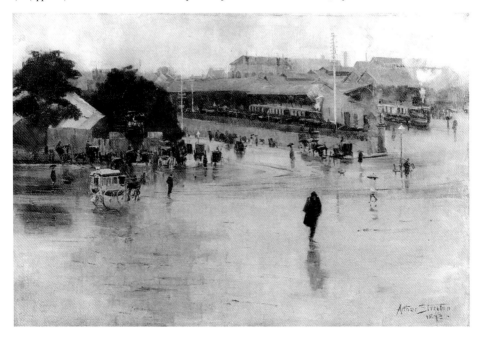

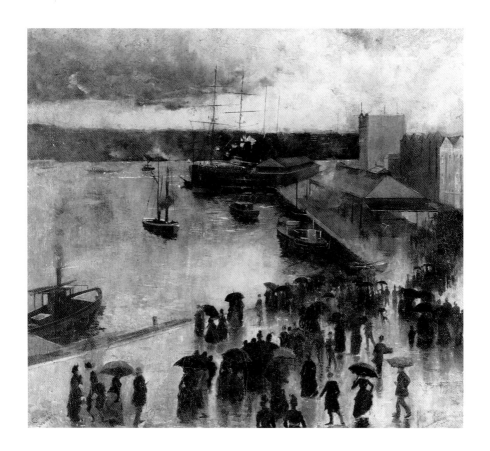

immediately interesting subjects to the epicentre of their inspiration. What is significant is that an artist like Conder did not share this central concern, because he did not have the same engagement with the historical and political question of Australia. Conder's work is an illustration of what Australian 'Impressionism' might have been like if it had not been essentially concerned with the problem of inhabiting a new land. His *A Holiday at Mentone* (1888) is a charming picture, but a 38 holiday implies a temporary stay in a place, without engagement. Similarly, *The Yarra, Heidelberg* (1890), painted shortly before his return to Europe, is a characteristic reply to Roberts's *The Sunny South* – two young women, naked but for the hat one of them is wearing, bathing in a quiet bend of the Yarra. Conder's charming combination of wit and discreet eroticism is foreign to the main current of Heidelberg, whose emotional range runs from the heroism of labour to the

lyricism of landscape, with occasional lapses of both into sentimentality. Neither humour nor sex had much place in this tradition; once again, the narrow range of human experience which formed the basis of the Heidelberg style must be part of the reason for its fragility.

Roberts's *Woodsplitters* (1886) is an early example of a characteristically Heidelberg subject; once again the axe plays an important role. Three men are splitting and stacking wood – apparently to be burnt for charcoal – in a clearing they have made in the forest. Roberts has conceived the two central figures as alternate moments of the same action, so that they imply a continuous rhythm of chopping. The picture evokes a hard but simple life, a world of very reduced human relations in which there is little or no talking, and the silence is broken only by the rhythmic thudding of the axe and crunching of splitting timber. The men's faces are invisible; there is none of the 'expression of the passions' that was fundamental to history painting and even to sentimental genre. The painter is neither interested in the individual personalities of his subjects nor in their feelings. Their actions have something of the anonymity and necessity of natural processes, like the cycles of the seasons, and this really is the point of the picture: that in their work, simply and economically adapted to the requirements of survival, they are at home in their environment.

42 Tom Roberts *Woodsplitters* 1886

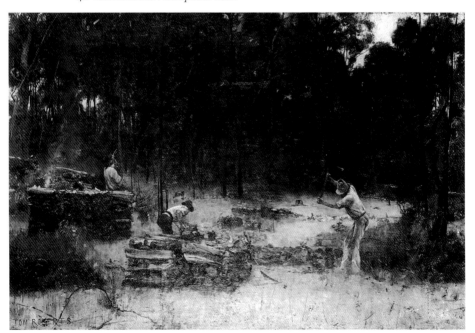

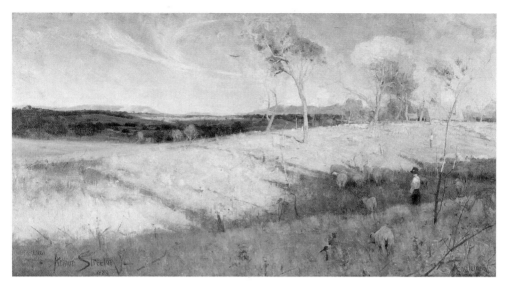

43 Arthur Streeton *Golden Summer, Eaglemont* 1889

It is by now clear enough that, as the sublime reduces man to a role of passive engagement, work was the means of establishing an active relationship with the natural environment. But it was at the same time the means of founding a human community, for work not only joins man to nature, but also man to man (and in this case the masculine gender is used advisedly). In both cases it founds a moral legitimacy which in early Australia had often been critically lacking. Illegitimacy is a recurrent theme – from the illegitimacy of corruption and crime to the illegitimacy of a colony of convicts as such. Sexual relationships were everywhere tainted with illegitimacy in the most literal sense, because even eminent men in the colony often lived with and had children by women whom they could never have been seen with in Britain. After transportation ceased – beginning with New South Wales in 1840 – and as the colonies grew with the massive increase in immigration after 1850, Victorian standards of morality were gradually imposed, but there must have been many points of tension between the older and the newer generations, even when the older included many prominent figures.

Colonial culture, with its handsome Georgian houses and aristocratic manners, often concealed what to a later period appeared

intolerable anomalies. The theme of work in Heidelberg painting speaks of a new beginning, of simple and honest people toiling to build a new nation. It is as though both artists and their public wanted to forget the dubious past of convict transportation and perhaps even of gold rushes, and to re-imagine the birth of Australian society, even if very few either of the artists or the public actually took part in such labours themselves. This is the period in which concern with the developing national type reaches its peak, authors frequently insisting on the vigour of a people bred out of hard work on the frontiers of civilization. In contrast to the implied corruption of earlier times, the words obsessively repeated are 'wholesome' and 'clean'. Brooding on the alleged 'weird melancholy' of the Australian landscape is now considered decidedly unhealthy, and that whole way of thinking is attributed to an earlier, less wholesome generation.

One of the most eloquent expressions of this 'new beginning' ideology is Streeton's *Golden Summer, Eaglemont* (1889). It contains all the individual elements that one might find in such a 'colonial' painting as

43

44 *(left)* Charles Conder
How We Lost Poor Flossie 1889

45 *(opposite, above)* Tom Roberts
Impression 1888

46 *(opposite, below)* Arthur Streeton
Impression for 'Golden Summer' 1888

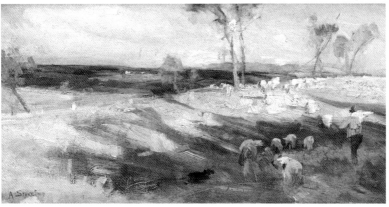

von Guérard's *Koort Koort-Nong Homestead, near Camperdown, Victoria* 22
(1860) – house, fence, sheep, even a child – but the overall meaning is
completely different. The house is off-centre, half-hidden. It does not
assert ownership of the land around it, but rather its own belonging.
The land where the sheep and child wander, equally naturally, is
unfenced. It is late afternoon, and although the light is still intense,
the shadows are lengthening, telling us that the day's work will soon
be over. If Streeton's *The Selector's Hut* of the following year speaks of 35
the first founding of the new home, this painting evokes the already

settled family. That the two paintings should have been made in this reverse order simply confirms the principle that artists work backwards towards the central point of their vision.

The Aboriginal people virtually never appear in Heidelberg art. This could easily be explained as a manifestation of racism associated with the rise of nationalism, but there is more to it than that. The Aborigines, as was pointed out in the last chapter, are intimately, but very ambivalently, involved in the European Australian's attempts to inhabit this land. They live and survive in a difficult environment with apparent ease; and yet they do not actually 'occupy' the land in any way recognized as permanent by the European mind. Nonetheless, their dispossession and the misery to which they are reduced inevitably adds to the illegitimacy that weighs on the conscience of the colonists, and this is no doubt why they so often appear in landscapes of the colonial or early settler periods, where they almost always mark some kind of malaise.

One of the consequences of the Heidelberg ideology of work, in assuring the legitimacy of the settler's occupation, is to displace these concerns about the Aborigine's familiarity with the land. Aborigines are at home in the sublime, but strangers to the world of work, as it is conceived by the settler. They were part of the colonial anxiety, but they disappear from the brave new world of settlement. And it seems generally true that the figure of the Aborigine appears in Australian art at moments of uncertainty or doubt, but is absent from the relatively few moments of unqualified confidence.

The Heidelberg group had asserted its presence and its claims in the first programmatic exhibition of art held in Australia: the '9 by 5 Impression Exhibition' of 1889. The show was organized partly to raise money, and the title came from the cigar-box lids that the artists had obtained from Abrahams's family business and used to paint on. Most of the works were oil sketches, and several included the word 'impression' in their titles. There was a flurry of controversy, but nothing like the institutional opposition that the French Impressionists had encountered twenty years earlier. Roberts, Streeton and their friends were able to enjoy the glamour of being Australia's first avant-garde without any of the practical drawbacks of social rejection. There was some criticism on artistic grounds, but it could not have the virulence it had in France where, because of the importance of the aesthetic in the system of cultural values, close equivalences had been established between artistic style and political ideology. Thus Impressionism, which was often associated with socialism, anarchism and pacifism,

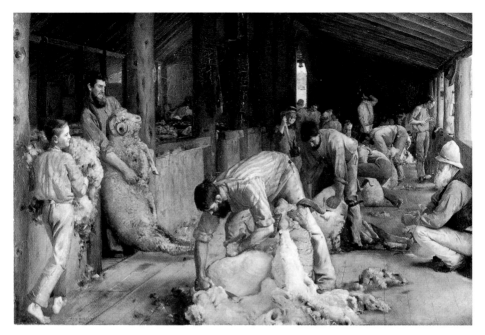

47 Tom Roberts *Shearing the Rams* 1890

was initially interpreted as unpatriotic and anti-nationalistic, whereas Australian 'Impressionism' was fundamentally nationalistic, and artistic conservatism was not reinforced by political reaction.

The '9 by 5' exhibition was attractively presented in an aesthetic *mise en scène* that recalled Whistler; as so often since, advanced art was confused with fashion. And the small format of the works, which precluded ambitious subjects, allowed the artists to indulge in precisely those qualities of humour, pathos and human sentiment that the momentum of the Heidelberg style increasingly tended to exclude. Thus Conder's *How We Lost Poor Flossie* (1889) is about the disappear- 44 ance of McCubbin's little dog in the city. Roberts's *Impression* (1888) is 45 the rare image of a couple by the water, the study of a moment between a man and a woman that manages to avoid the anecdotal and garrulous platitude of Victorian genre; other pictures evoked cities and ports, interiors, the countryside or the beach. It was, in fact, an eminently accessible show, and its success, in spite of some critical objections to the exhibition of oil sketches as finished works, was hardly surprising.

After the exhibition, the Heidelberg painters had become still more self-confident in the pursuit of their artistic and ideological aims. Streeton's *Golden Summer, Eaglemont* was completed in the same year –

46 a sketch was included in the exhibition – and *The Selector's Hut* in 1890. This was also the year of Roberts's *Shearing the Rams*, which *The Age*, when the painting was first shown, called 'the most important work of a distinctively Australian character which has been completed up to this time'.

47 *Shearing the Rams* is a crucial painting in the history of the Heidelberg Movement, one that comes close to the core of its inspiration and at the same time reveals the weaknesses that made it so short-lived. In the first place it is eminently a picture of work. The pastoral world evoked by Streeton in the genre of landscape is characteristically approached by Roberts through the genre of figure painting. The figures are highly realistic, and yet largely anonymous; Roberts has been as careful with the expressions as anything else, but the range of expression among men concentrating on a hard physical task is very limited (the children provide a slight relief in this regard). Although we may know the names of the shearers who posed for the artist, they are essentially types, and Roberts's aim, as in his *Woodsplitters*, has been to evoke the rhythm of work.

Unlike the woodsplitters, however, the shearers are endowed with monumentality. Above all, in contrast to the later and rather ridiculous art deco fantasies of a Napier Waller, it is a monumentality derived from work itself: like Millet in his *Sower*, Roberts has looked

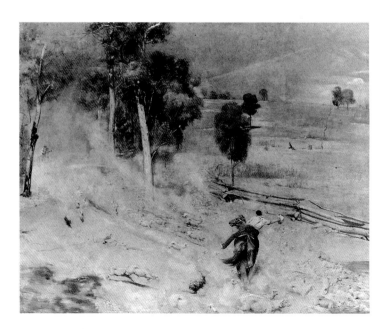

48 *(opposite)* Tom Roberts
A Break-Away! 1891

49 *(right)* Arthur Streeton
Fire's On (Lapstone Tunnel) 1891

for the moment and the attitude that epitomize the task and declare the dignity of the worker. These anonymous, idealized, heroic workers would appear to embody the heart of the Heidelberg vision. Yet in the process Roberts has uncovered the previously unspoken question underlying that vision: who does the work and who profits from it? In the Streeton compositions discussed earlier this did not arise, because their subject is the free work of the citizen-settler: however poor, such a man not only remains independent but shares in the building of a nation. But of course most of the work done on the land, most of the work from which the nation derived its wealth, was not of that kind: it was the wage-labour of a rural proletariat. This is what Roberts's picture reveals, uncovering the world behind the sunlit pastoral landscapes. Indeed, the shearers he idealizes were soon to hold a famous strike during the depression of the nineties.

But even if the potential meaning of the image was not read at the time (and remains apparently invisible to most viewers today, such is the folkloric charge of the subject), it was nonetheless a turning-point in the history of the Heidelberg Movement. The journey back to the

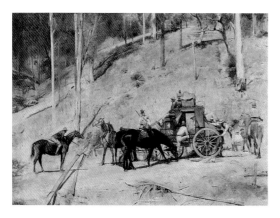

50 *(left)* Tom Roberts
Bailed Up 1895–1927

51 *(below)* Arthur Streeton
*The Purple Noon's Transparent
Might* 1896

52 *(opposite)* David Davies
Moonrise 1894

centre of inspiration was complete; the centre had been reached, and it was flawed. From this point onwards, discovery ends and repetition begins – the routine of finding new and important 'subjects' – with diminishing conviction. In the following year, 1891, Roberts painted *A Break-Away!* and Streeton *Fire's On (Lapstone Tunnel)*. But already both subjects are disasters: in one case a stampede of thirst-crazed sheep, the horseman desperately trying to prevent them from crushing and drowning each other at the water-hole; in the other the body of a dead miner being brought up after an accident. The subject is still work, but the outcome now defeat rather than victory. It is the return of

48, 49

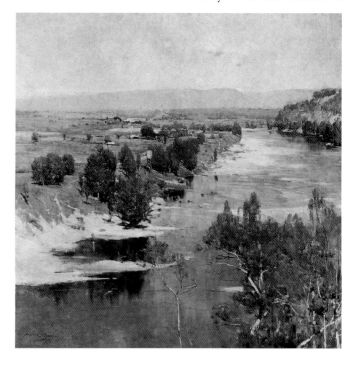

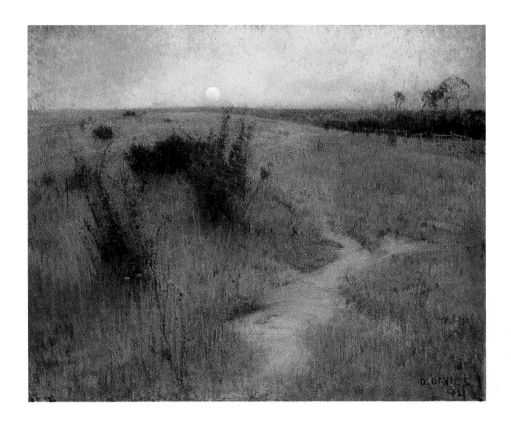

Victorian sentimentalism, briefly banished during the few years of confidence.

By the mid-nineties, a period of severe depression, the Heidelberg Movement was in clear decline. Roberts's *Bailed Up* (1895–1927) is neither a picture of work nor of the present, but a romantic historical composition based on an event from three decades earlier. The distance between the experience represented in the painting and that of its intended urban audience – and thus its ultimately spectacular function as a kind of middle-brow entertainment – becomes unmistakable. In the following year, Streeton's *The Purple Noon's Transparent Might*, although a beautiful painting, reveals a similar detachment from the historical sense that gave the earlier pictures their force. This is the nature that the Heidelberg painters had allowed Australians to feel at home in, but with only a hint of the process by which that sense of home had been earned. Streeton is carried away by the high lyricism

73

53 Jane Sutherland *Children Playing in a Paddock c.* 1895

of what is in a sense a swan-song: he left for England in 1898, where neither he nor Roberts, who followed later, succeeded in transplanting an art so closely adapted to the Australian experience.

The later years of the Heidelberg Movement were marked not only by a decline in quality – many of Australia's leading artists became expatriates between the end of the century and the Great War – but also by significant modifications of style and sensibility. Jane Sutherland (1855–1928) painted a number of pleasant landscapes, such as *Children Playing in a Paddock* (*c.* 1895), which take for granted the familiarity achieved by the earlier artists. David Davies (1864–1939) represents an important reorientation of sensibility. His best-known work, *Moonrise* (1894), is a nocturne, with barely a sign of human habitation except for the fine scrawl of a fence in the background. It is a picture of silence, solitude and private, dreamy experience antithetical to the active life of Roberts's and Streeton's earlier pictures. In *Early Morning, Heidelberg* (1898) by Walter Withers (1854–1914), the mood is even more ambivalent. The farmhouse is comfortably established now, long past the struggle of settlement; the very slightness of

52

the one human task represented – feeding the chickens – underscores the extreme stillness. The painting has precisely the feel of an epilogue, of a continuation after ending. Even the hour contributes to this sense of ambiguity: one side of the farmhouse is already lit by the rising sun, while the setting moon is still visible in the west.

The moon appears again in *Moonrise, Heidelberg* (1900) by Emanuel Phillips Fox (1865–1915), another artist who belongs essentially to the declining phase of Heidelberg. He had been a contemporary of the others at the National Gallery School in Melbourne, but had spent the crucial years from 1887 to 1891 in Paris. Consequently, he was closer in some respects to French Impressionism, but had no part in the heroic phase of the Heidelberg Movement. Fox was in any case

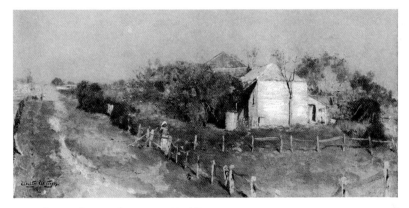

54 Walter Withers *Early Morning, Heidelberg* 1898

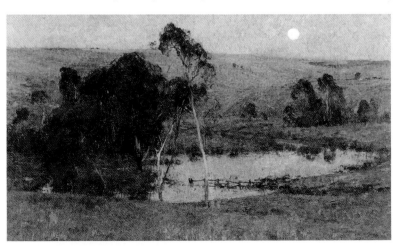

55 Emanuel Phillips Fox *Moonrise, Heidelberg* 1900

56 Emanuel Phillips Fox *The Convalescent* 1890

57 Sydney Long *Spirit of the Plains* 1897

constitutionally drawn to half-shade and dappled light rather than to the harsh glare of the Australian countryside, and in his earlier painting, *The Convalescent* (1890), his sensibility has found its ideal subject: a red-headed girl and her sister, all in white, who become a study in opalescent greens.

In general, these developments speak of a turning inwards from the bright sunlight and the theme of work to solitude, dreams and the imagination. Some artists reacted against the limitations of the Heidelberg vision even more strongly, like Sydney Long (1871–1955), who transformed it in *Spirit of the Plains* (1897) into an art-nouveau decorative frieze in which dancing brolgas follow a naked piper. There were a number of attempts to populate the Australian bush with some kind of spiritual or mythical presence, whether imported, native or a hybrid of the two. The result is usually either bathetic, as in the case of Rupert Bunny's *Sea Idyll* (c. 1890) and *Pastorale* (c. 1893) – Bunny had left Australia for Europe in 1884 – or vulgar, like Aby Alston's *The Golden Age* (1893), a typical Victorian confection in which a number of young milliners sit or prance around pretending to be nymphs. Compared to the absolute platitude of this work, Sydney Long is possessed of a vein of decorative ability and an undeniable, if mannered, sense of poetry.

Meanwhile the more serious Heidelberg themes did not disappear, but were repeated in an increasingly banal form. George Lambert's youthful *Across the Black Soil Plains* (1899) shows how a 58

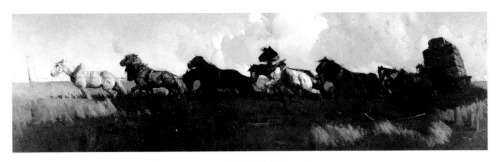

58 George Lambert *Across the Black Soil Plains* 1899

new generation could take the settler-art of Heidelberg and convert it into something prefiguring socialist realism. Lambert's straining team of horses, silhouetted against the horizon, replace the sober depiction of the settler's work with a declamatory metaphor of his triumph.

Finally Frederick McCubbin, who had always had a predilection for melancholy and passive subjects, from *Lost* (1886) to *Down on his Luck* (1889) and *A Bush Burial* (1890), produced the rather heavy-handed and sentimental triptych *The Pioneer* in 1904, soon after the colonies federated to form the Commonwealth of Australia. A long and admiring discussion of this picture by the Melbourne *Age* in 1905 shows both how effectively McCubbin summed up the ideology of Heidelberg and how perfectly attuned this ideology was to the mood of the times (bearing in mind that it was now fifteen years since the zenith of the Heidelberg Movement; social consciousness has gradually caught up with artistic vision). In the left panel we see the 'young, free selector' who has 'pushed into the depths of the bush'; the main focus of this panel, however, is his young wife, who 'is thinking of the home she has left far away, of the many human ties broken, that part of the gigantic forest may be cleared for human habitation.' Head resting on hand, she adopts the eternal posture of melancholy. But we are assured that this moment of sadness will not last long: 'The onlooker is sure that she will soon be setting about her duties with the blithe wifely spirit of the pioneer woman.'

In the large central panel, Streeton's axeman reappears, and to give credit where it is due, we should add Buvelot's axe resting against the log. Once again the settler smokes his pipe as he rests from the labour of felling trees, but now, in this compendium of images, the cottage already stands in the clearing behind (its smoking chimney too an immemorially ancient metonymy of hearth and metaphor of home): 'he sits smoking the pipe of peace on the trunk of the last giant to

60

78

crash before the axe that lies beside him. With the fallen leaves and bark are now mingled the chips that mark his slow dogged struggle with exuberant Nature.' Before him stands his wife, who has become a strong image of the feminine, carrying the child she has borne in the bush; the two look at each other with the directness of complete understanding and trust.

There is something utopian about the image of such a union between man and woman, each unreservedly joined to the other in the commonality and the complementarity of their beings and their tasks; something particularly utopian perhaps, at the time, in the evocation of a sexual relationship without self-consciousness or shame. Such an exclusive union and such innocence could hardly be realized in the city, and this is hinted at in the young woman's earlier regrets; she must forget many things to make a new life in the bush. In fact, if the first picture in the series suggests the expulsion of Adam and Eve, the second shows us humanity redeemed by work: a couple of poor city-dwellers have refashioned themselves as pioneers, and the child they have produced is of a new heroic race.

'The last panel is the triumphal stanza of the whole colour poem. A country youth, with reverent fingers, clears away the undergrowth

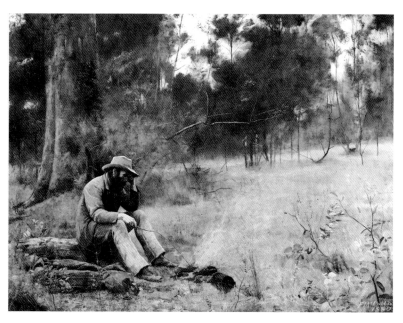

59 Frederick McCubbin *Down on his Luck* 1889

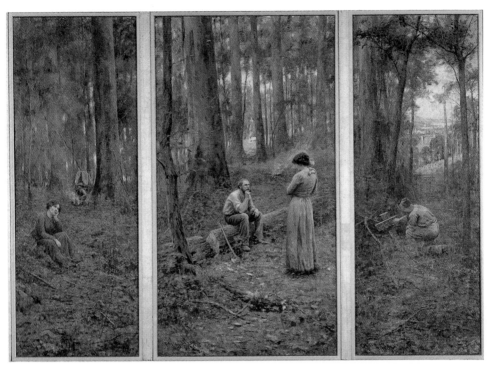

60 Frederick McCubbin *The Pioneer* 1904

from the rough wooden cross marking the last resting place of the gallant couple. In the distance the spires and bridges of a glorious young city tell of the joys that another generation is reaping from the toil of the once lusty pioneers now gone to dust.'

The sentimentality of this last image masks its ambivalence. How did the efforts of the young couple, in their own moral renewal and sober self-sufficiency, lead to the evident wealth of the 'glorious young city'? Has some stage in the process been omitted – something like Roberts's *Shearing the Rams*? And if they had to leave the old city to make a new beginning, is this new city free of poverty and corruption? And why is it a country lad who piously visits the neglected grave? Has the city forgotten? Here McCubbin suggests more than the sentimental ideologue of the *Age* is prepared to acknowledge. But even he unequivocally places this heroic age in the past, and thus may be said to bring the Heidelberg Movement to an end.

Unsettlement

The time-worn gums shadowing the melancholy water tinged with the light of fast-dying day seem fit emblems of the departed grandeur of the wilderness, and may appear to poetic fancy to uprear in the still evening a monument of the glories of that barbaric empire upon whose ruins the ever-restless European has founded his new kingdom. Glorified for a last instant by the warm rays of the sinking sun, the lonely trees droop and shiver as though in expectation of the chill night which will soon fall alike on the land they have surveyed so long and the memory of the savage people who once possessed it.

Marcus Clarke, *c.* 1874, on
Louis Buvelot's *Waterpool near Coleraine*

If the Heidelberg Movement came to an end, it was partly because the ethic of work on which it was founded was inherently flawed. That artists painted rural settlers when most Australians already lived in large coastal cities was not in itself an insuperable objection, since the axeman on his log was always metaphoric: it is through work that we learn to be at home in the new land. The problem was rather that the image of the citizen-settler's free work was made to conceal the reality of urban and rural wage-labour. But the Heidelberg idealization of work was also based on the assumption of a certain balance of power between the axeman and nature — his work is conceived as a 'slow dogged struggle', as the *Age* wrote of McCubbin's *The Pioneer*. There is something heroic about this struggle, and it is what in the end earns him the right to feel he belongs in and to the land he has fought with. The environment that has been the scene of the pioneer's work becomes the mirror of the new nation's spirit.

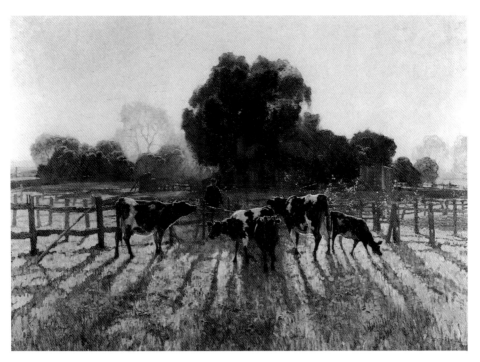

61 Elioth Gruner *Spring Frost* 1919

But that balance of power was short-lived. Already in the Heidelberg period, from the safe vantage-point of Melbourne or Sydney, the life of the settler was something of a romantic dream. Soon it was clear that the balance of power had irrevocably changed. Nature in the broader sense has always remained harsh and unpredictable in Australia. But in the specific respect that concerned the imagery of the settler – the clearing of bush to build farms – it was no longer possible to regard an activity carried out on such a vast scale and at such a relentless pace in an heroic light. The bush had become and remained a vital symbol of the national spirit: but instead of being a redoubtable opponent, inspiring a sense of strength and pride in contest, it began gradually to be perceived as defeated and almost pitiful, inspiring melancholy. Indeed the passage from Marcus Clarke cited at the head of this chapter shows that it was possible to feel this a decade before the beginning of the Heidelberg Movement, which makes the axeman on his log even more of a mythic figure, and helps

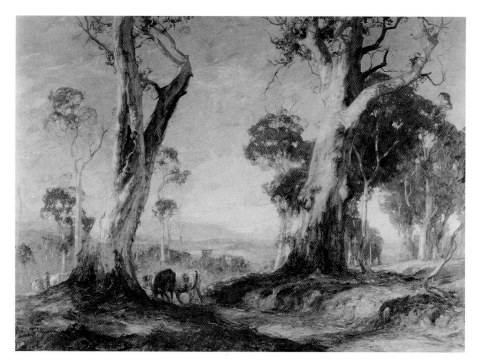

62 Hans Heysen *Red Gold* 1913

explain why this heroic dream could be so fragile. Of course the
changes in sensibility articulated by artists do not necessarily corre-
spond to popular sentiment, much less to the expressly formulated
ideologies of politicians – for some the intoxication of progress con-
tinued unabated, culminating in the ludicrous forecasts of population
and industrial growth published in *Australia Unlimited* (1918).

The new emotional tone can already be discerned in the paintings
of Davies, Phillips Fox, Withers and Gruner, and in the turn-of-the-
century fondness for 'faded things' in general. In many smaller works,
especially etchings which became popular in the later Edwardian
period, there is a proliferation of nocturnes, tonal effects, mysterious
silhouettes of trees and picturesque old buildings. With Marcus Clarke
in mind, one cannot help thinking of a return of the 'weird', briefly
dispelled by the brilliant light and voluntaristic ethic of Heidelberg.

In the high landscape tradition, it is Hans Heysen (1877–1968) who
epitomizes the generation after Heidelberg. In *Red Gold* (1913) two

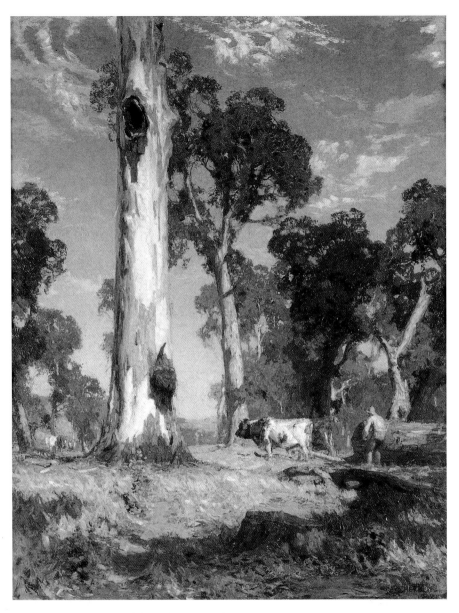

63 Hans Heysen *A Lord of the Bush* 1908

enormous ancient gum trees stand on either side of a country road which has been driven between them, just as the track in Whitehead's *Gippsland* had to wind its way around the huge trees of his forest. Heysen's trees compel the same accommodation, but the meaning is now completely different. They are condemned giants, survivors of another age, ancient, bare, almost leafless, stretching up their huge anthropomorphic limbs in vain. The cattle pass – like a symbol of man's inexorable herding and exploitation of nature. It is sunset, as so often in Heysen's paintings, and the mood is one of silent melancholy. Even more clearly, the earlier painting, *A Lord of the Bush* (1908) depicts a man driving a pair of oxen dragging away a felled tree; the title of the painting seems to refer, with perhaps unintentional ambiguity, both to the majestic tree that still stands and to the one that has just been cut down, and whose stump remains visible in the foreground. Tree-felling, the very symbol of the settler's heroic effort, now evokes only sadness. The same change of heart is clearly expressed in a fine etching by Jessie Traill (1881–1967), *Beautiful Victims* (1914), in which two men are seen ringbarking imposing gum trees.

64 Jessie Traill *Beautiful Victims* 1914

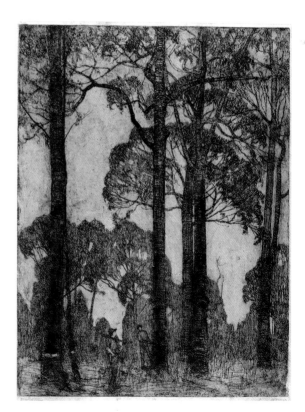

The Heidelberg Movement, in its most important and programmatic images, represented the human figure at work. Leisure and play appear in other paintings, but usually with the sense of rest from work. Now, with the fading of this ideology, the relation of the body to the natural environment undergoes a profound mutation. Sydney Long's *By Tranquil Waters* (1894), whose subject superficially recalls Roberts's *The Sunny South*, is conceived in an entirely different spirit – vesperal, poetic and erotic. The flute-playing boy in the foreground anticipates the piping figure of the god in the same artist's *Pan* (1898), and the comparison of these two pictures confirms what we might in any case infer from the latter – that classical mythology, here, as in Victorian painting, permits the slightly distanced and therefore more acceptable representation of sexual feeling. The particularity of the mythological painting that sprang up in Australia at this time lies in its continued concern for the inhabitation of the new land. The ancient gods are to be acclimatized among the gum trees, but they do not inhabit the bush as the settler did, by struggling with it – they *dance* among the trees. They invite us to a similar familiarity, not born of conquest but of harmony, in which nature is to be the mirror not of our will, but of desire, dreams and imagination.

37

65 Sydney Long *By Tranquil Waters* 1894

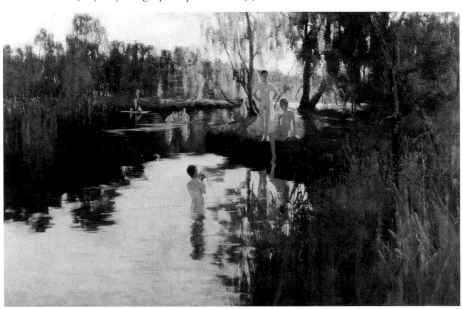

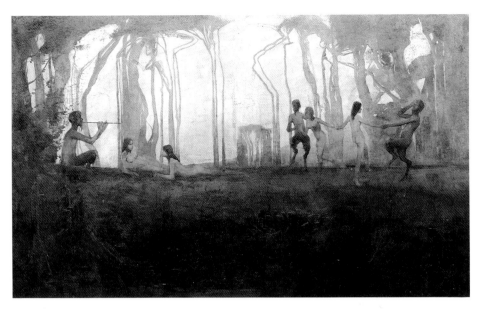

66 Sydney Long *Pan* 1898

This neo-pagan tendency in Australian art before the Great War is most poetically, and at times wittily evoked by Lionel Lindsay (1874–1961) (*Pan*, 1910), but more explicitly and provocatively by his 67 prolific younger brother Norman (1879–1969), who waged a long war against 'wowserism' – the prudish Victorian disapproval of wine, sex, dancing naked in the bush and anything else which might induce a dangerous state of excitement. Unfortunately Norman Lindsay's own work is usually painfully overblown and often ridiculous. His most overt – not to say hysterical – manifesto of paganism was *Pollice* 68 *Verso* (1904), in which a crowd of muscular pagans of both sexes extend their hands in the gesture of condemnation towards the crucified Christ. Nonetheless Lindsay's work was not merely the product of personal obsession, nor was it simply the negation of the Heidelberg School: his conception of an Australia populated by a new ideal race, healthy, pagan and fearless, is potentially complementary to the vision of Heidelberg. A new openness about the body and sexuality, without Lindsay's overheated visual rhetoric, is expressed in Cecil Bostock's *Nude Study* (1913–17), in which his subject looks directly at the viewer without either flirtation or shame.

87

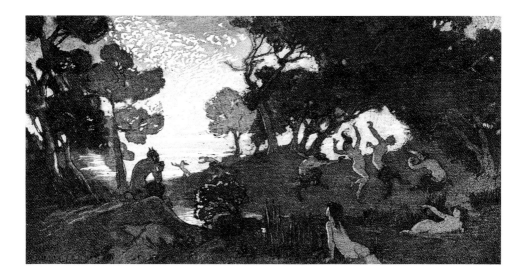

67 *(above)* Lionel Lindsay *Pan* 1910

68 *(below)* Norman Lindsay *Pollice Verso* 1904

69 *(opposite)* Rupert Bunny *Summertime c.* 1907

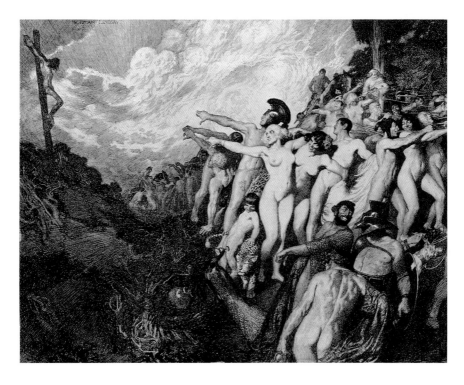

This twilight of the Heidelberg period was interrupted by the First World War. In fact the war broke in upon cultural life in Australia much more unexpectedly than it did in Europe, where it was to some extent anticipated by the explosive violence of the modern movement – most literally by the Futurists, but also by the critical analysis of Cubism, and by the expansive energy of early abstraction. There was nothing of this sort in Australia, and even Australian artists working in Paris at the time, like Rupert Bunny (1864–1947), had apparently no inkling of what Picasso was doing elsewhere in the same city. Bunny's most characteristic images, of women lounging on balconies, evoke the pre-war period's desultoriness and ambivalent relation to time and place.

The war was a fundamental event in Australia's history and in the formation of a national consciousness. The colonies had federated

into a Commonwealth which was inaugurated in 1901, and the war was the first great enterprise undertaken by this new entity – which indeed entered the conflict as part of the British Empire, but emerged as a nation with independent representation at the Versailles Conference and membership of the League of Nations. Both absolutely and in relation to its size, Australia's contribution to the war effort was enormous: a nation of only 5 million sent 330,000 soldiers to Europe and the Middle East, all volunteers (in 1916 the Government tried to introduce conscription to replace the many casualties, but referenda to this end were twice defeated after bitter political campaigns). The performance of the Australian troops confirmed the favourable impression made by earlier colonial contingents in the Sudan and China and especially by the 16,000 men who had taken part in the Boer War.

The single most enduring memory of the war was the disastrous landing at Gallipoli, where thousands of soldiers of the Australian and New Zealand Army Corps – the Anzacs – died storming heavily fortified Turkish positions. This image of heroic defeat became a symbol of the national spirit, recalling earlier themes of identity-in-alienation and anticipating their later treatment by artists such as Nolan and Drysdale – not to mention Heysen's vision of magnificent, doomed trees. Such ambivalences had been pushed into the background by the dominant spirit of affirmation in the Heidelberg period, but never quite banished. Nonetheless, the positive image of the settler developed by these artists was important in shaping the way the war was represented and talked about then and afterwards. Time and again the toughness and spirit of the Australian troops were attributed to their schooling in the bush, to the virtues of a nation of pioneers, even if so many of them came from the city. The war, it has been suggested, allowed many a young urban middle-class or working-class man to identify with the settler myth and thus effectively gave that myth a much broader application than it could have had originally. The Anzac was the pioneer at war, even if the appellation 'digger' alludes to the less glorious setting of the goldfields.

Australia, odd as it may seem, was one of the first nations to send artists to war to document history as it was being made. And because at the time of the Great War a politically disaffected and alienated avant-garde did not yet exist, it was the most eminent painters who were employed: among them Streeton and George Lambert (1873–1930). Perhaps it is not unreasonable to recognize in some of these images of conflict the Heidelberg ethic of work and struggle, trans-

70 George Lambert
*A Sergeant of the Light Horse
in Palestine* 1920

posed into a tragic mode. At any rate, Lambert's portrait of *A Sergeant of the Light Horse in Palestine* (1920) is an image of the settler turned soldier. He is the Englishman, fine-boned and blue-eyed, but reborn and toughened on the frontiers of Australia. The Australian 'type' was decisively vindicated by the trials of war.

After the war, the nationalistic connotations of the Australian landscape, as the breeding-ground of the citizen-soldier, were frequently emphasized. The theme of virility was often invoked, as though to banish not only the effeminacy of 'faded things' but also anxieties about the emasculation of the bush, totemic source of national vigour, by commercial exploitation and clearing. Australians could not become men if they could not pit themselves against a worthy opponent.

But perhaps this emphasis on virility served to mask another development. For what was promoted as the national genre between the

wars was no longer the landscape of settlement, with bush-clearing as its heroic moment, and home as the reward after hard work (so that even in Streeton's *Golden Summer, Eaglemont* we see the first house after clearing, the first family and the first child), but the pastoral landscape, cleared long ago by ancestors, and now a source of comfortable prosperity. Streeton's late composition, *The Land of the Golden Fleece* (1926) – with its significantly materialistic borrowing of the mythological reference – epitomizes this new vision. It is a broad open plain with mountains in the distance; a flock of sheep grazes in the foreground, and the shadows of afternoon lengthen on the left. At this distance, the trees are so small that they become mere patches of dull greenery varying the yellow plain (the brilliant blue and gold of Heidelberg is oddly transformed after the war into drab quasi-military khakis).

More surprisingly, there is no evidence of work here, except for the tiny though strategically placed windmill by the pond. There are no men in the composition, and there is no suggestion of that masculine confrontation with the environment, in which the environment too is endowed with masculine qualities. In spite of the 'masculine' sobriety of the colours, the land is pictured as essentially feminine: it appears to bring forth and nurture the sheep spontaneously. There is an element of simple naturalism in all this, for most sheep in Australia do graze on vast stations and hardly see a human being for months at a time. But this is an image charged with other meanings: it tells us that the wealth of Australia comes from the land, and not from man's work – from the bounty of nature, mother nature. This, it is suggested, is the real Australia, not the urban and industrial world in which most Australians in fact lived and worked.

The inner tensions of this new pastoral landscape genre – far graver than those of Heidelberg – become even starker when we realize that the owners of these domains may live in the city, or come and go as they please between city and country. Lambert's *The Squatter's Daughter* (1923–24) suggests such a very different engagement with the land: this lithe, smart adolescent is nothing like McCubbin's image of the settler's wife. She is not here to work, but has come back to the property from her city boarding-school for the holidays, and has ridden out before breakfast to breathe the country air. Lambert is even more explicit – in a sense artists cannot help telling the truth – in his *Weighing the Fleece* (1921): there the hierarchical relationship of owner, manager and hired hands is clear for all to see, as is the lack of involvement of the squatter's wife, who sits on a bale watching and waiting

92

71 Rayner Hoff
Idyll (Love and Life) 1924–26

for it all to be over. And yet this is a composition which ostensibly shows everyone sharing in the wealth of the land.

If Lambert's squatter's wife is nothing like McCubbin's vision of the young mother in the bush, the relationship between husband and wife lacks anything like the intensity of the earlier picture. There is intensity, but of a very different kind, in Rayner Hoff's (1894–1937) *Idyll (Love and Life)* (1924–26) where a young, nearly naked woman stretches on tip-toe towards the embrace of a still more naked young man – a subject that would be simply erotic if it were not for the infant they contrive to hold with their free hands. The infant's presence justifies the desire of the mother and father as the healthy, natural instincts that are needed to breed a new race of citizens. It seems that the sexually charged body discovered before the war, in the twilight of Heidelberg, has been re-appropriated to serve the nationalistic ideal of developing a pure, healthy race of Australians. Sexual appetite, politically ambivalent and certainly subversive of bourgeois morality a few years before, now becomes a source of energy to be tapped by the state. Hoff wrote in 1931: 'I doubt if even the Ancient Greeks produced better examples of physical beauty and grace. We don't allow

72 *(right)* Napier Waller
The Pastoral Pursuits of Australia 1927 (detail)

73 *(below)* Arthur Murch
Beach Idyll 1930

74 *(bottom)* Charles Meere
Australian Beach Pattern 1940

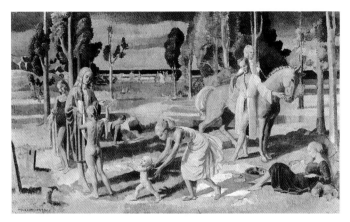

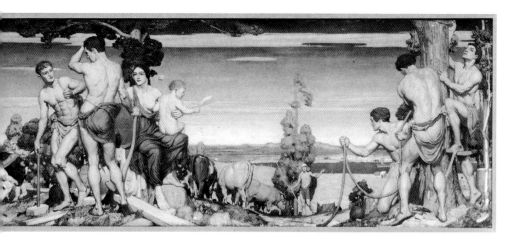

our bodies to become flaccid ... the call of the sun, surf, great open roads and wonderful bush is all too strong for any to resist. Hence we are active, virile and well and few nations can show such an average of body perfection.'

The same ideology is visible in Jean Broome-Norton's *Abundance* (1934), and indeed almost the same iconography except that the image of sexual union is more discreet; in compensation, however, the artist has clearly linked sexual and crop fertility. This is the race that corresponds to the new pastoral landscape ideal: not merely men and women reborn through work, but a race of autochthones, born from the soil ploughed by the pioneers (all particularly ironic in a land of immigrants). Napier Waller's (1894–1972) enormous frieze *The*

75 Max Dupain
Sunbaker 1937

Pastoral Pursuits of Australia (1927), intended as a celebration of the labours that produce Australia's wealth, is the vision of a world in which no one does anything much at all; the simple cultivation of physical perfection seems sufficient to guarantee abundance and prosperity. Napier Waller's picture recalls the well-known words of J. S. MacDonald, written in 1931 in a discussion of Streeton: 'If we so choose we can yet be the elect of the world, the last of the pastoralists, the thoroughbred Aryans in all their nobility.'

Later this genre of figure painting produced more poetic and less
73 ideological work, like Arthur Murch's (1902–89) *Beach Idyll* (1930).
74 But another seaside picture, Charles Meere's (1890–1961) *Australian Beach Pattern* (1940) is still a political statement about the ideal Australian race, except that the beach – an essentially urban experience of the outdoors – has significantly replaced the bush. It is no coincidence that one of the most famous of all Australian pho-
75 tographs, Max Dupain's (1911–92) *Sunbaker* (1937), should also belong to this period. It is an image of the harmony of the body between the elements of earth, air, fire and water; the swimmer is enjoying that moment of blissful repose after the struggle with the waves, when consciousness is all gathered into the body's sensations in the hot sun after the cold sea. If Meere's painting is a rather silly and artificial display of activity, this is a deceptively charged image of potential energy.

Although these figure compositions were complementary to its ideology, it was the pastoral landscape, as epitomized in *The Land of the Golden Fleece*, that remained the mainstay of what was considered serious painting between the wars. There was some encroachment by styles derived from international modernism, at first in a spirit of reasonable mutual tolerance, and then in the face of increasing resistance, until open conflict broke out in 1938 with the foundation of the conservative Australian Academy of Art. But the beginnings of modernism arose out of the same general conditions that had led to the transformation of the landscape tradition. That is to say, if Federation and the war had made Australia into a nation in its own right, then the first – colonial – phase of its history, which was necessarily concerned with establishment in a new land, had come to an end; the question that now arose was how to take an equal part in British, European and world history. It was natural that the first phase should have been concerned with local problems, but equally natural that artists should now aspire to consider the same sorts of questions that faced modern artists everywhere in the Western world.

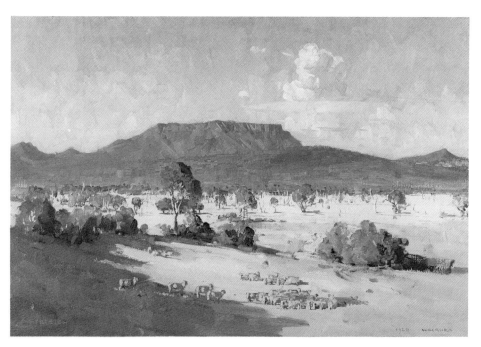

76 Arthur Streeton *The Land of the Golden Fleece* 1926

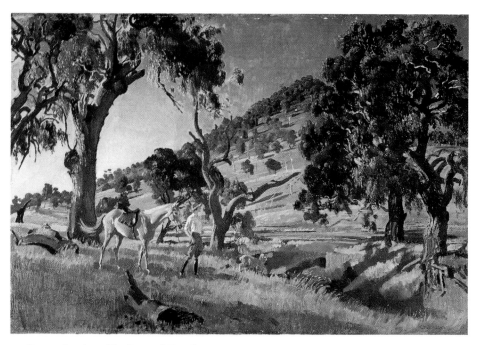

77 George Lambert *The Squatter's Daughter* 1923–24

This was not quite so easy to achieve as it might seem, however. Neither Australian artists nor the public that supported them had an adequate understanding of the complex background of modernism: behind Cubism, for example, lay the long tradition of the critical analysis of vision from Alberti and Leonardo onwards, and the whole series of practical models from the perspectival depth of the quattrocento to the flattening of space produced incidentally by the Impressionists and deliberately by the Post-Impressionists. But behind this and other modernist styles lay too the succession of ideas about humanity, nature and history, from early modern humanism to the scientific revolution, the Enlightenment, Romanticism, Darwinism and the late nineteenth-century giants, Marx, Nietzsche and Freud. It is probably true to say that hardly any Australians, in the first decades of this century, understood what was at stake in modernism, or could conceive the enormous pressure under which immediately pre-war modern art was formed. Inevitably it appeared to many an incomprehensible aberration, while to others it seemed superficially chic and exciting because it was associated with the 'modern' world generally (unaware of course that most forms of 'modernism' in art have been critical of the 'modern world').

This lack of access to the tradition from which the necessity of modern art arose meant that modernism tended to arrive in Australia as style (in the narrow sense) without content. It looked new and clever, and it did not really matter that no one knew what it was for, since as style it was essentially the sign of something else: youth, smartness, wealth. Consequently 'modernism' was very soon popular in interior decoration, women's magazines and advertising. Anything more substantial was inevitably decades late, so that artists struggled to understand movements that were already worn out and superseded by others. The first modern style that arrived in Australia while it was still really alive (if not quite at its zenith) in Europe was Surrealism, which will be discussed in the next chapter. There were a few tentative experiments in abstraction in this first phase of Australian modernism (which had consequences after the Second World War), but by and large the styles most successfully practised were varieties of Post-Impressionism. This is true even of those artists who had the opportunity to experience modernism at first hand in Europe, or to study with modernist teachers. Artistic language is meaning, not just technique, but technique, or 'style' is what can be taught directly. The meaning, the motivation, are far more indirectly imparted and assume that much is already understood.

The state of art teaching in Australia did not make the task of understanding modernism any easier. On the whole it was old-fashioned, and conservative prejudices were strengthened by the prestige of returning masters like Streeton and even Lambert, though he was more sympathetic to innovation. In Melbourne, Bernard Hall (1859–1935) was director of the National Gallery and head of the school from 1891 until his death. Hall practised a kind of tonal naturalism which was developed into a pseudo-scientific dogma by his pupil Max Meldrum (1875–1955), who ran his own school from 1917 to 1954 and was for many years the most influential figure in the Melbourne art world. Meldrum was much admired for his personal and political principles, and for his open mind in other respects, but he was staunchly opposed to modernism.

The Sydney Art School (now the Julian Ashton Art School), founded by Julian Ashton (1851–1942) in 1896, was also basically conservative, but a more open spirit reigned from 1898 onwards in the classes run by Anthony Dattilo Rubbo (1870–1955) in his own school and also at the Royal Art Society of New South Wales. His pupils included Norah Simpson (1895–1974), Roland Wakelin (1887–1971), Grace Cossington Smith (1892–1984) and Roy de Maistre (1894–1968), authors of the first Post-Impressionist experiments in Australia. Cossington Smith's *The Sock Knitter* (1915) and Wakelin's *Down the Hill to Berry's Bay* (1916) are among the earliest of 'modernist' pictures. They are hardly experimental by contemporary European standards, but they do give some idea of the importance of Post-Impressionism in the Australian context. The cluster of movements that followed the 'passive', retinal reduction of Impressionism all drew attention to the active, constructive role of the artist: artistic *mimesis* begins with the process of making – making two-dimensional shapes, making areas of pigment and harmonies or dissonances of colour. In an art world that still held naturalism to be axiomatic, the conceptual reversal entailed by such a stylistic shift had something of the copernican. The sense of making an image on a flat surface is unmistakable in Cossington Smith, and Wakelin draws explicit attention to the role of the artist by including one in the foreground of his composition.

During the war, de Maistre became interested in the use of colour in the treatment of mental disorders, and he and Wakelin read newly available books on the history and theory of modernism. They were particularly fascinated by the idea of an analogy between colour and music (in various forms, this idea goes back at least to the

78
79

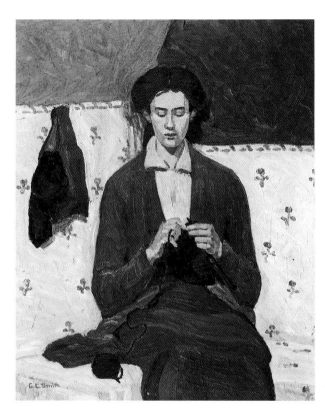

78 *(left)* Grace Cossington
Smith *The Sock Knitter* 1915

79 *(below)* Roland Wakelin
Down the Hill to Berry's Bay
1916

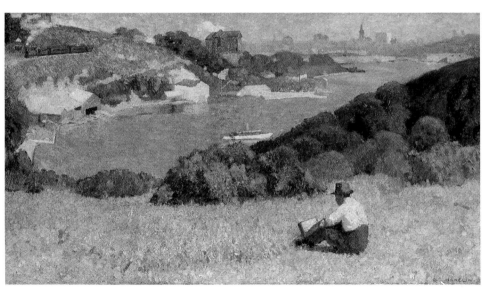

80 Roy de Maistre *Rhythmic Composition in Yellow Green Minor* 1919

eighteenth century, and the principle of such 'correspondences' had appealed to Baudelaire and Rimbaud). In 1919 they held an exhibition of 'synchromies' including de Maistre's *Rhythmic Composition in Yellow Green Minor* (1919), together with theoretical exhibits and a lecture by de Maistre. It was not well received by the press, and these early experiments were short-lived – both Wakelin and de Maistre (after his period in France, 1923–26) returned to a more moderate Post-Impressionist position, which they practised alongside Grace Cossington Smith, Thea Proctor, Margaret Preston, and others.

It is these women who epitomize the 'modern' style in Sydney between the wars. Some, like Thea Proctor (1879–1966), represent the contemporary interest in design and graphic effects, and make use of decorative stylization as a vehicle for a delicately erotic content (*The Rose*, 1928). But others approach the question of discovering a content for the modernist style more substantially. That content is, once again, derived from work, but now it is the work of industrial

81 Margaret Preston *Implement Blue* 1927

technology and production, rarely represented in the landscape tradition dominated by the most prominent male painters. Margaret Preston's (1875–1963) *Implement Blue* (1927) seems at first sight to speak of the female domain of interiors and sociability, but it is also a picture of craft or industrial forms and so implies the processes by which they were produced. Dorrit Black's (1891–1951) somewhat later *The Olive Plantation* (1946) imposes on the landscape an art deco aesthetic which ultimately evokes an industrial morphology.

More striking is the imagery of work itself, and of one vast project in particular, which seems largely to have been the preserve of women artists: the Sydney Harbour Bridge. Jessie Traill systematically

documented the stages of the bridge's construction in a series of fine etchings, such as *Building the Harbour Bridge IV: The Ant's Progress, November 1929* (1929) and *Building the Harbour Bridge VII: Nearly Complete, June 1931* (1931). Cossington Smith also drew or painted the bridge during its construction many times, most dramatically in *The Bridge In-Curve* (c. 1930). The bridge project was a powerful national symbol of affirmation during the miseries of the Great Depression, and the display of a new industrial strength particularly embodied in the immense growth of steel manufacturing. This image of industrial power naturally became a symbol of modernism too – the unjoined curves, in particular, have something of the élan of futurism. But most interesting is the fascination it held for women artists: it was after all a 'virile' subject whichever way you look at it. There is a suggestive symmetry between this female interest in a male subject and the contemporary interest of the male artist in the feminized land of the pastoral genre.

Cossington Smith painted landscapes too. In *Eastern Road, Turramurra* (c. 1926) – in contrast to the bland complacency of the pastoral landscape – the 'unsettlement' of Australia between the wars is

84

86

85

82 Dorrit Black *The Olive Plantation* 1946

83 *(above)* Ethel Spowers *The Works, Yallourn* 1933

84 *(below, left)* Jessie Traill *Building the Harbour Bridge IV: The Ant's Progress, November 1929* 1929

85 *(below, right)* Grace Cossington Smith *Eastern Road, Turramurra c.* 1926

86 *(opposite)* Grace Cossington Smith *The Bridge In-Curve c.* 1930

clear. It is a picture of ambivalent inhabitation, of farmland turning into suburbia, clusters of houses encroaching on fields, telegraph poles stretching half-way down the hill like scarecrows and then stopping for no reason. A road runs obliquely through the middle of the view, less an access than a wound: it stretches without end to an horizon askew in the distance, and its progress is broken into discontinuous jolts of movement by rises and falls. And the vehicle that approaches in the foreground – counter to the implicit direction of perspective – is not a car but a horse-drawn cart. This is what has become of the path into the bush that so often appears in settler art: a road of uncertain purpose, destination and even direction.

Cossington Smith painted a similar subject three years later: *Landscape at Pentecost* (1929). Perhaps it was as a remedy for such uncertainty that the Harbour Bridge was so appealing, with its enormous power and sense of purpose, but it is significant that the bridge only appealed *during construction*, that is so long as it was incomplete. The sense of purpose was as irresistible as it was limited; once the task

was completed, it would be merely another road, directly connected to the aimless road through Turramurra. So even these early works suggest a turning inwards to subjective experience rather than outwards to the landscape, and anticipate what are perhaps her finest paintings, the late compositions such as *Interior with Wardrobe Mirror* (1955) in which the outside world is seen from the vantage point of the artist's own room, either through a window or indirectly in a mirror. They are pictures of a radical retreat from the world of action and engagement, indeed a turning away from the world of material things in search of a light that belongs to the realm of the spirit.

Preston's progress is very different. Her most characteristic works are the paintings of Australian native flowers, and numerous woodblock prints, often hand-coloured. She believed that the forms of Australian flora had great potential for modern design, and her work was so effective that we can hardly look at a flannel flower or a waratah even today without thinking of these brilliantly decorative images. She extended the process of imaginative inhabitation of Australia in a particular but important area, although she did not paint her flowers in their natural setting. They became accessible to design once picked and collected in a vase, that is once already brought into the home.

Preston also made prints of landscapes, originally picturesque corners of Sydney Harbour. Later in the thirties, however, she discovered Aboriginal painting and decided that this was the ingredient needed to produce original Australian art. Her interest in Aboriginal art and culture is certainly an important development in the history of Australian art – the Aborigine, even as a subject, had been eclipsed from the time of Heidelberg, and the idea of drawing inspiration from their art was unprecedented. But her own attempts at such a fusion, in paintings like *Aboriginal Landscape* (1941), though decorative, have little in common with the principles of Aboriginal painting. In one sense the discovery of Aboriginal art looks like a local repetition of the pre-war European discovery of 'primitive' art, especially African. But its meaning in Preston's hands was rather different. She was in many respects a conservative (a member of the Australian Academy of Art formed in 1938), and she was an ardent nationalist. Aboriginal art offered the possibility of a reconciliation between modernism and the nationalist landscape tradition.

A new generation of modernists who emerged in the thirties, including Anne Dangar, Grace Crowley, Ralph Balson, Dorrit Black, Rah Fizelle and Frank Hinder, attempted to go further in the pursuit of abstraction. Dangar and Crowley went to Paris in 1926 and by 1927

87 Grace Cossington Smith *Interior with Wardrobe Mirror* 1955

88 Margaret Preston *Flannel Flowers* 1928

were studying with the Cubist André Lhote. Others made their way
to England or, in Hinder's case, to the United States. Dangar later
went to live in the artistic commune set up by another Cubist, Albert
Gleizes, at Moly-Sabata on the Rhône, where she spent the rest of her
life, continuing to correspond with Crowley in Sydney and send
advice from Gleizes. This group put on 'Exhibition 1' in 1939, which
they claimed to be the first abstract show in Australia, although their
abstractions still included much figuration. But they were not to be
the prophets of an original Australian modernism, one motivated by

content rather than style. Their work was too formalistic, too insubstantial – it would mature into something more focused after the war.

All this had taken place in Sydney, in an art world dominated not only by the conservative Ashton, but also by the relatively tolerant George Lambert who had formed the Contemporary Group with Proctor in 1926, and Sydney Ure Smith, who set up the magazine *Art in Australia* and published it from 1917 to 1938 and became the President of the Society of Artists in 1921. In Melbourne modernist styles, opposed by Bernard Hall and Max Meldrum, had made slower progress. But Meldrum's tonalism did in fact offer a starting-point for modernist simplification of form, and his student Clarice Beckett (1887–1935) found her way back from tone to colour. Pictures like *Sandringham Beach* (c. 1933), following Meldrum's tonal philosophy, 90 have the flat optical quality of a photograph, without any sense of space of volume, and yet succeed in forming strong colour patterns on the flat surface. The 'photographic' effect suggests immediacy, but these are in reality pictures of complete, at times almost disturbing disengagement.

89 Margaret Preston *Aboriginal Landscape* 1941

90 Clarice Beckett *Sandringham Beach c.* 1933

Arnold Shore (1897–1963) and William Frater (1890–1974), originally Meldrum's students, moved gradually towards a Post-Impressionist style that still owed something to him, although they were drawn respectively towards van Gogh and Cézanne. They in turn influenced George Bell (1876–1966), a former student of Hall and McCubbin who had spent many years in England and had become a successful academic painter. Back in Australia after the war, he became dissatisfied with the academic style and sought to

understand the art of Cézanne. In 1932 he set up a new school with Shore, and spent two years (1934–36) studying modern art in Europe. From 1937 he continued to run the school alone.

The period of 'unsettlement' finds its logical conclusion in the foundation of the Australian Academy of Art, for the antagonists in this famous controversy were, in the first instance, the old conservatives and the moderate modernists led by Bell. The formation of the Academy was proposed by Robert Menzies, and a list of potential Academicians was drawn up in December 1935 when Menzies was Federal Attorney-General (he was to become the longest-serving Prime Minister of Australia after the war). It was intended as a national association of artists, and was part of Menzies's longer-term plans for national arts funding and a National Gallery. All of this might have been attractive to artists if it had not been clear from the first that Menzies wanted the Academy to institutionalize the values of the Heidelberg and later pastoral schools of Australian landscape. Menzies was a close friend of J. S. MacDonald, who had been Director of the National Gallery of Victoria since 1936 and considered even quite moderate modernism to be decadent 'filth'.

Menzies himself did nothing to allay these fears. Early in 1937 he was invited to open the Annual Exhibition of the Victorian Artists' Society and in his speech made it clear that the Academy was to represent 'certain standards of art' and 'certain principles' in art. 'Great art', he said, 'speaks a language which every intelligent person can understand. The people who call themselves modernists today talk a different language.' The Attorney-General expressed these views standing before the wall on which the most modern pictures in the show were hung, including those of Bell, Shore, Frater and Adrian Lawlor. His speech was an open attack on Bell, who had already opposed the foundation of the Academy and declined membership, and was followed by a virulent exchange of letters in the Melbourne press throughout 1937 and early 1938. It was in this climate of bitter controversy that the Academy was launched in Canberra in June 1937.

It should have been clear by this time that the Academy could never command general support among Australian artists, and Menzies himself soon realized he would not obtain a Royal Charter for an institution that remained so controversial. At the time, however, the battle lines were not quite as clearly drawn as we might assume. Prominent Post-Impressionists, such as Cossington Smith, Wakelin and Preston, became members, as did Shore in Melbourne (at the cost of his friendship with Bell). On the other hand, many of the most

important of the older establishment artists, including outspoken conservatives, declined: Streeton himself, Meldrum, Norman Lindsay, Long and Will Ashton all turned down invitations to be among the seventeen founding fellows. Bunny and others rejected offers of associateships. Their reasons varied, but in general there seems to have been a suspicion that the new body would encourage mediocrity. The open-minded Ure Smith, who had been a supporter of a national arts association, became Vice-President in order to give it a chance of success, even though he thought Menzies obsessed by absurd ideas of emulating the pomp of the Royal Academy.

The Academy held its first exhibition in 1938, and continued mounting lacklustre shows until 1946; in 1949 it was wound up. Ure Smith had withdrawn the 'northern division' in 1941, supposedly for the duration of the war. Menzies, by now Prime Minister, lost office in the same year, and the Academy was deprived of its powerful patron.

The ultimate reason for the Academy's failure was not simply that the old 'conservative' values it espoused were exhausted – with hindsight we can appreciate that the principle of intelligibility that Menzies raised is a serious objection, even if in the circumstances his appeal to cultural democracy was perhaps specious and interested. The demand for popular intelligibility would be reiterated by left-wing artists a few years later. But historically speaking, the very battle the Academy was fighting was anachronistic. It saw a moderate modernist like Bell as the enemy, but it has been clearly demonstrated that this kind of modernism was already a new – indeed a rival – establishment. The artistic front was elsewhere, as would soon become apparent. In fact the greatest historical significance of the Academy was that it provoked the formation of the Contemporary Art Society under Bell's leadership. And the CAS, in bringing together the whole disparate collection of 'modernists', set the scene for a second split between moderate and radical modernists; and then a third which gradually developed between political and artistic radicals. But that is the subject of the next chapter.

The Uninhabitable

Because I can look up into the sky
and see there nothing of myself,
and into the sun
and see there nothing of myself...

James Gleeson, 1938

The previous chapter covered a period characterized as one of 'unsettlement', in contrast to the vigorous imaginative effort of settlement that had preceded it. There was no revolt against Heidelberg, merely a waning of its inspiration into melancholy, with artificial attempts to revive the vision in the form of an ideology. At the same time new generations of artists began to be interested in European modernism, but they did not really understand what was intellectually or politically at stake. Above all there was no effective demand, no audience. Modernism arrived as style, as something 'exciting', but no one was quite sure why they should be excited. Style was in search of content, of motivation.

All of this took place in a milieu of *depressurization*, as it were – there was no great intensity either in attack or defence. There may have been passion and even dogmatism on the surface, but it is understanding that makes true conviction. That strength of deeply founded conviction is equally lacking in the pastoral landscapes, Lindsay's mythologies and the essays in abstraction of a de Maistre. Cossington Smith and Preston, among others, produced some beautiful and memorable images, but they still seem to exist somewhat ambivalently in relation to their time and place, in spite of all attempts at topical references, local scenery or flora, and even indigenous style.

The period or movement that now begins is, in contrast, one that develops under intense pressure: the pressures of economic crisis, war, and class struggle; of bitter rivalry, ambition, personal danger, mental anguish, sexual jealousy and intellectual controversy. Modern art was

no longer a genteel and semi-amateur pursuit, much less a form of social chic. It was no longer in search of content and motivation, but forced to decide between alternative contents. All the competing tendencies return – from varying points of view – to the central questions of social life in the Australian setting; and their common verdict is a negative one, even if the negation is more complex than Marcus Clarke's.

The principal scene of this period is Melbourne, where Meldrum's teaching had encouraged a distrust of formal 'innovation' for its own sake, and an emphasis on the broader social concerns of the artist. Although the extreme pressure from which the new movement emerged did not build up until the end of the thirties, the elements were present from the beginning of the decade. In 1930, Gino Nibbi had opened his bookshop and Adrian Lawlor exhibited pictures considered shockingly modern. Sir Keith Murdoch, the publisher of the *Herald*, had held an exhibition of modern paintings from Australian collections at the paper's offices in 1931 – an event that stimulated the formation, under the leadership of Bell, Frater and Shore, of the Contemporary Group and its first exhibition the following year. In 1932, Bell and Shore had opened their 'School of Creative Art' and in 1933 Murdoch had become a trustee of the National Gallery of Victoria and Sam Atyeo exhibited *Organized Line to Yellow*, the most controversial and provocatively modernist painting made in Australia before Sidney Nolan's (1917–92) *Boy and the Moon* (c. 1940).

96

Tension started to rise from the middle of the decade: in 1935 the director of the National Gallery, Bernard Hall, died and the ultra-conservative J. S. MacDonald succeeded him, after much political lobbying and against the wishes of such progressive trustees as Murdoch, who preferred Basil Burdett. The latter became the art critic of the *Herald* in 1936 and in the following year the Australian Academy of Art was established. The most important response to the foundation of the Academy was the formation of the Contemporary Art Society in 1938.

Initially the Contemporary Art Society was a broad alliance under the leadership of Bell, representing the moderate modernists who had established themselves over the previous few years, and who had gained the support of powerful patrons like Murdoch. It was appropriate that they should lead the fight against their old opponents, but those opponents no longer had much real power, and the revolt against the Academy masked another far more vigorous and danger-ous conflict. The struggle that really mattered was between the mod-

91 Sam Atyeo
Organized Line to Yellow 1934

erate modernists, who had finally won acceptance for the Post-Impressionist style, and a younger generation of radicals whose understanding of modernism went beyond style to content, whether social or psychological. Within this group of radicals a further bitter opposition lay concealed for a few years more.

This opposition between the two modernist camps was present from the beginning. It was not only that the Society included artists of various generations, with different conceptions of art and political affiliations, but also that laymen were involved as well, and had been among the founders of the group. The young solicitor John Reed was a lay Vice-President. Differences of opinion arose over the active participation of laymen and over criteria of selection for the group exhibitions, and both of these questions ultimately hinged on the way modern art was to be considered: as a craft to be practised by trained professionals, or, in the spirit of Rimbaud and more recently the

Surrealists, as a way of changing the world. Reed considered the equal participation of laymen essential if the association was to remain open to broader concerns of modern culture, and non-selective exhibitions if it was to be truly receptive to new talent.

The moderates dominated the first exhibition in June 1939, but the deep tensions generated in the process were not yet overtly visible. The exhibition was held at the National Gallery itself, thanks to Murdoch, now the Chairman of the Trustees, and it followed the second exhibition of the Academy in the same place. In spite of the selection process, many young artists were shown to a wide public for the first time, and visitors must have been impressed by the mass and diversity of Australian modernist work. Meanwhile Murdoch had sent Burdett to Europe to put together an important exhibition of contemporary French and British art. The *Herald* exhibition opened at Melbourne Town Hall in October 1939, shortly after the outbreak of the Second World War in September. It contained works of high quality by most of the leading French and British artists of the late nineteenth and early twentieth centuries, and was a revelation to many artists and art lovers who had seen very little modern art except in prints and reproductions in magazines.

At the same time, the exhibition included almost no analytical Cubism – and so omitted the most intellectual of modernist movements – no German Expressionism, no Dada and very little Surrealism. The work that was shown must have, on the face of it, strengthened the resolve of the moderates, but perhaps it also helped the radicals to understand what had gone before, and through first-hand works, rather than the pale imitations of their older contemporaries. The younger artists, however, were more interested precisely in Expressionism and Surrealism, styles which offered ways to articulate the personal or political revolt that motivated them. In fact it is the absence of Cubism that was probably least missed. Cubism was a movement that dealt primarily with problems intrinsic to the tradition of representation itself, and such formal or epistemological questions were not yet of deep or urgent concern in Australia. The new art was much more profoundly motivated by moral, psychological and political concerns, at a time of depression and global war.

A confrontation between the two groups within the CAS towards the end of 1939 eventually led to Bell's resignation as President in June 1940, and not long afterwards he and many of his supporters resigned altogether, amid considerable bitterness. These events left the radicals in undisputed command of the Society, but lost them the support of

92 Yosl Bergner *Aborigines in Fitzroy* 1941

the powerful backers of the moderates, like Murdoch. The 1940 exhibition, soon after Bell's resignation as President, went ahead at the National Gallery, but in 1941 the Society's application was turned down. This exhibition, however, was the first to give a representative view of the emerging movement. Albert Tucker's (b. 1914) *Spring in Fitzroy* (1941) shows how the political could still be reconciled with personal expression. His gaunt, tense figure staring out into an inner-city street is in a sense the reverse of Streeton's selector on his log, and the coincidence of physical attitude is significant. The subject of both paintings is work: in Streeton's the rest after work accomplished, in Tucker's the enforced and restless idleness of a man who has no work. Streeton's figure looks around him at the world he is shaping; Tucker's stares hopelessly at a world already made, over which he has no control.

The theme of work is as important in this period as it was in Heidelberg, but the perspective has changed. There the emphasis was on the individual's encounter with the land, and the foundation of social relations through work in common was a secondary theme. Now the domination over nature is taken for granted (at least in the urban setting) and the focus shifts to work as the basis for human community. Unemployment becomes a symbol for the breakdown of the social order itself. The characteristic images of such politically motivated artists as Noel Counihan (1913–86), Victor O'Connor (b. 1918) and Yosl Bergner (b. 1920) show workless figures drifting in city streets. Bergner's *Aborigines in Fitzroy* (1941) adds further layers of complexity to this imagery because his unemployed figures are native Australians whom he associates with Jewish refugees. It is significant, incidentally, that Bergner, himself a Jew and a refugee, should have been so concerned with the Aborigines – they do not otherwise figure in Australian art as images of general human experience until after the war, and even then they are seen in the light of the European Australian's experience.

In 1942 the pressure increased again. The Japanese took Singapore in February and in the same month made the first foreign attack on Australian land. In March they invaded New Guinea. Australian troops, who since the beginning of 1940 had been in Palestine, North Africa, Syria and Greece, were recalled to defend their country from imminent invasion. Tucker and Nolan were conscripted into the army (Boyd had joined the year before). In this crisis tensions began to appear between those artists who were primarily political militants and those who believed their first duty was to the integrity of an

93 *(right)* Albert Tucker
Spring in Fitzroy 1941

94 *(below)* Albert Tucker
Futile City 1940

artistic vision. The first group became more closely aligned than ever with the Communist Party, which had been illegal between 1940 and 1942, but which under the international 'united front' policy directed its members to cooperate with established governments in the struggle against fascism. The second group became associated with the magazine *Angry Penguins*, which was founded by Max Harris in Adelaide in 1940, but moved to Melbourne in 1943 after the third issue to be edited and published by Harris and John Reed. *Angry Penguins* published both sides of the ensuing debate, but it was increasingly seen as representing the avant-garde group within the Contemporary Art Society – Harris, Reed, Tucker and Nolan – a group, moreover, that was asserting its dominance of the Society.

It is hard to exaggerate the importance of John and Sunday Reed in the Angry Penguins group. They were patrons, but much more than that: John Reed gave up his law practice to work for the Contemporary Art Society and to publish *Angry Penguins*. He took a leading role in the intellectual and political debates of the Melbourne art world. He and his wife funded the magazine and the publishing firm of Reed and Harris, supported several artists, including Tucker, by direct stipends, and made their home Heide, near Melbourne, a centre for artists and writers, who frequently lived and worked there. They provided the material, moral and intellectual structure that enabled a disparate group of avant-gardists to become a movement.

At the end of 1942, the Contemporary Art Society put on an 'Anti-Fascist Exhibition' at the instigation of the Communist members. Behind the seeming show of unity, the Communists were dissatisfied with the response of the Angry Penguins group. Counihan accused them of 'demoralization, pacifism, defeatism'. The break between the two groups was as inevitable as that between the French Surrealists and the Communist Party a decade or more earlier, with the difference that the Party was for the time being not trying to overthrow bourgeois governments, but to collaborate with them in the war effort. At one level the Angry Penguins group was in the right: although significant art does have a political horizon, it is not the same as politics. Politics is action, art is consciousness. But it is harder to be satisfied with the Angry Penguins' response to the war, which was by now, for their country, one of direct self-defence. Tucker's attempts to evade conscription and Nolan's later desertion may not be matters for moral judgment, but they are symptomatic of the lack of solidarity that Counihan identified, and which ultimately corresponds to the moral limitations of their

95 Albert Tucker *Image of Modern Evil 24* 1945

art – limitations that became more noticeable as the career of each gradually waned in later years.

Nolan's *Kiata*, in the Society's 1943 exhibition, marks the distance between the avant-garde position and that of the social realists. It is a picture that speaks of alienation and emptiness, but with so deliberate a detachment and stillness that it must be understood as a direct response to the intense pressure of the times; Nolan responds to heat with coldness – even the bright light, which he adopts from the Heidelberg painters, is luminous but not hot. Significantly, it is he, the least overtly concerned with moral and political questions, who would rediscover and transform the landscape heritage of Heidelberg. Other artists, like Tucker and Boyd (who shall be discussed below), responded very differently. Both were passionate, not detached like Nolan – Tucker's passion was anger, Boyd's a complex mixture of desire and frustration – but they remained finally private passions.

The credibility of the Angry Penguins suffered a severe blow when, in 1944, they were the victims of a literary hoax. Harris, Reed and Nolan published (in an issue with a special cover designed by Nolan) the works of a bogus 'Surrealist' poet, Ern Malley, who was in reality the fabrication of two young anti-modernist writers, James McAuley and Harold Stewart. The victims of this hoax later claimed that the poems had been produced, on their authors' own admission, by the perfectly surrealistic methods of random assembly and automatic writing (and thus were good in spite of their authors' intentions), but the reputations of all concerned, especially Harris, remained permanently damaged. Taking advantage of this setback, the Communists tried, and narrowly failed, to seize control of the Society at the annual general meeting of 1944. The cumulative result of these struggles was to weaken the Contemporary Art Society and its cultural authority, especially after the war ended the following year. Quite suddenly the intense pressure of the war years seemed to dissipate. In 1946 Tucker broke with *Angry Penguins* and left Australia in 1947. *Angry Penguins* ceased publication at the end of 1946, and Harris returned to Adelaide. In 1947 the Melbourne branch of the Contemporary Art Society was itself disbanded. Nolan left Melbourne and Bergner left Australia. It was during these years that the *Angry Penguins* artists exhibited some of their most important pictures, as though the release of pressure allowed a final surge of creativity.

In spite of the reservations already suggested in outlining the events of these crucial years, the art of the Angry Penguins group remains among the best and most original produced in Australia. Although

the members of the group were interested in international modernism, they were not derivative in the way that much pre-war modernism had been. Surrealism and Expressionism may have been inspirations, but the artistic languages evolved were driven by necessity, and style was forged to accommodate meaning. This quality of necessity, moreover, came not only from contemporary circumstances, but also from a sense of the tradition of Australian art – of its inherited problems. Thus for example what seems in retrospect to have been a central concern of the Angry Penguins – the populating of the country with mythic figures grown from the land and its history – has no counterpart in mainstream modernism. It is a rediscovery of the perennial Australian difficulty in inhabiting this continent. Equally Australian is the concern with work and the various forms of alienation that correspond to non-work.

The most dramatic contemporary image of non-work, or of work perverted, is in Tucker's *Images of Modern Evil* series (1943–46). The encounter of soldier on leave and prostitute becomes the pattern of human relations in a city of vice and despair. The digger, who during the First World War had been represented by the image of the citizen-settler, is now a coarse brute, groping for oblivion in a respite from danger and suffering. The real 'workers' are the girls, but their trade is exploitation and still further bestialization. As the series progresses, they become less and less human, ending up as limbless torsos, with a single huge eye on a stalk and a predatory red crescent for a mouth. Human life regresses to an animal or even plant-like level of stimulus and response, symbolized by the dismemberment of the body. The working body represents purposive engagement with the world – it is the subject of will. Tucker's limbless, floating torsos are subjects and objects of appetite, endowed with just enough consciousness to locate and entrap their prey.

'His derivations are many, his loyalties few and unpredictable,' the *Sydney Morning Herald* critic Paul Haefliger wrote of Nolan in 1944, 'He is the "enfant terrible" of Australian art.' Unlike Tucker, Nolan never seems to have been passionately involved in the moral or political problems of his time. Tucker's artistic vision was driven, and ultimately distorted, by anger (art cannot feed on hate alone). Nolan seems to have been fundamentally indifferent to anything beyond the problems of his art and his own feelings but by good fortune these areas of interest were able to coincide and to cohere with problems of his time and place. He once said of his Kelly pictures that they were in a sense autobiographical, but they are not decodable as autobiography

95

96 Sidney Nolan *Boy and the Moon* c. 1940

97 Sidney Nolan *Kiata* c. 1943

98 Sidney Nolan *Ned Kelly* 1946

in any straightforward sense: he possessed the eminently artistic ability to transmute personal experience into impersonal vision.

Nolan began as the most 'experimental' of the group, gratuitously so in the eyes of some. *Boy and the Moon* was regarded as a mystification, and later the communists were irritated by his lack of social commitment. When he exhibited *Kiata* in 1943, Nolan had rediscovered the Australian landscape. As he later recalled, 'I gradually ... completely identified with what I was looking at and I forgot all about Picasso, Klee and Paris ... and became attached to light.' But there was in this 'relationship with the landscape' an implicit relationship to society, which he developed during the years between his desertion from the army in 1944 and his dishonourable discharge under a government amnesty in 1948.

Nolan discovered in Ned Kelly, the bushranger executed in 1880, his most powerful symbol and the most important metaphor

of an Australian relationship with the land since the Heidelberg settler. The two figures are immediately antithetical: the anonymous but heroic settler and the spectacular criminal; one man who earns the right to his new home by work, and the other who lives as a homeless outcast by stealing from the legitimate settler. But Kelly could not have become such a powerful image in Nolan's hands had the opposition been quite so clear-cut. In fact Kelly has always been considered as something of a hero, a victim of injustice and even (if implausibly) a champion of the oppressed. And the image of the anti-hero in home-made armour has been irresistibly romantic.

Nolan preserves and enhances the ambivalence of the bushranger. He remains the antithesis of the settler: he does not work and he does not settle. The figures in the narrative sequence are flat cut-outs, never quite inhabiting the formless Australian landscape. Kelly himself roams through the countryside as a kind of nomad, at once alien to it – protected in his steel carapace – and at ease in his nomadism. In one of the most remarkable pictures in Australian art, *Ned Kelly* (1946), he rides away into the immense plain, his armour fused to the body of the horse and the sky visible through the empty helmet. In this strange combination of harmony and alienation, Nolan has developed a paradigm of inhabiting the uninhabitable.

The other suggestive, though much less well-known, alternative to McCubbin's 'strong spirits who opened up this continent' was a couple: the runaway convict Bracefell and Mrs Eliza Fraser, the survivor of a shipwreck on what is now known as Fraser Island. Rescued by Bracefell after the Aborigines had speared her husband and 'enslaved' her, Mrs Fraser, according to the most familiar version of the story, lived with the convict for months, persuaded him to take her back to civilization and promised to plead for a pardon, and then betrayed him. In *Fraser Island* (1947), Bracefell stands confidently in the water, profiled against the amorphous sea and sky. In *Mrs Fraser* (1947), the shipwrecked woman drags herself through the low scrub, reduced by exposure and exhaustion to the posture of an animal. Both figures are naked, but the first (freed of the signs of his outcast status) seems at home in the shapeless flux of nature, the other is defeated by her separation from social order.

The third important figure associated with the Angry Penguins group, Arthur Boyd (b. 1920), was in reality far less closely involved either with the magazine or with the inner circle of Tucker, Harris, John and Sunday Reed and Nolan, which congregated at Heide.

99 Sidney Nolan *Fraser Island* 1947

100 Sidney Nolan *Mrs Fraser* 1947

101 Arthur Boyd
The Brown Room 1943

102 Arthur Boyd *The Weathercock* 1944

103 Arthur Boyd *Melbourne Burning* 1946–47

Unlike the others, Boyd came from a family with a long artistic tradition, and the paternal home at Murrumbeena was itself a centre for artists and writers, though in a much less highly charged and especially less political ambience. Boyd was also very different in artistic temperament from either Tucker or Nolan. In fact they epitomize three quite different types, each with its characteristic strengths and weaknesses: Tucker paints in anger, Nolan in detachment, and Boyd in passionate involvement. If Tucker's defect is an incapacity for sympathetic feeling, Boyd's is perhaps an excess of it. His early work creates an hallucinatory world of anguish, pity,

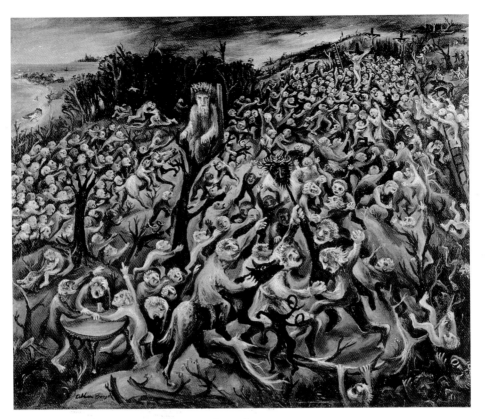

104 *(above)* Arthur Boyd *The Mockers* 1945

105 *(opposite, above)* Arthur Boyd *The Expulsion* 1947–48

106 *(opposite, below)* Arthur Boyd *The Boat Builders, Eden, New South Wales* 1948

loneliness, terror and frustrated desire. Nothing remotely approaching this emotional intensity had been seen before in Australian art.

101 Already in *The Brown Room* (1943) there is an unbearable, if under-
102 stated pathos in the figure of his aged father. In *The Weathercock* (1944), the young artist has assembled his characteristic repertoire of figures – lovers sheltering in a passionate embrace under a dead, wind-blown tree, spied on by a cripple; a solitary figure huddling in loneliness; another figure dancing with a dog-like animal around an open coffin. But by this time Boyd was trying to distance himself a little from images of personal anguish by recourse to the iconography of shared

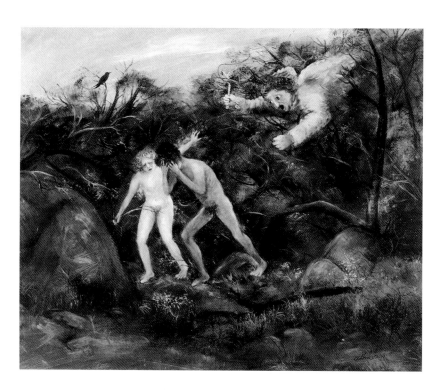

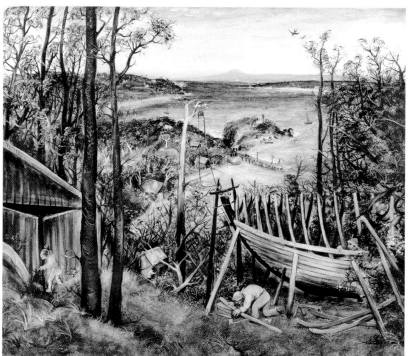

beliefs. *The Mockers* (1945) is a transitional picture in which the Crucifixion in the background is dominated by the mysterious figure of an old king in the centre of the composition – in reality a new incarnation of the father in *The Brown Room*. The mass of crowded figures and the restless movement of these compositions comes from Breughel, whose artistic idiom has nothing to do with modernism but allows Boyd to reconcile a measure of objectivity with both the tone and the detail of his own imagery.

By around 1947 Boyd could produce a work of the concentrated
105 power of *The Expulsion*, in which private feeling finds public expression in a canonic subject, while the unmistakably Australian setting acclimatizes this subject in the artist's environment. In the late forties, Boyd's painting reveals a new serenity in almost idyllic Breughelian landscapes: not surprisingly, these are pictures of rural work and thus of belonging and harmony with nature. The landscapes of the early fifties are more ambivalent, with hints of death or melancholy; imagery of work seldom appears. His subsequent paintings belong to the next chapter, but two patterns characteristic of Boyd already emerge: the tendency to cumulate and rework imagery, and an alternation between periods of mythic and of landscape compositions.

There were other painters in this circle in Melbourne who should be mentioned, one of whom is Joy Hester (1920–60), the wife of Albert Tucker, and an artist of occasional power, if narrow range. Hester had nothing to say of the public questions that concerned the others, but concentrated almost exclusively on the domain of private experience – relations between man and woman, or simply a woman alone, in a series of pictures that are substantially, if not literally, self-portraits. The features are flattened, with deep shadows, as in *Face (with Crossbar)* (c. 1947–48), in which one eye is dramatically bigger than the other, and seems wild with panic while the other is inert and dejected. These pictures belong mostly to the years immediately following the war when, after the birth of her son by another man, the couple separated, Tucker went overseas, Hester became involved in a third relationship and then discovered she was suffering from Hodgkin's disease.

John Perceval (b. 1923) was another sensitive and talented artist in this group, who later worked closely with Boyd for a time. *Boy with*
108 *Cat* (1943) is a characteristic image of raw tension, a metaphor for almost hysterical malaise. It is hard to imagine any way out of this state
109 other than the almost equally hysterical exuberance of *The Merry-Go-Round* (1944), but in the later forties his art finds a serenity similar to

132

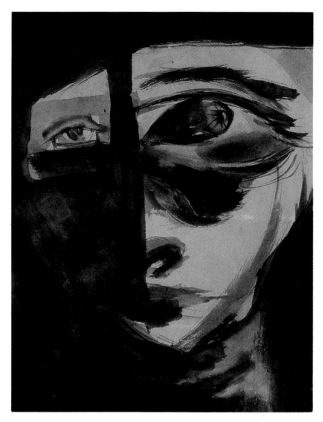

107 Joy Hester *Face (with Crossbar)* c. 1947–48

Boyd's in Breughel-like subjects. For some years after that, Perceval devoted himself to the Boyd family pottery works.

The Sydney art world during these crucial years lacked the intense pressure of Melbourne and the savagery of its political infighting. The milder forms of modernism had flourished there for years in a reasonably tolerant atmosphere (no doubt this is one reason why so many Sydney modernists were prepared to join the Academy), and had adapted themselves to the commercial worlds of publishing, interior design and advertising. It is really in this period that the mutual stereotypes of the two cities became fully developed: Sydney, depending on your point of view, either brilliant, cosmopolitan and

133

108 John Perceval
Boy with Cat 1943

intellectually liberal, or superficial, hedonistic and meretricious; Melbourne either cultivated, serious-minded and intellectually rigorous, or snobbish, gloomy and fanatical. Like most stereotypes, there is some truth in all of these claims and counter-claims. Sydney, the beautiful seaport founded at the end of the Enlightenment (but as a penal colony), or Melbourne, soberly handsome at best, founded in the Victorian period (but enriched by the gold rush)? The solution to an irreducible cultural polarity was to invent Canberra, a city without a history or culture of its own, as national capital.

It is characteristic of this polarity that Sydney should have been the scene of the most spectacular confrontation between the new and the old art, several years after the substantial battle had been fought and won in Melbourne. In 1943 William Dobell (1899–1970) painted a portrait of his friend and fellow-artist, Joshua Smith (1905–95), which he entered for the Archibald Prize, Australia's most prestigious annual

110

134

109 John Perceval
The Merry-Go-Round 1944

prize for portrait painters. Early in 1944 the trustees of the Art Gallery
of New South Wales awarded the prize to this picture. Two unsuc-
cessful exhibitors and otherwise forgotten portrait painters, Mary
Edwards (1894–1988) and Joseph Wolinski (1872–1955), applied to
the Supreme Court to have the trustees' award overturned on the
grounds that the picture was not a portrait but a caricature. There
ensued an extraordinary court case in which questions of aesthetics
and art history were debated at length by artists, critics and gallery
directors; it ended in the dismissal of the plaintiffs' suit, but Dobell was
deeply shaken by the controversy, and suffered a serious illness which
left him with impaired sight in one eye. Smith never recovered from
the intrusive and wounding publicity.

The irony of the case was that Dobell was not a self-conscious
modernist, much less a member of the avant-garde. He considered
himself a 'traditionalist', but in his hands the tradition proved too

135

110 *(left)* William Dobell,
study for the portrait of
Joshua Smith 1943

111 *(opposite)* William Dobell
The Red Lady c. 1937

malleable for his Archibald rivals. What they seemed to find intolera-
ble was that the expression of the inner being of the sitter should be
allowed to distort the external form of his body beyond the bounds of
'objective' likeness. In the tradition as they understood it – and once
again we should not discount the arguments of 'conservatives' in the
modernist period – a balance was to be maintained between the
objective and the subjective aspects of the sitter. Such a balance is the
visible expression of the equilibrium between private and public self
that constitutes sanity, and sanity is, among other things, the ability to
function in society. One witness in the trial said the picture reminded
him of something he had seen in a psychiatric textbook. The picture
was disturbing because it suggested that the sitter was mad, abnormal
or in some way excluded from participation in society.

All of this had a particular meaning in the context of the Archibald Prize, established in 1921 by the former publisher of the nationalistic *Bulletin* magazine to encourage the portrayal of eminent Australians. The bequest stipulated that the subject be 'preferentially ... some man or woman distinguished in Art, Letters, Science or Politics'. The intention was clearly to commemorate the achievements of a society,

112 James Gleeson *We Inhabit the Corrosive Littoral of Habit* 1940

and in particular its achievements in *work*. This was not the manual work of Heidelberg, but the efforts of the mind and the imagination, which can only be implied; and the artist's responsibility to evoke this intangible activity is all the greater. It is significant, therefore, that when J. S. MacDonald gave evidence for the plaintiffs, he declared that the sitter did not look like 'a man who could paint a portrait fit for entry into the Archibald Prize' – in other words, a man who was capable of the work for which he was noted and which justified his being the subject of the picture. The fact that Smith's work was *also* to paint Archibald Prize portraits gives the whole drama another little twist: it is clear that the affair is not just about taste but the preservation of a society's memory of its own achievements.

If Dobell upset the balance between inner and outer self, his younger contemporary and later biographer, James Gleeson (b. 1915)

138

113 James Gleeson
The Citadel 1945

went much further. Gleeson was of all Australian artists the one who
best understood European Surrealism and adopted it in the most pure
form: in Melbourne Surrealism entered into a chemical reaction with
social realism and political engagement, with the results already dis-
cussed. Gleeson's vision was essentially private and subjective, and one
of his most powerful themes was of the disintegration of the human
face and identity. In an early version of this theme, *We Inhabit the
Corrosive Littoral of Habit* (1940) the features peel away to reveal empti-
ness within. But if this is still a kind of conceit, presenting identity
primarily as an intellectual and aesthetic question, the later *The Citadel*

(1945) is far more urgent, an image at once moral and physiological –
a ghastly face melting and mutating, consumed by hideous organic
growths from within, identity nearly suffocated except for one terri-
fied but almost extinguished eye.

Like Dobell (and in his way even Gleeson), Russell Drysdale
(1912–81) retained but modified the stylistic equipment of natural-
ism. He did not break, as Nolan did, with the fundamental axioms
governing the relation of vision to painting that had prevailed since
the Renaissance; and yet he produced the images which, together
with those of Nolan, have come to epitomize the modern Australian
consciousness. Drysdale's work met with acceptance almost
from the very first. With Dobell and Gleeson, he was generously
represented in Ure Smith's *Present Day Art in Australia 2* (1945), a well-
illustrated survey that deliberately ignored Nolan and the Melbourne
Angry Penguins.

Drysdale left Melbourne, where he had been a student of George
Bell's, partly out of disgust at the takeover of the CAS by the radicals,
and came to Sydney in 1940. His earlier pictures were essays in the
School of Paris style, but he soon abandoned this urban, sophisticated,
decorative manner for images closer to the experience of his old
pioneer family. Although Heysen had painted landscapes in the
Flinders Ranges a decade earlier, Drysdale was the first Australian
artist to discover the significance of the outback – the arid inland of
the continent, beyond the fertile coastal farmlands that had been the
setting of Heidelberg painting. He was the first to consider what it
means to inhabit this vast emptiness, neither recognizably farmland
nor categorically desert in which it is impossible to live.

Colonists and settlers had always known about this interior of
the continent, and there are heroic stories of nineteenth-century
explorers travelling through the unknown centre, or perishing in the
attempt, like Burke and Wills. But Drysdale discovered the outback –
and was soon followed by others – as the expression of an existential
state. Part of the material and moral difficulties of settling in Australia
had always been its distance from Europe – although this would
become a particular source of anxiety *after* the war – but the outback
represented distance within, the acute sense that only the coastal lands
had been settled successfully: at the backs of the great modern cities
remained a boundless, largely uninhabited emptiness.

Drysdale's painting expresses the ambivalent feelings Australians
have for the outback: a combination of anxiety about the legitimacy
and security of settlement in this continent, and of admiration for

114 Russell Drysdale *Man Feeding his Dogs* 1941

115 Russell Drysdale *The Rabbiters* 1947

those who live, unlike themselves, at the very limits of the habitable. The literal conditions of their lives come to replace those of the Heidelberg settler as metaphoric of Australian life and the Australian character. The enormous success of the popular film *Crocodile Dundee* (1986) demonstrates how true this remains even today.

114 Drysdale's earliest images of outback life, like *Man Feeding his Dogs* (1941), evoke this inhuman world in a strangely mannerist idiom, like dream-visions. An enormously elongated figure strides across a barren landscape of dead trees, bringing meat in a sack to three greyhounds. A broken cartwheel and an idle figure in the background hint at the cessation of farm work. The greyhounds are not working dogs, either, but racers; they appear to be a luxury in an environment that lacks even the necessary amenities of life. Other paintings from the early forties also evoke idleness, leisure or the half-comical, half-touching picture of a local Volunteer Defence Corps with two rifles between them.

In 1944, a year of severe drought, Drysdale was commissioned by the *Sydney Morning Herald* to travel with a journalist to western New South Wales. This experience seems to have brought him to a new realism – the long mannered figures disappear – but also to a new understanding of the surreal that lies almost on the surface of reality in such unfamiliar territory. The bones of dead cattle and twisted trunks of long-dead trees are nightmarish enough, but especially so are the remains of huts destroyed by fire or fallen into ruin, sheets of corrugated iron curved into semi-organic forms or half-detached and rattling in the wind. There is an unsettling dichotomy in his work of the mid- and late forties: on the one hand, pictures of outback towns, long perspectives of streets in absolute stillness with perhaps a motionless figure standing on a verandah; on the other, disturbing studies of wrecked and abandoned buildings, rocks, bones or trees. There are rarely any figures in these subjects, which seem to exclude a human

115 presence. In one important work of this time, *The Rabbiters* (1947), two men are introduced into an almost surreal landscape, but they are dwarfed and ill at ease. They seem to be dogged by their own shadows, which remarkably anticipate the artist's later interest in the Aboriginal people as the 'natural' inhabitants of the outback world.

To this period, finally, belong the best of that group of talented but lesser painters often known as the Sydney Charm School. They shared, in varying degrees, qualities of draughtsmanship and colour that come of a long local tradition of painting and drawing with pleasure. The best of them, however, also express, even if in a minor

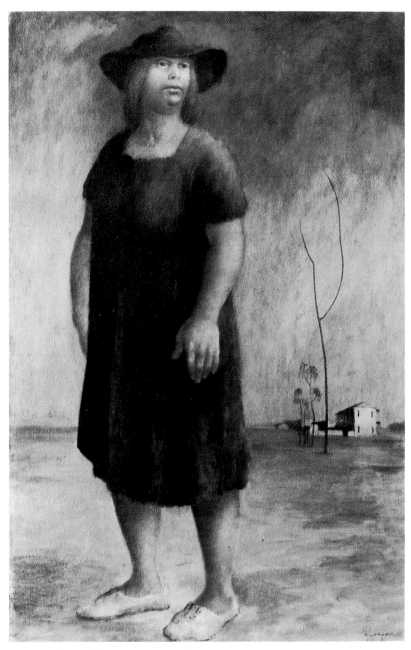

116 Russell Drysdale *Woman in a Landscape* 1949

117 Donald Friend *An Exotic Garden Viewed at Different Levels* 1957

118 David Strachan *Lovers and Shell* c. 1945–46

mode, some of the alienation and ambivalence between home and homelessness of their more important contemporaries. Aestheticism is also a form of exile.

Donald Friend (1915–89) is the best known of the group; his attitude to Australia was expressed in almost life-long expatriation. Friend's case is a little like Whiteley's later, except that he was more intelligent and was thus spared the latter's many vulgarities. What they had in common was a great facility of draughtsmanship which was not valued by the dominant tradition of the times, therefore not disciplined and not developed. Friend's work shows little significant evolution, but it has something of a consistent vision: groups of figures, vividly evoked in line but neither anchored in volume nor situated in space, appear like the anticipations of desire, or the memory-notations of someone who has travelled too much and who could say, like Baudelaire, *j'ai plus de souvenirs que si j'avais mille ans*. The pair of painted doors that are now in the Art Gallery of New South Wales, *An Exotic Garden Viewed at Different Levels* (1957), epitomize the longing for departure – also a very Baudelairian motif – towards an unknown exotic destination. Each glimpse of the imagined paradise is painted

119 David Strachan *Batterie de Cuisine* 1956

over one of the door's glass panels, replacing the daily realities
beyond.

The most interesting of them all, however, and one of the best
examples in Australian painting of a minor artist of real quality and
interest, is David Strachan (1919–70). Strachan tried his hand at land-
scapes, but though he produced some fine views of Hill End, this was
not the genre to which he was best suited. In his vases of flowers,
seashells from which the heads of lovers emerge, and, during a period
of crisis, still-lifes of kitchen implements, we recognize a highly keyed
sensibility struggling to find the place in which it can take root and
grow. But Strachan's imagination and dreams could not be transplant-
ed into the soil of contemporary Australia.

118

146

Escape Routes

> The accelerated avant-gardism of the metropolitan centre looks
> even more threatening from a position within a provincial art
> community. How do I judge these new styles? Which one ren-
> ders the one I'm working in redundant? How does it do so?
> Can I adapt, expand, extend my art to meet this new chal-
> lenge? If I can't, what is there for me?
>
> Terry Smith, 'The Provincialism Problem', *Artforum*, 1974

The period discussed in the last chapter reaches a natural conclusion
with the mature works produced by its most important representatives
just after the Second World War. Then there was a lull or hiatus,
followed by the emergence of a new set of tensions: the internal
momentum of Australian art had flagged, and New York was asserting
its leadership in the field of contemporary culture. Australian art
between the end of the Angry Penguins and the very different world
of postmodernism can be considered from one point of view as a
period defined by the tension between an 'international' – increasing-
ly American – avant-garde, and a variety of local aesthetic, social or
political concerns. The hegemony of abstraction met with resistance
from the beginning, and was first systematically opposed by the
Antipodean exhibition of 1959. A decade and a half later, as the epi-
graph to this chapter testifies, even the avant-gardists were facing the
inevitable paranoia entailed by the allegiance to the 'centre' in which
they had acquiesced. New art forms began to emerge as attempts to
escape the tyranny of New York and of art markets everywhere that
had adopted its conception of the avant-garde.

But these are not the only 'escape routes' referred to in the title of
this chapter. The 'international' avant-garde itself originally appeared
to offer an escape from Australian provincialism, an attempt to shrug
off the burden of a specifically Australian art history. And at the same

147

time much of even the most 'Australian' art of the time has something of an 'escapist' quality, a tendency to resort to dreams and more or less homemade myths or quasi-religious forms of abstraction, all of which, from a distance, are equally lacking in the urgency of the previous period, and stand in a similarly ambivalent relation to their time and place. From this point of view both 'local' and 'internationalist' artists of the time are once again implicated in a specifically Australian set of concerns.

The first important works of this period are those of Drysdale and Boyd in the 1950s. Both artists travelled to the bush and visited Aboriginal communities in 1951, and subsequently produced some of their most powerful work. Their almost simultaneous visits may have been a coincidence, but the response to the subject illustrates a deeper principle that underlies Australian art history. The Aboriginal people, as we have already seen, tend to disappear from Australian art in periods of confidence and energy, like Heidelberg or the Angry Penguins, and to reappear in more insecure times. For the subject of the settler's confidence or anxiety is always ultimately the viability and legitimacy of his tenure on the land; and the Aborigine stands for a *natural* belonging. As Drysdale himself put it in an essay published in 1962:

120 Russell Drysdale *Mullaloonah Tank* 1953

121 Russell Drysdale *Ceremony at the Rockface* 1963

The unemotional meeting of mesolithic nomad and civilized man in the Great Victoria Desert may seem normal because the scale of time and environment is too large for wonder. To discover a man lost five years gone is an event of great emotion. To find a man from the period of the last Ice Age is too remote for joy of solicitude. Too difficult for immediate response, too damned odd anyway. So nobody remarks and the courtesy of a cigarette breaches a span of time beyond the reach of history. Curiously it is not the fact that you met him in the mirage, or of what he is that astounds you. It is that he should be there where no man should be and, not just within his forbidding landscape, but part of it.

In his earlier pictures of Aborigines, Drysdale sometimes set them in his characteristic outback townscapes, where they inevitably have an air of displacement. But from the first he also depicted their relationship to the land, among forms that were becoming increasingly massive and sculptural. In *Mullaloonah Tank* (1953) the group of two men and two women has something of the monumentality of the landscape behind them. But they are still divided from it by a curtain-like canvas shelter, and they still wear modern clothing. In 1956 Drysdale made another journey to the outback, which was followed by a much deeper immersion in the subject. He made nude studies of the characteristic physique, attitudes and physiognomy of the Aborigines, and he began to paint them not only in the landscape setting, but with forms and colours drawn from the landscape and directly evocative of the analogy between the people and their environment. In one of his most remarkable series of compositions, the landscape itself is not represented, but indirectly evoked through figures set among burial poles, as though generations present and past were the personified incarnation of the land. A painting like *Man and Woman* (1960), although clearly expressed through the conventions of European representation, also demonstrates an intuitive understanding of Aboriginal culture. *Ceremony at the Rockface* (1963) reveals an even more explicit interest in Aboriginal religion. The central group of father and son recalls images of the Virgin and Child, but there is nothing otherworldly about this initiation: the gesture of the boy speaks of war and hunting, of gaining and defending a livelihood in this world.

Boyd's experience was somewhat different. His first reaction was one of shock at the conditions in which the Aborigines of the

Simpson Desert lived. Until this visit he had, by his own account, only ever seen one Aborigine, 'a chap around Melbourne who played a gumleaf'. This may seem surprising to anyone not familiar with Australia, and especially with the divide that separates the few great cities – in which most of the population lives – from the country and the outback. While country people have often lived in relative proximity to the Aborigines, the urban majority, especially in the past, rarely saw and still more seldom met them.

Boyd did not begin the series eventually called *Love, Marriage and Death of a Half-Caste* until 1955 – when he painted *Half-Caste Wedding* – and most of the series was executed in 1957 and 1958. By this time the original impressions had settled and transformed themselves in the artist's imagination, and what he produced was in no sense a piece of social-realist commentary. In fact, reconsidering the series in 1981, Boyd said that they should have been 'much more Goyaesque. ... There should have been a bit of compassion.' It is significant that Boyd himself, considering his original undoubtedly compassionate response to the plight of the Aborigines, should have come to find his own pictures lacking in this quality. But their imaginative strength, as in all art, lies in a balance between sympathy and detachment. The paintings of Aboriginal subjects by his brother David illustrate the dangers of overtly 'committed' art.

Boyd's series is certainly ambivalent, but it brings together both his ideal of harmony with the environment and his sense of the tragic impossibility of love in the image of the 'half-caste' bride. She is the symbol of alienation, lost between cultures, and leading her Aboriginal lover away from potential harmony with the land to eventual disaster. In *Half-Caste Child* (1957), with white face and black limbs, she pleads for the affection of the man who is not her father, while her mother crouches in an attitude of shame in the entrance to the family hut. In one of the most successful compositions in the series, *Bride Running Away* (1957), she flees from either father or lover on a moonlit beach. Boyd is not an intellectual painter, and it would be pointless to look for narrative or sequential coherence in these images. His strength and his weakness is that he is led by a sense of the poetic image rather than by any conception of structure or purpose. Thus we come perhaps closest to the poetic centre of his vision in a picture such as *Shearers Playing for the Bride* (1957), far from the too legible moral drama of *Half-Caste Child*. The three black shearers appear to be quite at home playing cards in the night while moths flutter around the hurricane lamp; but the bride emerges like a ghost

122 Arthur Boyd *Half-Caste Child* 1957

123 Arthur Boyd *Shearers Playing for the Bride* 1957

124 Arthur Boyd *Clay and Rockface at Bundanon* 1981

from among them, a figure of dangerous seduction accompanied by one of Boyd's recurrent symbolic beasts, the lustful 'ramox'. It is only the title that tells us the shearers are playing for her. In later pictures, the bride is again an apparition in the air, a 'phantom bride', or a reflection in a creek which the lover tries in vain to embrace. Boyd could not produce, like his brother, simplistic images of spoliation and oppression, because his theme is much more a quasi-imaginary people and the fatal seductions that destroy their harmonious existence.

So both Boyd and Drysdale, in these important paintings of the later fifties, evoke the Aborigine as actually or potentially at home in the Australian landscape. In a sense this is a direct response to the unstable conclusion of the previous period, which affirmed a dwelling-in-alienation, but left unresolved questions of legitimacy and the basis of social life, since Nolan's Ned Kelly and even Bracewell are criminals. But Boyd's and Drysdale's Aborigines are not an answer to these questions, because they are precisely *unlike* us in enjoying a 'natural' relationship with the land. At most such figures of the Aborigine can represent the unattainable ideal as a benchmark against which to estimate our own situation. And as such they stand not within but beyond history. Nor are these questions really dealt with in Boyd's often very beautiful late paintings of the Shoalhaven River, which ambivalently evoke both intimacy with and remoteness from the landscape.

The most important 'escape routes' in these years, however, were those offered by the successive forms of abstraction that dominated Australian painting from the mid-fifties until the beginning of the seventies. Never had an aesthetic ideology achieved such a tyrannical and exclusive hold on art in Australia, threatening all who failed to submit with obsolescence and irrelevance. Never, perhaps, have more dreary pictures been painted; and never did a movement end in a more spectacular collapse.

The origin of the flight into abstraction must lie in a kind of historical fatigue. The art that had developed in the Depression and during the war had been driven by a sense of collective enterprise. The great questions of the time were the struggles against economic crisis, against fascism, then against foreign invasion. From whatever angle these questions were viewed, there was no doubt about the need for solidarity and common effort; and there was equally no doubt that art had an important part to play as a custodian of humane and progressive values. The dignity and seriousness of art were indissociable from its political and historical responsibility.

It was not unnatural that the end of the war should be followed by a turning away from such intensely political and social engagement, especially as the avant-garde of that time had disbanded of its own accord. The flaws and limitations of a movement are never more apparent than in its dissolution: the rancorous dogmatism, the mutual intolerance and the failures of discrimination seemed less excusable when the urgency of the time had dissipated. The reaction was particularly strong in Sydney, which had never deeply sympathized with the

125 Godfrey Miller
Still Life with Musical Instruments
1963

Melbourne avant-garde and its passions. Sydney artists, pushed aside by the Angry Penguins, returned to their formalist preoccupations, and were understandably predisposed to welcome a movement which offered them, once again, leadership of the avant-garde.

In contrast to the collective spirit that animated the art of the war years, abstraction drew on a romantic conception of the artist as solitary creator. Of course the romantic artist was not merely an individual 'expressing himself'; creation arose out of an intuitive understanding of something essential in the human spirit, nature or God. But such a view of art assumes that the reality with which it is to deal is not to be found in social relations, but through the solitary experience of the individual. Art has always had a political horizon and a religious horizon – no artist can wholly ignore either, but most are more strongly drawn to one or the other. In the case of the Angry Penguins, it was the political; the abstract painters tended, ultimately, towards the religious horizon, even if some of them did not reach far beyond personal 'expression'.

At the same time, the 'escape' into abstraction was not only motivated by a fatigue with political and historical engagement, but also – and this has been a perennial theme in the history of modernism – by withdrawal from a society increasingly dominated by the industrial production of lowbrow and middlebrow culture. High art found itself, in its attempts to secure a position of integrity, driven to increasing remoteness and reductiveness.

The earliest post-war abstract artists were individualists of a relatively introverted temper, building on the constructivist abstraction first seen in Sydney before the war. Godfrey Miller's (1893–1964) meticulous analysis of his subjects into thousands of tiny facets takes apart the objects of perception and reassembles them in an ideal, hermetic world. In his best pieces, he grasps the point of analytical cubism: the critique of the distinction between figure and ground, body and space, axiomatic in the tradition of modern painting ... but it is all seen through a temperament as febrile as Picasso's was forceful. John Passmore (1904–84), too, explored the boundaries of abstraction and figuration. His *Bathers* (1954) is heir to Cézanne's own immense difficulty with the figure, visible from the earliest work up to the last *Baigneuses*. Like Cézanne's, Passmore's nudes are exiled from the history painting tradition to which they belong to the pictorial dump of the 'bathing' scene. The sense of discomfort is only heightened by the allusion to Michelangelo's own history-bathing composition and, in the central figure, to his late *Pietà*.

Frank Hinder (1906–92) continued his analysis of form and movement into cubistic patterning or semi-abstract rhythms. Ralph Balson

126 Frank Hinder
Subway Wynyard 1948

127 Ralph Balson *Painting No. 9* 1959

(1890–1964), born in England and originally a house-painter, developed late in his life the personal and intimate style of abstraction of *Painting No. 9* (1959). Countless dots or patches swim in a surface that appears undifferentiated, but which is in reality shaped both by general lines of force and by currents of organic movement in which Balson himself saw a transposition of a cosmos in a constant state of flux.

A newer and more outward-looking abstraction began to appear from the mid-fifties, and is particularly associated with the figure of John Olsen (b. 1928), whose energetic style of abstract expression never entirely renounced figurative elements. Olsen's work, in this sense, remains a part of the dominant Australian landscape tradition, but instead of transcribing the visible shape of the country,

or articulating the historical experience of its inhabitants through myth, his art aims for a direct assimilation and gestural enactment of the land and the culture. Olsen conveys a powerful but undisciplined creative energy, although whether it really is a picture of the mind of God at work in the creation of Australia is another matter: it cannot all have been done in a burst of *joie de vivre*.

There were many other abstract painters in Sydney at the time, some of whom, like William Rose (b. 1929), were still working in a constructivist mode. In 1956 Olsen and Robert Klippel (b. 1920) organized the abstract exhibition 'Direction 1', which also included Passmore, Rose and Eric Smith (b. 1919). Later in that year the Orient Line held an exhibition of Contemporary Australian Paintings aboard the S.S. *Orcades*, in which both the older Constructivists and the younger Abstract Expressionists were well represented. Sydney critics enthusiastically spoke of the necessity to 'follow the current of history'. It is significant that this concern with 'history' – that is *art history* – arises precisely at the moment when art is most clearly turning away from history in the political sense.

The early Abstract Expressionists were more directly influenced by European models than by American and, like previous generations, generally encountered the new styles in England, although they gradually became more aware of the art of New York. French models can easily be seen in the paintings of Stanislaus Rapotec (b. 1913) or Peter Upward (1932–84). Other related European movements were influential as well, especially the matter and texture paintings of the Spanish artist Antonio Tàpies. Elwyn Lynn (1917–97) adopted this style and, once again, in his best pieces continued to be influenced by the image of the Australian land.

128 Elwyn Lynn
Four Burnt Paddocks 1987

129 Roger Kemp
The Cross 1968

Melbourne was much less receptive to the new claims of abstrac-
tion. The figurative tradition there remained strong, and sceptical of
Sydney's stylish fads. But the opposition of abstract Sydney and figura-
tive Melbourne has often been overstated. A particular brand of
emblematic abstraction was developed by Roger Kemp (1908–87),
with a characteristically religious flavour. Kemp's compositions,
sometimes heavy and graceless, but always animated by a searching
intelligence, combine references to the cross, the human body and
machinery in what sometimes looks like a divine clockwork. Leonard
French (b. 1928) followed his example, but without Kemp's depth
of mind. His geometric compositions are laden with gold leaf and
portentous but vague imagery. There is something peculiarly
Melburnian about these two artists, highly regarded at home but not
easily exported.

130 Charles Blackman *Suite of Paintings* 1960

131 Robert Dickerson *The Tired Man* 1956

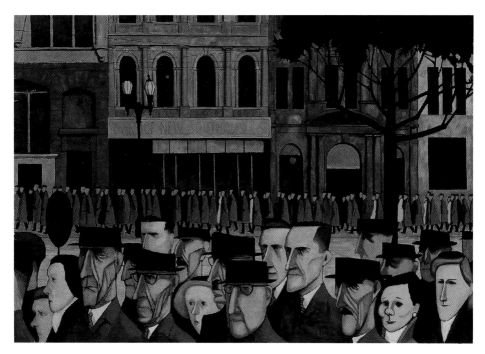

132 John Brack *Collins Street, 5pm* 1956

Arthur Boyd's *Bride* series, on the other hand, should have been eminently exportable; it was shown in Sydney in 1958. But such was the fanaticism of the abstractionists – in which prejudice was mixed with the resentment of past humiliation – that it was simply condemned as bad painting. Early the next year, John Reed's important collection, including works by most of the artists with whom he had been associated, was greeted with outright hostility in Sydney. The work had, according to the *Sydney Morning Herald* critic, a 'hillbilly flavour'.

The response of Melbourne was one of the most famous, and for a time notorious, events in Australian art history. A group of six Melbourne artists (Arthur and David Boyd, John Perceval, Charles Blackman, John Brack and Clifton Pugh), one Sydney artist (Robert Dickerson) and the art historian and critic Bernard Smith, formed themselves into an alliance called the Antipodeans. They held an exhibition in August 1959, accompanied by a catalogue essay drafted by Smith. The 'Antipodean Manifesto' upheld the validity of

figurative painting, of the image and the tradition to which it belonged, and of the mythic imagination. It stood, in effect, for art as an expression of involvement with society and with history; it was sceptical about the claims of the abstractionists to be engaged in a 'purification' of painting, or to have invented a 'new language'.

The aims of the Antipodeans, although naturally considered reactionary by their opponents at the time, now seem much more laudable. 'Art is willed,' they asserted: 'No matter how much the artist may draw upon the instinctive and unconscious levels of his experience, a work of art remains a purposive act, a humanization of nature.' In practice, however, it is hard for the artist to find purpose alone; art is not the originator of meaning, but the voice of a community: if artists do indeed make meaning, it is from the elements of experience and will present in at least some active group of those around them. The Antipodeans found themselves on their own, in a society without passions or ideals, the very world that Barry Humphries soon began to satirize in the persona of a suburban housewife, Edna Everage. The disappointing outcome of the Antipodean revolt illustrates the perennial difficulty of being much better than one's time.

Of the Antipodean group, Arthur Boyd has already been discussed. He was at the time the most successful in creating a new imagery, but the tendency to retreat into an imaginary world has already been mentioned. His brother David, in contrast, was too literal-minded in his political engagements, and later tried too hard to extract a universal symbolism from the mythologization of his own family. Perceval, Arthur Boyd's brother-in-law, had abandoned painting for ceramic sculpture for many years; the engaging figures he produced during this period and the excitable, lyrical landscapes he later painted were equally divorced from social reference. Pugh painted pictures of the Australian bush which impressed many at the time but with hindsight are often dangerously close to kitsch.

Blackman (b. 1928) is an artist on whom judgments are divided. His work is held in high regard by many, although to my mind it is
130 ultimately thin and cloying. At any rate, his pictures of little girls with flowers certainly belong to a register of personal sentimental experience, not to the social domain. Dickerson (b. 1924), on the other
131 hand, is explicitly social; and yet his pictures of the lonely and the outcast are narrow in their range and have tended increasingly towards repetition. Of all the Antipodeans, Brack (b. 1920) is the most intellectual, and the most effective in dealing with the world that these
132 artists confronted. *Collins Street, 5 pm* (1956) is a grim picture of blank-

133 Frank Hodgkinson *Time of the Last Cicada* 1963

faced office workers leaving the city on their way back out to suburbia. It has always been a paradox of Australian life that most of the population lives in a few enormous cities, and yet few people actually dwell in the city; middle-class and working-class alike have traditionally – though this has become less true since the eighties – aspired to the suburban block. Brack's composition is the dissection of a pseudo-urban culture: these people do not function together as an organic citizenry, they commute into the city to earn their living, and then march in silence, separately, back to the train station to return home. For the artist, the problem is not just that such people are philistines; but that they are incapable of generating the kinds of ideals or collective thinking that could nourish an artist. It is not surprising that Brack later painted a portrait of Barry Humphries as Edna Everage.

Naturally, the Antipodean movement had no effect on the relentless progress of abstraction in Sydney. Some of the best of these pictures were produced in the early 1960s, including Olsen's *Spring in the You Beaut Country* (1961) and Frank Hodgkinson's (b. 1919) *Time of the Last Cicada* (1963). The former is an expression of passionate engagement with the environment, expressed in line and colour, while the latter is detached and meditative; and is appropriately composed of surface and texture. Both, however, take up the perennial theme of the Australian landscape, and affirm the possibility of communion with it, although in each case such a communion is achieved

134 *(opposite, above)* Ian Fairweather *Monastery* 1961

135 *(opposite, below)* Tony Tuckson *Black, Grey, White* 1970

136 *(above)* Fred Williams *Upwey Landscape II* 1965

through an individual state of consciousness (excitement or serenity), not through any collective or social mediation. The theme of work, even in its inverted form, disappears; the relation to the land is ultimately religious rather than political.

The most spectacular 'escape' of the period was unquestionably that of Ian Fairweather (1891–1974). After years of wandering around the world, culminating in 1951 in a virtually suicidal voyage on a raft through the Timor Sea, Fairweather retired to an island off the coast of Queensland, where he lived as a hermit and painted until the end of his life. He moved gradually towards an abstraction that allowed him to transcend personal anxieties and construct a cosmological or

134 religious vision in which, most perfectly in *Monastery* (1961), the movement of becoming and the stillness of being could be held in a tenuous equilibrium. Fairweather took no part in the artistic movements of his time, but his work was so exemplary in its integrity that it has formed a local reference-point for Australian abstract painting ever since.

135 Another such artist was Tony Tuckson (1921–73). His 'escape', as absolute in its way as Fairweather's, took an entirely different form. He was Deputy Director of the Art Gallery of New South Wales and a Curator of Primitive Art, but for years painted almost in secret, and refused to exhibit his work. It was only at the end of his life that his first one-man shows, in 1970 and then in 1973, six months before his death, revealed a painter who had taken the logic of gestural abstraction almost to the very limit, to that point of reduction and concentration at which a few lines brushed in seconds can either mean everything or nothing. In the best of Tuckson's works we recognize a compelling vision, but one which demands silent attention and, like so much of the best of modern art, categorically excludes the social and collective experience of humanity.

A third important painter of this time, Fred Williams (1927–82), is more accessible than these last two because he travels back, as it were, from abstraction to figuration, and in particular to the

136 representation of the Australian landscape. But abstraction is indeed Williams's logical starting-point, and this is what gives his pictures their particular appeal. Williams seems to capture not so much the actual appearance of a view, but rather such qualitative properties as the sparseness of tree-cover on a hillside. Individual brush-marks may not look like any known form of vegetation, and yet the overall effect is intuitively accurate and exceeds the purely visual – the painter makes an image not only of what is *seen*, but of what is

137 Lloyd Rees *Illawarra Pastoral* 1961

experienced in the most general sense. This is true even of a romantic realist like Lloyd Rees (1895–1988). In Williams, however, the process seems especially clear: his procedure is openly metaphoric rather than mimetic.

Finally, in a very different vein, John Coburn (b. 1925) developed 138 a fluent and decorative style with spiritual resonances which lent itself particularly well to tapestries – he designed, for instance, the grand stage curtains woven at Aubusson, for the opera and drama theatres of the Sydney Opera House. Coburn's work was always both lucid and sincere, but has tended to grow increasingly remote from the social and artistic developments of his time.

Abstraction appeared to be flourishing and even to have rediscovered the Australian landscape. But there were voices of dissent, like those of the 'Annandale Imitation Realists' – Colin Lanceley (b. 1938), 139 Michael Brown (b. 1938) and Ross Crothall (b. 1934) – who in 1962

138 John Coburn *Curtain of the Sun* 1971

exhibited assemblages of junk inspired by Dada and Surrealism. Lanceley subsequently abandoned satire for a distinctive and elegant Surrealist whimsy, combining painting with three-dimensional elements. Brown remained an outsider, especially in the established art world; what he wrote about it in 1964 has never ceased to be relevant (although it should not be restricted to Sydney or the stars of the time):

> To say that Sydney art is sick would be misleading, as sickness tends to imply a deviation from a customary state of good health. Present-day mainstream Sydney art should not be likened to a diseased organism but to the disease itself – it is a kind of cancer which won't stop flourishing until, inevitably, it eats the heart out of its own futile existence.

An exhibition of Brown's work, held late in 1965, was considered obscene by the Vice Squad and the artist was sentenced, a year later,

to three months with hard labour; the sentence was revoked on appeal in the middle of 1967, but the conviction was upheld. The question of obscenity was in the air: the same magistrate had in 1964 found the satirical magazine *OZ* obscene and sentenced its publishers, including the artist Martin Sharp, to gaol with hard labour (these sentences too were overturned on appeal). Gareth Sansom (b. 1939) began exhibiting his images of sexual ambiguity in the middle of the decade. Sexuality was already beginning to emerge as the last domain of imagined freedom in a society regimented by the industrial efficiency of production and consumption.

140

It appears that, in spite of the aspirations to transcendence of the Abstract Expressionists, the social and political world would not entirely go away. It resurfaced in this vein of Pop sensibility that was contemporaneous with the triumph of Abstract Expressionism. In Australia, Pop never achieved quite the cool insolence of Andy Warhol, nor his objectivity; it was sometimes anarchic and satirical, sometimes merely twee or even kitsch. But it was an irritant to the ambitious art of High Modernism, just as Dada had earlier been an irritant to the serious modernism of the beginning of the century. The 'hippy' version of Pop, more concerned with expanding the mind through sex, drugs, music or art than with the nature of the

139 Colin Lanceley *Glad Family Picnic* 1961–62

140 Gareth Sansom
The Blue Masked Transvestite
1964

consumer society that increasingly narrowed it, reached its culmination in the activities of the artists who lived, initially under Martin Sharp's leadership, at the Yellow House in Sydney from 1970 to 1972.

Two complex individuals who can be broadly attached to a pop sensibility, but whose work has continued to evolve since this time, are Richard Larter (b. 1929) and Jeffrey Smart (b. 1921). Larter became known for his provocatively sexual subject-matter and the application of paint with a hypodermic syringe. Smart practises a kind of deadpan realism coloured with surrealism; the pop element is in his constant flirtation with abstraction. There is a deep ambivalence in his work, between formalism and social observation, but in the best of his pictures, such as *Cahill Expressway* (1962), he captures something of the cold and impassive surface of modern city life.

A definitive 'escape' from all this, however, seemed to be promised by the next phase of abstraction, hard-edge or colour painting. This

movement, which began to take hold in the mid-sixties, proclaimed the need for a rigorous purification of the medium of painting, an elimination of all extraneous matter, all vestiges of figuration. 'Expression' was now to be subordinated to the quest for the 'autonomous object, independent of any experience external to itself'. The 'current of history' became absolute: for the first time it seemed possible to escape from Australia altogether, and inhabit art history itself.

If Australia had persisted as landscape in the work of Olsen, Lynn and Williams, it was now reduced to mere absence: it signified nothing more than the *distance* that separated the artist from the epicentre of art history in New York. But in that disembodied form, Australia's grip became more oppressive than ever. It was at this very time that the historian Geoffrey Blainey published a work whose title entered the language, his *Tyranny of Distance* (1966). Provincial remoteness became an obsession, and it produced provincialism. Australian artists, their longing exclusively focused on the will o' the wisp of High Modernism, for the first time found that they had nothing to say about their own country and history. A sympathetic critic could write in 1970:

141 Jeffrey Smart *Cahill Expressway* 1962

142 *(left)* Michael Johnson
Window One 1969

143 *(below)* Alun Leach-Jones
Noumenon XXXII, Red Square 1969

144 *(opposite)* Robert Rooney
Kind-Hearted-Kitchen Garden II 1967

Today, few young painters can afford to remain in Australia for any length of time. There are no longer any 'schools' to stimulate and sustain the creative mood, or to provide ideas for aesthetic development. Constant travel is necessary to make contact with the great movements of the USA.

Perhaps for this reason, the hard-edge or colour painters are harder to appreciate today than any artists in Australian history. In pursuing the elusive, autonomous 'essence' of painting, in trying to make paintings that are *nothing but* paintings, and not images of anything else, they were engaged in an activity as inherently contradictory as the attempt to use words without reference. On the whole it was not essential paintings that they produced, but just very empty paintings. That this was not seen by competent judges at the time is as significant as the earlier persistence in believing the feeble successors of Heidelberg were virile nationalists. The answer is to be found in the same principle: the pictures were seen through an ideology so powerful that they were charged with a temporary meaning. Those shapes of bright, inorganic colour were not simply what they are, but were pregnant with what they are not: they spoke of their rejection of subject-

matter, literary reference, sentimentality and kitsch. They acquired their meaning by being seen through the dogmas of formalist and 'autonomous' art history; from this point of view they did not seem empty but full of bold and provocative meaning. By the later sixties their status as the representatives of the avant-garde was beyond doubt, and the growing establishment of the avant-garde was signalled by their invitation in 1968 to hold a group exhibition, 'The Field', at the new National Gallery of Victoria.

It has often been observed that no previous avant-garde movement achieved so swift an acceptance in Australia. That acceptance, it has also been said, was premature, for the artists were young, and the work of mixed quality. For these and other reasons the triumph was short-lived. Many of the group took very different directions in later years, including Dale Hickey (b. 1937), Peter Booth (b. 1940), Paul Partos (b. 1943) and Michael Johnson (b. 1938). The latter re-emerged in the mid-eighties with an opulently painterly style epitomised in *After Sirius* (1988). But even among the artists of 'The Field' itself the spirit of pop had not been entirely banished. It subsisted in its most sophisticated form in the work of Robert Rooney (b. 1937) and Alun Leach-Jones (b. 1937), for although the work of each appeared rigorously 'abstract', hard-edged and coloured, in neither case did the forms have the absolute autonomy to which others aspired. Rooney's patterns, especially, were made with stencils cut from cornflake boxes, but even Leach-Jones's belonged to a lexicon of highly personal, semi-organic shapes, evocative of mental or biological events.

On the face of it, it seems strange that an art whose meaning was so dependent on a particular view of art history, and one that affirmed the autonomy of art history, should have found an audience beyond the art world. But colour-painting could appeal to a wider public on several grounds. It was bright, fresh and new, and the audience for 'advanced art' had by now been accustomed to continuous novelty. It was chic. The 'tradition of the new' was well established, and a measure of purist reductionism was expected in serious art. The idea of an autonomous art history, abstract as it may seem, also held a powerful appeal. The logic of the modern world was one of functionalism, leading to the specialization of each domain of human activity and the constitution of distinct techniques, laws and criteria, which tend to free such domains from the rule of general moral and social principles. Henceforth, as Hermann Broch memorably wrote, 'war is war, art is art, business is business.' The autonomy of art was paradigmatic for modern society.

The elimination of reference and the reduction of the art work to the status of autonomous object belong to the same logic. Reference is what makes art so hard to pin down, as the deconstructionists have emphasized (and over-emphasized): art gathers and forms experience rather as a sheep-dog drafts sheep into a paddock, moving around its material, darting backwards and forwards at variable speeds – and in the end some animals may get away and have to be collected afterwards. The very margin of undecidability constantly refers us back to experience, to the world. But an art from which all reference has been rigorously banished (bearing in mind that this condition is never quite achieved) becomes the perfect object, perfectly graspable, with no slippages and leakages of meaning. It demonstrates that the life of the spirit too can be reified. The implied viewer of colour-painting, then, is someone who likes the clean, functional, mechanical quality of modern life, and looks into these compositions to find the reflection of an impersonal self, and the model of an objective 'self-possession'.

Significantly, sculpture, which now in the post-war generations becomes an important medium of artistic expression, does not illustrate the same logic of disengagement. The sculptors of this period, like Inge King (b. 1918), Clement Meadmore (b. 1929) or Ron 146, 147 Robertson-Swann (b. 1944) use industrial metal, sheet iron, tubes and bars, rather than stone, timber or bronze. They neither carve nor model and cast. Sculptors had done one or the other since antiquity, and their work variously implied the imposition of order on nature, the discovery of latent form, or the realization of ideal form in matter. Modernist sculpture, on the other hand, took as its material metal that was already shaped by industrial processing and was associated with the most utilitarian applications. It was an aesthetically inert material, in which no one could ever imagine that a virtual beauty lay hidden. It was also a material of limited malleability, so that the artist could never transform it into the perfect embodiment of idea, or conceal its original nature. And this resistance in turn prevents the artist's process from becoming, in its consummation, invisible. We remain, before a sculpture by Robertson-Swann, such as *Elvira Madigan* (1971), con- 149 scious at once of the properties of the material and of the effort by which this recalcitrant substance has been turned into the image of ease and elegance.

In spite, therefore, of superficial analogies between the sculpture and the painting of this time, these arts are too different in their essential properties for their meanings ever to be equivalent. Sculpture has

145 Keith Looby *With the Death of the Talking Mural* 1988

never been a fundamentally visual art, but rather one experienced sympathetically and almost kinaesthetically, like dance. The figurative sculpture does not ask to be looked at, but to be imitated. It speaks not to the eyes but to the bones and muscles, and proposes an attitude or bearing which is the enactment of a moral state of being. The modern welded sculpture does not represent the human figure but refers to it metonymically, by displaying its work. It speaks, quite directly, of an experience that is both conditioned by history (the material refers to the social world) and founded in work; and so it evokes an engagement that is quite unlike the retreat of contemporary painting.

In Robert Klippel's (b. 1920) case the involvement with industrial 148 materials is even more obvious, since he has always preferred to work with discarded pieces of industrial machinery or the wooden moulds from which casting forms were made. The logic of his work is that of assemblage, even of bricolage – turning things once utilitarian into the building-blocks of imaginary monuments. This process of assemblage is entirely different, however, from that of working impassive metal into form, and the activity it evokes is rather play than work. And perhaps this is an adaptation, such as artists intuitively make, to the realities of our time. For the real difficulty of sculpture has been in finding a place and a function. Sculpture was originally a monument in a public place; in an age when there was no longer a public place nor a purpose for monuments, and when the style of sculpture had become unsuited to this function in any case, it is significant that the 'sculpture garden' has been invented, rather like a retirement home, to accommodate objects that should once have stood in the heart of the city. Perhaps Klippel's false monuments contain a built-in disclaimer of pompous intention.

The engagement of sculpture with the material world and with the processes of its own making allowed it to some extent to adapt and evolve in the face of changes in the world of the avant-garde that almost, for a time, drove painting to extinction. As suddenly as colour painting had triumphed, it was almost as abruptly swept into obsolescence. The fundamental reasons for this change have already been mentioned: it was all too easily treated as a commodity by the new art market, run by dealers intent on promoting the careers and products of their stables. This post-war market, which had developed in its modern form in New York, soon spread to Australia, if in a somewhat less aggressive form, replacing the traditional artists' associations as the intermediary between painters and their public.

146 Inge King *Planet* 1976–77

147 Clement Meadmore *Virginia* 1970

148 *(right)* Robert Klippel
Opus 655 1987–88

149 *(below)*
Ron Robertson-Swann
Elvira Madigan 1971

Reaction against a commodification that took little account of the meaning of art and promoted the priority of style over content was inevitable. But the swiftness of these changes is indicative of a tendency that was to become greatly aggravated in the eighties. The art world was already becoming top-heavy with publicists and 'theorists' who helped to accelerate evolutions in taste, and turn retreats into routs, especially when the social bonds among artists, and between artists and public, were being weakened by the new market structure. Tom Wolfe satirized the verbiage that surrounded the cult of 'flat painting' in *The Painted Word* (1975). Australia, in the sixties and seventies, had art critics in the principal city dailies and one national paper, and the important national quarterly *Art and Australia* (founded in 1963). But it was really in the eighties that the local critical hubbub reached international noise levels: *Art and Text* and *Artlink* were founded in 1981 and *Australian Art Monthly* in 1987, and many other publications survived for longer or shorter periods. Just as the dealers' galleries replaced the artists' associations, the new publications superseded the broadsheets of the Contemporary Art Society branches that had provided a forum for news and debate since the war.

Painting was, if somewhat prematurely, declared to be dead. Performance, installation, happenings, political posters, photography and conceptual art flourished in an ambience of renewed social and political consciousness. The reaction against American cultural hegemony was fuelled by opposition to the war in Vietnam, in which Australia had (as earlier in Korea and then Malaysia) a substantial involvement, partly made up of conscripts. The general ambition that lay behind the varied artistic manifestations of the time was the critique of a social and economic system that fractured communities and separated individuals, and the attempt to rediscover common human bonds. There were elements already of what was to become postmodernism in the rediscovery of art as an activity implying complex relations with society and the world, but it is probably true to say that the spirit of the time was rather late modernist than postmodernist. The dominant tone was engaged and radical rather than, as later, contemplative and sceptical. For a last time the revolutionary ideal of modernism rose up against the dead-end in which High Modernism found itself.

Some of the artistic expressions of the time were highly sophisticated, others deliberately naive. At the deepest level, however, the attempt at social engagement failed, and for the reason that has already been mentioned: art does not create meaning autonomously, and

much less is it capable of action in the world. Though art may be an 'imitation of action', it is primarily concerned with consciousness: action itself may follow from consciousness, but only if the mechanisms of action, which are inherently different, exist and are capable of response. The principle of action is will, and the fate of art in the modern period has been its separation from the world of communal will, both as the source of meaning and as the field of reception of meaning. When that circuit has been broken, art runs the risk of becoming, literally, *of no consequence*. Indeed while the muralist movement of the seventies tried to open a line of communication to the working class, Keith Looby (b. 1940) became increasingly concerned, 145 in such works as *Life as a Prohibited Mural* (1981), with the nature of a society and an art world that rendered such ambitions futile.

Little of the 'alternative' art of the seventies remains available to us two decades later. Most notable were the performances of Mike Parr (b. 1945), Ken Unsworth (b. 1931), Jill Orr (b. 1952) and Stelarc (b. 1946), displacing attention from the creative gesture to the artist's

150 Ken Unsworth
Suspended Stone Circle II 1984

body and finding authenticity, if not in action, then in suffering. But in seeking to demystify one idea of art, they ran the risk of fetishizing the person of the artist in a way that had affinities with the contemporary cult of the rock star. Similarly, both performance and installation, initially meant to escape the logic of the commodity, turned out to lend themselves surprisingly well to documentation and publication. In some respects, they were better adapted to new models of distribution, consumption and funding than the old unique-object art work.

But the accessibility was deceptive. Anyone who was close to the art of the last couple of decades will recall some installations and performances with pleasure: the sense of occasion, for example, when Arthur Wicks (b. 1937) pedalled his absurd Leonardesque wooden helicopter, or of mystery when an invisible figure crawled almost imperceptibly beneath a floor of autumn leaves, in a piece by Joan Grounds (b. 1939) – I mention, deliberately, two events from the mid-eighties at The Performance Space in Sydney, with which I was closely associated in its early years. The audiences were very small, largely made up of people who knew each other and often also the artist, and the space exiguous: everything contributed to the sense of involvement and intimacy – a quasi-tribal closeness which is at the opposite extreme from the impersonal international 'art world' of Biennali and the journal *Flash Art*. Even the exhibition spaces were highly specific: part of the pleasure was in the transformation of familiar rooms, and such events always worked better in more or less makeshift or recycled buildings than in the clinical environment of a modern state gallery.

151 Mike Parr
Integration 3 (Leg Spiral) 1975

The truth is that these works were much more 'exclusive' than the precious objects of high art. As the Australian colloquialism puts it, you had to be there. A few performances, like those of the American Chris Burden (b. 1946), have been so conceptually strong that they seem to maintain their existence even as narratives, even if necessary without images. Parr's notorious actions of real or illusory self-mutilation are among the only Australian equivalents. The burning coil around his leg (1975), the chopping off of his false arm (1977) and the vomiting of dye as though it were paint (1977) have all become references. Most of the others, for better or for worse, live in the memories of those who were present at the time, and are reduced to a ghostly half-life in largely incomprehensible photographs for those who were not.

Among conceptual artists, Ian Burn (1939–93), who was associated with the international Art & Language group, produced some of the most significant meditations on the nature of the art object and the

152 *(right)* Ian Burn using one of the mirrors of *1–6 Glass/Mirror Piece* 1967 to shave

153 *(below)* Ian Burn *1–6 Glass/Mirror Piece* 1967

153　process of looking. In one work he exhibited a row of mirrors – the first was covered by a single pane of glass, the second by two panes, and so on. There were multiple resonances: it was the work of art as window onto the world or alternatively as reflection of the viewer's subjectivity – and yet in both cases the deceptive transparency was

152　shown up. By shaving in front of his work, the artist raised questions about the aesthetic of the ready-made: if the utilitarian object could be given significance when set in the contemplative environment of the gallery, could it be stripped of significance by being used? Burn himself later wrote a penetrating critique of conceptualism in 1981. Hickey's *90 White Walls* (1970), a box of file cards with photographs of blank walls, differentiated only by the play of light and shade, represented an extreme act of abnegation on the part of an artist who had exhibited two years before in 'The Field'. Among those artists who chose active political engagement, Redback Graphix and others produced posters which, although forceful in their original concepts, hang oddly in museums today; a paradoxical honour which detaches even these overtly committed works from their sphere of action.

Perhaps the most enduring development of the time was the women's art movement, not least because subsequent feminism has been assiduous in preserving the memory of women artists of all kinds and degrees of achievement. Indeed the women's art magazine *Lip*, in its initial manifesto, declared its ambition to 'dismantle the myth of individual genius', which was held to be part of the reason for the overwhelming preponderance of men in art history. Accordingly,

154　Dale Hickey *90 White Walls* 1970

155 *(above)* Ponch Hawkes *Sheila and Janie* from the *Our Mums and Us* series 1976

156 *(right)* Vivienne Binns *Mothers' Memories, Others' Memories* from the Blacktown Community project 1980

Vivienne Binns (b. 1940) produced a collective work, *Mothers' Memories, Others' Memories* (1980), in which she involved women from the Sydney working-class suburb of Blacktown. A number of women adopted photography as a medium free of the heroic associations of oil paint and that also allowed them to produce quasi-collective works, such as Sue Ford's (b. 1943) *Time* series (1964–74), exhibited at the National Gallery of Victoria in 1974, in which she photographed a number of friends over several years, recording the process of ageing. Ponch Hawkes's (b. 1946) *Generations* (1989) was devoted to mothers and their daughters, and Carol Jerrems (b. 1949) produced studies of individuals and communities she knew well.

185

If there is one artist who, among so many discontents, truly speaks for middlebrow Australian culture in the seventies and eighties, it is Brett Whiteley (1939–92). He was an extraordinarily talented young man who would have benefited from the discipline of an academic apprenticeship and the imposed subjects of traditional commissions. Instead, he was left to his own resources, and they proved painfully limited. But the media loved him, and his every sketch met with adulation. Whiteley was treated as a genius and for want of anything better, genius and its torments became his subject-matter – he thought it quite natural to depict himself as van Gogh. With his brilliant facility, bright colours, images of sun, sea and sexual passion, he became the acceptable face of modernism and his pictures, though growing steadily worse and more vacuous, continued to fetch higher and higher prices. Whiteley self-consciously embodied the 'myth of the artist as genius' as it appealed not only to his own imagination, but also to that of a whole society. His painting offers the last and ultimately the most disappointing of 'escape routes' in post-war Australian art.

157 Brett Whiteley *Self Portrait in the Studio* 1976

Homeless

To assume that quality lies always with the *avant-garde* [is] a uni-
linear view not at all borne out by a study of quality in
Australian art. In Australia the best has usually been a little out
of date.

Bernard Smith, in the second edition of
Australian Painting, 1971

The period roughly from 1950 to 1980 was, as we have seen, domi-
nated by a struggle between home-grown and international styles in
art which manifested itself in a number of different guises. It appeared
as the rivalry between abstraction and figuration, between Melbourne
and Sydney, between acclimatized abstract or semi-abstract painters
and the new purism of hard-edge. Then the veil of the 'current of
history' was torn away to reveal the promotional machinery of the
New York art world, and even more ineluctably the logic of an inter-
national modernism dominated by the biggest and most powerful
player. Australian artists found themselves caught in the provincialism
trap, baited with the lure of the avant-garde. The seventies became a
transitional period in which anxiety about Australia's position co-
existed with various radical or conceptual critiques of the internation-
al art system and its styles.

In contrast, the period since 1980 has been one of greater
Australian confidence at home and in the international arena. This is
largely because the world has changed. New York was not able to
produce, in the eighties, artists of acknowledged stature, and the bal-
ance shifted for a time towards Europe, where the 'return' of painting
produced a crop of new Germans and Italians. A decade later most of
them look rather the worse for wear. The world seems less clearly
focused on a single centre, and therefore more willing to accept
Australia as one of a constellation of centres making up a contempo-
rary cultural world, which now consists of Western Europe, the new

European nations that have grown from British colonies (and to a much lesser extent those founded by the Spanish), and increasingly, parts of Asia. But it is too early to say what the consequences of these changes may be, for they are only part of the immense transformation of global economics and politics over the last two decades.

Economic globalization was already visibly coming to dominate the political life of both developed countries and the Third World in the seventies and eighties; by the end of the eighties its irresistible momentum produced the spectacular collapse of Communism, and thus the end of the Cold War. But this did not mean simply the triumph of the free market, or the end of the spectre of nuclear war – it was also, in the West, the loss of a reference point outside the capitalist system, which has left us with no general alternative model to industrial consumerism. Much of what has recently passed for radical politics is minority lobbying, and has proved surprisingly compatible with the free market's valorization of 'opportunity'. The workers must be kept healthy, contented and motivated, but the unemployed underclass can apparently be ignored. The only perspective for future political development seems to be in the direction of the ecological crisis: globalization may in the end provide the necessary international platform for concerted action.

The art world has developed in the shadow of these immense changes. It played out the disappearance of politics in its use of an increasingly futile language of opposition: in the eighties and early nineties, almost everything was held to 'subvert' a 'dominant discourse', if not, in one case, to 'shatter the armatures of the scientific gaze ... disrupt systems and order ... prize open the mechanisms that lock down a purely rationalistic and controlling approach to reality.' The language is strikingly violent, even hysterical, in so abstract a context. It is compensatory, like the ingrown self-righteousness of 'political correctness'; substitutes for action where none is possible. For high culture, no matter how much it tried to rise above or even to appropriate the manufactured trash of commercial culture, could see that it was drowned out by the cacophony of television, popular music, pornography of various sorts – soft, hard, sentimental or violent – and all of it linked by the manipulative technology of advertising.

This was the mass culture that early modernists had feared: necessarily low-brow and exploitative, and in the end driving high culture out of its traditional territories and into reservations called museums, where like all things that live in protected enclosures, it became increasingly etiolated. The rise of mass culture had always pushed high

culture towards a more mandarin stance, and this was its consummation. But art was not quite literally enclosed in the museum, because it became fashionable. As mass entertainment grew ever more crass, Australia moved noticeably further from its traditional 'egalitarianism'. Differences of income and of wealth greatly increased in this period. Apart from the established wealth of business and the professions, a new class of semi-professionals developed, often out of what had previously been considered trades, and in service industries attached, for example, to the rapid growth of tourism.

The desire of these new semi-educated classes to mark themselves off from the masses led to a kind of semiotic revolution – clothes, hairdressing, interior decoration, wine connoisseurship – almost everything became potentially a sign of status. Even beer, once shared by rich and poor alike, was overtaken by this snobbery: suddenly there were chic beers, designer beers, boutique beers. And thus contemporary art was seized on as a mark of distinction by the newly sophisticated just as the opera was patronized by an older bourgeoisie. It was easy for them to consume at openings, in a familiar party atmosphere, without the discomfort of attention, for which they were not trained. The burgeoning art world became exquisitely stratified, with galleries that showed the crass and the meretricious, and others that displayed only the most rarefied of contemporary work. It was not even necessary to understand the complex play of conceptual allusion; the sophisticate could see that it was complicated and clever, and knew that this was the right gallery to be seen in. Art became part of 'lifestyle', the word that sums up the contemporary market view of the good life. The earlier expression 'way of life' had associated consumerism with post-war free-world ideology, but 'lifestyle' is purely narcissistic, its object self-representation.

If the commercial galleries flourished, there was an even more impressive boom in government-funded art institutions, which collectively constitute the 'museum' mentioned above. Artists were surrounded by a proliferating bureaucracy of federal and state grant administrators, gallery directors, curators, magazine editors, critics, publicists, teachers and 'theorists'. The Biennale of Sydney, covering international art, was held in even years, and Perspecta, presenting local work, in odd years. Dozens of small thematic exhibitions, often with ambitious titles, took place every year in Contemporary Art Spaces and elsewhere. Hundreds of thousands of words of catalogue essays were produced, dressed up in whatever theory and ideology the authors had learnt at art school. By the mid-nineties, however, the

economic recession, and a certain loss of élan, seemed to bring this boom to an end. Private and corporate collecting was greatly reduced, and in Sydney at least there were gallery closures followed by a reshuffling of artists from galleries strongly associated with certain styles and aesthetic principles in the eighties to others, more eclectic but perhaps more commercially attractive.

Of the artistic currents of the eighties, the most historically characteristic was undoubtedly postmodernism. Coming after Pop art, it went much further in its analysis of the language of art. Pop, in a rather *ad hoc* and opportunistic way, had grasped the significance of the commercial imagery and packaging that clutters modern life. It suggested that the scope for what had come to be seen as the essence of modern art – expression – was small in a world so crowded with prefabricated forms and simulacra of the expressive. But Pop itself was succeeded by a new and apparently armour-plated variety of abstraction in hard-edge or colour painting. Here was an art that indulged in no sentimental illusions about expression; if, like all abstract art, it looked still towards a spiritual horizon, it proposed to reach that horizon through cold metaphysics, not outbursts of emotion.

The reaction, or rather reactions, against the 'autonomous object', in the seventies, emphasized the ways in which the work of art was *not* autonomous. All the various movements of the time share a concern with art's involvement, implication and engagement with things outside itself. Perhaps these concerns can be gathered into three sets of relations:

> relation to the natural world
> relation to the audience
> relation to tradition and language

The first explains not only a renewal of figuration, but the movement to rediscover matter, to mix media, to experiment with materials beyond the official repertoire of high art, and to make works of sculpture and performance with organic elements or in a natural setting. The second opened up questions of reception, of public, of constituencies and ultimately of political responsibility. The third led to a renewed consciousness of the conventions that come into play even in art which imagines it is direct expression or *ex nihilo* construction; of language and genre, both within art and in neighbouring or competing media.

In retrospect, all of these concerns seem to emerge in the seventies, but without a satisfactory theoretical basis. Of course they had been

theorized in earlier centuries, but those accounts had been declared null and void by modernism. It seems plausible to suggest that their reappearance in the seventies marks the end of the modernist dream of renewal, but that as there was then no developed theory capable of explaining them, they were for a time reclaimed and marshalled by what now looks like late-modernist social and political thinking. Hence the odd mixture of seventies culture, political in general feeling but anti-modernist in many of its artistic forms. Such internal contradiction may explain why that decade appeared even at the time to be a confusing period of rapidly exhausted fads. It was in fact a transitional phase in which many things were happening that would only be satisfactorily explained (or so it would seem for a time) a few years later.

If the art of the seventies looks like a disparate group of artistic movements in search of a theory, postmodernism soon presented itself as the answer to their prayers. The term was probably first given wide currency in 1979, with Jean-François Lyotard's work of cultural criticism, *La Condition postmoderne*. Thanks to the international circulation of journals such as *Flash Art* (founded in 1967), new ideas spread around the world almost instantaneously, and already by 1980 Clement Greenberg was asked, in an interview published in *Art and Australia*, whether the term might become a period label. Even then his interviewer, Paul Taylor, preferred such terms as Popism or New Wave, which he used in the first issue of his new quarterly *Art and Text* in 1981 (New Wave has been well characterized as the superficial or 'disco' version of postmodernism). By 1984, with the 'Futur★Fall' conference at the University of Sydney, the postmodern condition had become all the rage. Postmodernism found a theoretical basis in the ideas of poststructuralism and deconstruction – or rather an expanding universe of more or less related theories, as that movement of thought underwent a massive inflation in the seventies and eighties, under the combined influence of fashion and assimilation into a university system that eventually proved to be its natural home.

Against the modernist belief in new beginnings, direct expression and an aesthetic functionalism unhindered by the memory of arbitrary forms, poststructuralism insisted that we can only articulate our experience through language, which brings with it inherited forms and meanings. Everything is seen through the refractions of tradition and memory. Structuralist linguistics had articulated such an analysis of language, demonstrating that meaning is composed of a web of

158 *(opposite, above)* Imants Tillers *Pataphysical Man* 1984

159 *(opposite, below)* Imants Tillers *Conversations with the Bride* 1974–75

160 *(above)* Imants Tillers *Kangaroo Blank* 1988

relations between terms. Subsequent theoretical developments variously emphasized the inescapability of the system of language; the undecidability of meaning (because the web of relations is potentially infinite); the fragility of structures of meaning; or alternatively the tyranny of systems of discourse. They also (in theory) abolished the privileged 'outside' viewpoint of the intellectual observer, so that even the discourse that described the indeterminacies of meaning was not above the dangers it evoked. Such ideas were on the whole inimical to radical politics, because they tended to introduce a universal relativism and scepticism, though for the same reasons they could be exploited by minority groups against the hegemony of dominant thinking.

The most important and representative of postmodern artists in Australia is Imants Tillers, born in Sydney in 1950 of Latvian parents. In effect, Tillers demonstrates that Australia is the postmodern culture *par excellence*, for the sense of being trapped by the reified forms of the past is exacerbated in a country whose access to pictorial tradition is primarily through reproduction. When a painting becomes an image in a book or magazine, it loses the scale and quasi-tangible surface texture that make it a unique object, endowed with the *aura* and authority of which Walter Benjamin wrote in his essay 'The Work of Art in the Age of Mechanical Reproduction'. However, Tillers also finds in this flattening of the image a kind of liberation from the overwhelming authority of the original. Though limited to the 'second-degree' experience of images, we are relatively free to use those images for our own purposes.

Tillers has systematically worked from reproductions, and being a gifted painter, brings his models back to life as his own distinct works. In the process, he has made a conceptual virtue of a technical necessity: in squaring up a photograph for copying, he transfers each section to a separate canvasboard. This has allowed him to develop the idea that each board – they have been numbered consecutively since 1981 – is something like a page of the 'universal book', the comprehensive translation of the world into literature that Mallarmé imagined as the writer's ultimate ambition. But perhaps the most important aspect of Tillers's art is his conjunction of different images in the same painting. In a museum culture, we do not have the unique relationship to a sequence of artistic models that is provided by a coherent tradition; we are buffeted between quite heterogeneous images, equally available and yet unavailable. Tillers recognizes this by making his pictures into a 'battleground' between images.

The first important battleground he set up was in *Conversations with* 159
the Bride (1974–75), shown at the São Paulo Biennale in 1975. It con-
sisted of a series of tiny images in which elements of Marcel
Duchamp's *Bride Stripped Bare...* (1915–23) were superimposed onto
reproductions of Heysen's all-too-famous evocations of giant eucalyp-
tus trees. Heysen's pictures were painted at around the same time, but
the point is less to show up the provincial interests of an Australia
barely aware of the European avant-garde than to emphasize that
Heysen's imagery is as artificial and 'cultural' as Duchamp's, and to
locate the Australian experience at the intersection of the two.

In *Pataphysical Man* (1984) Tillers has copied and enormously 158
enlarged an image by Giorgio de Chirico, superimposing on it a
crowd of details, including images taken from a Latvian children's
book. Here the art-historical material is animated by a popular
imagery which has become, because of the remoteness of its own tra-
dition, recondite and almost private. Nonetheless we recognize the
play of images that usually belong to separate strata in the mind, to
public culture and to personal memory. In *Kangaroo Blank* (1988) 160
Tillers has taken as his model *A Portrait of the Kongouro from New
Holland, 1770* (1773) by the English animal painter George Stubbs. It is
a complex starting-point, because Stubbs, who had never seen a live
kangaroo, worked from a skin and some sketches, and placed the ani-
mal in an imaginary setting. Tillers repaints the picture in a different
palette, omitting the kangaroo altogether, and adding on the right one
of the columns that appear in the work of the Japanese-American
artist Arakawa, with golden lines radiating from its top over the whole
picture surface. The effect of a beacon shining in an empty wilderness
seems to suggest the operation of the mind: but is this the
Enlightenment mind with its scientific ambitions, or the creative
mind of God or nature?

The irreducibility of these paintings to any simple reading, their
density of signification, is what makes them stand out from so much
postmodern art. For an art based on quotation is inevitably pervaded
by an ironic stance, and irony is something to be handled with care.
The light it casts on works and individuals of the past can be trivializ-
ing and smug. The damage is compounded if the irony is motivated
by the spirit of resentment into which the idea of oppositional art
degenerated as it came to sense its own futility. This was the great
weakness of postmodernism: a mechanism of irony which, like
the sorcerer's apprentice, it set in motion but did not know how to
control. In the end, the unregulated play of irony made it increasingly

difficult to know what, if any, beliefs could be held within post-modern thought.

In Tillers's own case, his most difficult appropriation is of the New Zealander Colin McCahon's (1919–87) huge, quasi-mystical compositions – monochromes made largely of words. It is clear that Tillers is not trying to belittle McCahon, but the very act of imitation, the neutral irony, as it were, jars with the painful intensity of McCahon's painting. Less important artistically, but an interesting example of the principle of irony run out of control, was his picture *Pure Beauty*, painted in 1991 to raise funds for the new Museum of Contemporary Art in Sydney. For a contribution of $1000, donors could have their names inscribed on the painting. The Beuysian inscription *Kunst= Kapital* was meant to cover this gimmick with a protective layer of irony, but however much the joke ricocheted around, it did not do much credit to artist, donors, or institution.

The painting of Juan Davila, born in 1946 in Chile, is also based in part on a collage of quotations, in his case accompanied by the names of the artists from whom he has borrowed; it is less clear how this obviously postmodern aspect of his work fits with the other, and the most notorious one, which is his use of provocatively explicit sexual imagery. In some cases, the point of conjunction is the derision of various famous subjects from Australian art history. Davila had the good fortune to have one of his pictures, *Stupid as a Painter*, seized for obscenity by the police at the Fourth Biennale of Sydney in 1982, and thus found himself a martyr to the principle of artistic freedom.

Although a talented painter, Davila's work soon became repetitive, but this was a common problem for the postmodern artist: often working with a single idea, or a single formal approach to the commonplaces of the time, they found their resources wearing thin, and were rarely able to renew them. Lindy Lee (b. 1954) is a textbook case – for years she has largely produced variations on one pictorial idea: copies of well-known Old Master paintings, usually in a series, progressively obscured by thicker and darker veils of paint. Peter Tyndall (b. 1951), in an extensive series of works devoted to the conventions of looking at pictures, demonstrated that postmodern irony could be entirely free of a sense of humour.

Of course painting was not the only medium of the period; photography was particularly popular and lent itself to a variety of conceptual devices. Anne Zahalka (b. 1957), for example, composed a meticulous reproduction of Charles Meere's *Australian Beach Pattern* (1940), a rather obvious reflection on life's tendency to imitate art.

162
74

161 Lindy Lee
Heartbeat and Duration 1992

Unlike those photographers whose work grew out of the observation and documentation of their social environment – which is after all perhaps photography's real, though modest, vocation – these artists usually made pictures of elaborately prepared subjects. Among the most successful of such projects were Fiona Hall's (b. 1953) images of the *Deadly Sins* (1984) cut out of sardine tins. The figures were witty and the colour and texture of the material she had used for the sculptures had a particular affinity with the image quality of black-and-white photography. 163

The most prominent of the photographers is, however, without a doubt Bill Henson (b. 1955), if only because he achieves what is hardest for the photographer – that is to construct an *imaginary world*: in his case it is a night-world of naked bodies, ruins and disaster. These are images of vulnerability – the figures are usually very young – suggestive of tragedy or some kind of evil, but always stopping short of the specificity that could allow us to apply a simple moral analysis. At the 164

162 Anne Zahalka
The Bathers 1989–90

same time these images have often been juxtaposed with others, evoking the comfort and security of high culture, and this exacerbates our malaise about the position and involvement of those who witness these things – that is the photographer and ourselves, the viewers. We are all drawn into a dangerously ambiguous territory between journalistic voyeurism and the institutional respectability of serious art.

These few may stand for the scores of postmodernists who flourished in the eighties, and who had more or less technical ability, more or less conceptual originality in their subjects and styles, more or less of those ineffable qualities which make a picture, in spite of everything, appealing. But most of them suffered, in exacerbated form, the same problem that had already afflicted their modernist predecessors: because they were entirely responsible for inventing subject *and* style, and because now 'conceptual' invention was everything, there was enormous pressure to find an 'idea' early on, often when they were very young. Frequently this 'idea' did not allow for real development, and so we witnessed either the gradual exhaustion of the idea (presented by publicists as a 'refining' process), or else, *in extremis*, the leap to a completely different one.

At the same time, with the spread of the art market and art publishing, the glossy magazine – Australian or preferably international – became the real place of 'exhibition', and the three weeks in an inner-city gallery only a phase in the cycle of marketing. But in this new

198

163 *(right)* Fiona Hall
*Inferno, Canto XIII:
The Forest of the Suicides*
from the *Illustrations to
Dante's Divine Comedy*
series 1988

164 *(below)* Bill Henson
Untitled 1983–84

forum, where hundreds of different works appeared anonymously side by side, the competition for attention was ruthless. Your 'idea' had to be striking enough to make the bored professional – perhaps the director of a foreign Biennale – stop turning the pages for a second look; and this idea, if it made any impact, became a trademark which it was dangerous to abandon.

Postmodernism, then, has been the most historically characteristic style of the period immediately preceding the time of the writing of this book – the one which obviously responded to and embraced the new historical conditions in which Australia is as involved as the rest of the world. The greatest fault of the postmodernists is that they embraced the 'postmodern' world too eagerly. Warhol saw that Pop was not just a criticism of the 'pop' world – *Pop is liking it*; similarly,

165 (left)
Peter Booth *Painting 1971*

166 (below)
Peter Booth *Painting 1982*

167 Peter Booth *Painting 1977*

168 Peter Booth *Winter 1993*

postmodernism in art has been guilty of liking the postmodern world too much and being unwilling or unable to criticize it. The strength of modernism was that so much of it was a protest against the modern world. Postmodern relativism and irony had a corrosive effect on political and cultural authority of all kinds, and thus attracted many who felt excluded by established authority. But these cultural refugees were deceived: the postmodern world is not ruled by authority but by power; the paradox is that in eroding the possibility of authority, postmodern culture has damaged our defences against the brutality of unregulated power. The inadequacies of postmodernism are nowhere more evident than in its love affair with the commercial mass media. Refusing to see that this was not the same thing as popular culture, postmodernism has often been guilty of collaboration with the most dehumanizing forces in the contemporary cultural environment.

Beyond aesthetic or moral judgment, however, postmodernism has also had an important influence on the question I have taken as the Ariadne's thread of Australian art history, that of effectively inhabiting this place. It has put an end to dreams of escaping the geographical-historical construction called 'Australia' and soaring towards the pure ether of an absolute art history. But it has also produced a systematic suspicion of all those 'myths' that used to be regarded as the peculiar achievement of Australian art in adapting itself to its foreign environment. Not only the honest selector, but even his shadow, the bushranger, have been disqualified, or so relativized as to no longer be living presences in the contemporary imagination. This is not a matter for blame. It is, as Nietzsche wrote long ago, the disadvantage – the *Nachteil* – of history to destroy the power of myths. European culture is essentially historical; and postmodernism is really the period in which our sense of history, after going through various phases in the nineteenth and early twentieth centuries, has caught up with us.

This aspect of postmodernism has specific consequences for Australia. We are ostensibly free to leave, but there is nowhere to go to, since there is no longer a 'centre'. At the same time the freedom to leave is only apparent, for as even Tillers has shown, certain relations to the world and to cultural tradition are ingrained in the minds of those who have been born in a country or lived there long enough. One can appreciate the many beauties of Australia, and enjoy life in the great cosmopolitan cities, but there is rarely an absolutely necessary sense of relation to place. The postmodern experience of Australia is of a homelessness without angst.

169 Mike Parr, two etchings from the *12 Untitled Self-Portraits (Set 1)* series 1989

But beside those artists who have sought to represent the 'current of history' and to articulate the postmodern condition, there have been others whose relation to contemporary doctrines has been less programmatic, or whose interpretation of history has been significantly different. Prominent among them is Parr, whose work has for some years consisted largely of self-portrait studies. These works are an act of resistance to what he calls 'photodeath': literally the reification of the human features by photography, but by extension the potential reduction of any objective representation. Photography is really a metaphor for the reification of the human person imposed by social rules and institutions, and internalized as the superego. Such a fusion of Marxian and Freudian themes helped to produce the crisis of legitimacy of postmodernism, but Parr does not adopt the same means as the postmodernists. In effect he is concerned with what has always been the problem of representation, but he pursues this question in the light of modernist psychological and political theory. Technically, too, he draws on the modernist critique of the mimetic techniques developed by the Renaissance, and of their *reductio ad absurdum* in the age of photography. It is this metaphysical and moral conundrum that accounts for the distortion of his self-portraits, rather

170 *(above)* Susan Norrie
Fruitful Corsage, Bridal Bouquet, Lingering Veils 1983

171 *(left)* Allan Mitelman
Untitled 1993–94

172 Rosalie Gascoigne *Monaro* 1989

173 Robert Hunter *Untitled* 1992

174 Hossein Valamanesh
Untouchable 1984

than an expressionistic desire to reveal inner torments. Anamorphic and other perturbations of objective rendering present features glimpsed in motion, not grasped once and for all.

Parr is critical of 'the post-modernist idea that you pick up ... fragments and create [a] fetching montage' and identifies the danger of 'dandyism' in these sophisticated games. Another important artist who continues to build on a critical modernist tradition and who refuses to believe that inherited or imported images have become our *prima facie* reality is Peter Booth. His evolution is particularly interesting, for he was among the artists represented in 'The Field' exhibition – the triumph of colour-painting in 1968. His pictures from that period, such as *Painting 1971*, are at once extraordinarily severe in their exclusion of any mimetic content, and yet allow a little painterly life to stir at the edges of the immense stillness. After the collapse of this movement in the seventies, Booth stopped painting altogether for a time. Then gradually he began to draw, and was surprised at the images that started to emerge. At the 1979 Biennale he reappeared transformed – as though emerging from a metamorphosis – with *Painting 1977*, a large canvas in which the viewer was confronted by a solitary figure with a white dog, standing in a landscape of Beckettian desolation. Here was not only the 'rebirth' of painting, but a work that stood head and shoulders above most other Australian artists of the seventies, not to speak of the German Neo-Expressionists and Italian Neo-Symbolists who soon became fashionable.

During the eighties, Booth's pictorial world developed and he produced a series of intense and frightening allegories with no easy key. There were hysterical crowds surrounding a monstrous, blindfolded leader; there were more wastelands populated by cripples and monsters. 'The place called the Id ...,' he said in 1985, 'is essentially what interests me, and the path I have taken is to find this landscape inside the brain.' Unlike the postmodernists, Booth believes in the possibility of direct access to the subjective. But if personal anxieties enter into the making of these works, the landscape of the Id to which the artist pursues them is situated below the level of individual personality. And at the same time, the artistic language he employs, which owes much to both Goya and the late work of Philip Guston, is ideally suited to articulating that landscape as a social metaphor. These pictures of violence and irrationality are also allegories of historical experience.

Booth's latest works, however, suggest another deep change in his outlook or in his relationship to his time and place. Towards the end of the eighties the crowd scenes gave way to desolate, stony wastes.

175 Jan Senbergs *Sticht's Smelters, Penghana 2* 1982

Then, in the early nineties, a vast empty forest appeared, filled with 168
snow. Forests in the snow are not of course unknown in Australia, and
yet they are a deeply uncharacteristic subject in the history of
Australian art. But almost any other landscape subject would carry
with it an excessive load of associations; forests in the snow are inno-
cent of historical memories and suggest a withdrawal from the scene
of history.

History and place are always intimately involved in the work of
Jan Senbergs (b. 1939): place is shaped, even deformed by human
intervention. Among his most characteristic and memorable works is
Sticht's Smelters, Penghana 2 (1982), a study of mines in the notorious
Tasmanian city of Queenstown. Here there is none of Ethel Spowers's 83
(1890–1947) futuristic enthusiasm for the efficiency of industry:
Spowers's simple dynamic forms are replaced by an incomprehensible
tangle of perhaps obsolete scaffoldings and conveyor belts. But
Senbergs never assumes a moralizing tone: there is at once a matter
of factness and a fantasmagoric quality to these images, which make
them emblematic of human ambition and the wasteland it can
produce.

176 Simone Mangos *Tolling Läuten* installation at Künstlerhaus Bethanien, Berlin, May 1989, showing (*left*) morning view and (*right*) evening view

177 Simone Mangos *Sounding* installation at the Bond Store, Eighth Biennale of Sydney, April 1990

In a more familiar setting, Ken Whisson (b. 1927) too is concerned with the historically shaped landscape. He suggests the fragmented, disconnected space of suburban life partly by the simple device of including several vertically stacked perspectival spaces in the same composition. The first effect of a Whisson picture is often of a rough-ly gridlike arrangement, but the image defies analysis into either the old grid of perspectival space or the modernist grid of the flat surface. He evokes a world in which the settler's fencing has become illogical, arbitrary and merely divisive. In contrast, the early work of Susan Norrie (b. 1953), like that of Booth, depicted an inner world of sub-jective experience: in her case a mysterious world of feminine allu-sions in forms and colours that evoked undersea flora. In 1987 she 170 became the first winner of the Moët & Chandon Prize, the highest for contemporary art in Australia.

Another artist whose relation to history is highly ambiguous is Rosalie Gascoigne (b. 1917). Her work is based on a kind of bricolage, using found materials but imposing on them a thorough transforma-tion, which ends up being a profound meditation on the nature of mimesis. Gascoigne's materials have typically undergone two stages of formation before she begins her own process. They are old Schweppes drink-crates, for example, or fluorescent road signs with banal messages like 'WORKMAN AHEAD' – both of these materials are usually yellow, a favourite colour – or else corrugated iron, the com-mon material of building in the outback. These materials, then, were industrially produced in the first place, but do not interest the artist until they have been battered by use and worn by exposure to the ele-ments. Then they have somehow become part of the order of nature, like ruins. Discarded, Gascoigne collects them, cuts them up and assembles them into new forms.

The road signs are put together into rows of letters that resist the mind's instinct to decode words, to *read* them, even though sometimes we are allowed to guess the word a letter may once have belonged to; it is as though by provoking and yet frustrating at the same time the immensely powerful, if not (in a literate person) dominant mechanism of verbal recognition, Gascoigne forces that faculty into abeyance and makes us rediscover the silence of the visual.

The same silence is imposed by the wooden drink-crates, cut into slivers so that the words are made more or less unrecognizable; these slivers are reassembled with a flexibility and organic movement that once belonged to the tree from which the timber was cut, but was entirely suppressed in the humble and functional drink-crate. In her

172 most important work of this series, *Monaro* (1989), Gascoigne has turned her unpromising material into an abstract composition of great beauty which unexpectedly evokes a great wheat-field in the wind.

Silence seems to be a particular quality of much of the best work made in Australia in this period, in spite of the unprecedented torrent of verbiage that has surrounded the exhibition and publication of art. It is a response to the disconnection of art from the public, from any community other than the more or less professional community of the art world itself, in the circuit of production and reception. Artists sense that they can neither speak for nor to their society; this does not mean that they have nothing to say, but it does mean that they are reduced largely to speaking for themselves, which is very much like an actor forced to perform without an audience. An actor is someone whose whole art consists of knowing how to speak to an audience, how to communicate certain things to them; and that inevitably means speaking for them too. An actor cannot perform without an audience.

For the artist as for the actor, the speaking for and speaking to are intimately connected. When artists can no longer speak for a public, they can no longer speak to a public either – what is lost is the dimension of *public* address. Reduced to speaking for themselves, their art tends to address us individually; we feel that meaning is produced, as it were, in a one-to-one exchange. This is why so much of the best contemporary art is relatively modest in scale, and demands our quiet, solitary attention. It is also why such work may seem out of place when transported to the big public galleries of contemporary art which have sprung up all over the world in the last two decades – or when thrust into the trade-fair cacophony of a Biennale.

171 Allan Mitelman's (b. 1946) abstract paintings, for example, have nothing in common with the inflated vacuities of certain very big abstract pictures designed to adorn office foyers. Mitelman's work is at once dense and minimal, forcing the viewer to enter into a close tête-à-tête if anything is to be seen at all. These are not pictures to be glanced at over someone's shoulder at an opening, nor do they lend themselves well to reproduction. But attention is rewarded by the subtlety with which matter is balanced against form – the matter of paint itself, rich in its amorphous variety, and the form of almost imperceptible compositional structure; as simple and yet as fundamental a dialectic as could be wished for, and above all one which is to be experienced in its untranscribable immediacy.

If Mitelman's work demands attention above all, that of Brian Blanchflower (b. 1939) invites us to lose ourselves in something vaster

than we can comprehend. *Canopy XXVIII...* (1993) is based on a simple combination of regular and random marks, and is executed on a monumental scale, so that it evokes a sense of being locally in constant flux but ultimately undifferentiated. It seems to invite minds overstrained by the manipulated anxieties of contemporary life to open themselves to what Rousseau called the 'sentiment de l'existence'. Other artists too evoke the quest for emptiness with quite different means, like Robert Hunter (b. 1947) whose apparently white paintings reveal prismatic compositions of the subtlest tones as soon as we give them the time they need to become visible. The best contemporary work often exhibits this kind of built-in defence against the lazy and inattentive habits of 'art-lovers'. 173

Although her work is at the opposite pole from Mitelman's or Blanchflower's temperamentally, Aida Tomescu's (b. 1955) painting makes a similar demand on the viewer's attention, and draws us into the intense concentration of its own making. If Mitelman's work, for example, is built up through a gradual, almost meditative process, Tomescu's starts with energy and movement and seems to be trying to do the near-impossible – to reach stillness from such a starting-point. Here gesture itself drags matter into shape – sometimes gesture still as recognizable as handwriting, but often so overlaid in the struggle that dense masses are formed, and the colours with which the composition may have begun turn to monochrome, tonal bodies of paint. Yet somehow in the end she achieves her paradoxical aim: a balance of movement and stillness. The hyperactive contemporary mind, overfed with 'information', talks itself into silence. Tomescu's case (which may stand for others) shows that valuable work can be done with a style that is neither 'new' nor self-consciously a neo- or post- version of itself. 178

Hossein Valamanesh (b. 1949) demonstrates further that outstanding work may come from outside the field of contemporary styles – so often saturated with self-conscious reference – and even from beyond the range of a familiar cultural tradition. Valamanesh was born in Iran, and many of his works allude to the rich tradition of Persian poetry. But his work communicates through an exceptional sense of his materials and of the ideas that he intends to articulate. So sure is his grasp of both that he moves effortlessly between painting, printmaking, sculpture and installation without a break in focus. A work like *Untouchable* (1984), for all its specifically Persian sources, speaks of the same concern for attention and equilibrium that we have found in other contemporary Australian artists. 174

There are many other artists who would deserve discussion in a longer book: painters as different as William Robinson (b. 1936), who in his best works has renewed the picturing of the Australian landscape; John Nixon (b. 1949), who made a career of repeating the unrepeatable, and repainted Malevich's black cross; or Dale Frank (b. 1957), who finds a paradoxical beauty in pushing to the extreme his derision of avant-garde styles like gestural abstraction – in such a work as *The Long Stunning Death of the Premature Ejaculator ...* (1995) the flat surface of the modernist painting and the transparent surface of the pre-modernist both seem to collapse together in the mass of resinous varnish that runs heavily down the canvas.

Many sculptors and installation artists could be mentioned too: Ken Unsworth, whose objects always seem to retain a performative quality; Richard Goodwin (b. 1953), the author of some memorably theatrical figures; Ari Purhonen (b. 1953), the laconic and yet elaborate conceptualist; the lyrical Bronwyn Oliver (b. 1959); the unpredictable Adrian Hall (b. 1943), whose 1989 installation *Mondo Faxo* involved artists and other friends from all over the world sending

texts and images into an empty room which was soon papered with them; Michael Esson (b. 1950), who has expressed his Scottish fascination with the body and medical science in sculpture, mixed-media works, prints and now paintings; Bruce Armstrong (b. 1957), with his deceptively simple beasts carved from monumental blocks of timber; Victor Meertens (b. 1955), who constructs massive figural shapes from beaten corrugated iron over a wooden armature; and Robert MacPherson (b. 1937), the author of enigmatic installations juxtaposing, for example, the scientific names of tropical frogs with rows of camp beds, as though to make us ponder the gulf between words and things.

Among a number of women installation artists, including Carol Rudyard (b. 1922), Joan Brassil (b. 1919), Janet Laurence (b. 1949) and Jennifer Turpin (b. 1958), Simone Mangos (b. 1959) stands out for the lucid directness of her work. There is something at once romantic and conceptual in her use of archetypal materials such as salt, in an early sculptural work (1985), honey in an installation which drew bees into the gallery, or honey and ash in a work commissioned for the

178 *(above)* Aida Tomescu *Seria Unu I, II, III, IV* 1993

Bicentennial Perspecta of 1987–88 which included the charred trunk of an uprooted tree. In each of these pieces, Mangos used her elemental materials in ways that involved a sense of the passage of time; in her later *Tolling Läuten*, made in Berlin in 1989, she juxtaposed the natural time of the sun's daily cycle with the historical time implied by a collection of ruins from a Nazi bunker.

176

For the Biennale of 1990 Mangos constructed a grid-like barrier of chalk-sticks in a doorway leading from one part of the old warehouse where the exhibition was held into another part which was not being used and was still full of old machinery. The chalk itself was natural in substance but industrial in form, the barrier meticulously constructed but almost as vulnerable as a house of cards and the whole work presented itself as no more than the ambiguous screen that divided the consecrated space of the exhibition from the unhallowed, unlooked-at world of 'reality' beyond. The idea of art as a screen, as something looked through, recurred in a work shown in Berlin (where the artist now lives) but not in Australia. It consisted of a series of old windows salvaged from demolitions, leaning up against each other until the layering of glass became opaque.

177

The theme of opacity, like that of silence, brings us back once again to the solitude of the aesthetic experience, to the barely audible, the minimally communicable. This sensibility is an important factor in the increasing attention given to Aboriginal art during the last decade and a half. Aboriginal art assumed a new form during this period, after a young art advisor, Geoffrey Bardon, introduced acrylic paints to the people of Papunya in the Western Desert in 1971, and they began to paint in durable form the designs that had since ancient times been laid out in coloured ochres in the sand on the occasion of ceremonies. Aboriginal art, which had until then consisted in the eyes of the public largely of stylized animals painted on bark, suddenly appeared in a deceptively contemporary form as colourful, dynamic 'abstract' designs. Of course they are not abstract at all, but symbolic and spiritual maps of the land.

This 'new' Aboriginal art made a profound impact on Australia first of all, and then on international art markets. A new authenticity had been discovered, which was seized on by an art world desperate for the authentic, and with a bulimic appetite for novelty. In Australia the attitude towards Aboriginal art was especially charged with political associations: it was evidence that Aboriginal culture was still alive, in spite of two centuries of fragmentation and, in some parts of the country, almost complete breakdown. State museums and galleries, in

purchasing it, seemed to be making an act of reparation for past wrongs, and there was no doubt that the production and selling of paintings contributed both to the self-respect and material well-being of the communities involved. But it was also clear that Aboriginal art was much more than a school of painting for which one could have greater or lesser regard. It had become the latest avatar of the Aborigine in European Australian culture.

We have already seen the special place of the Aborigines in colonial art, their disappearance from Heidelberg painting, their occasional reappearances between the wars (including Preston's interest in Aboriginal art), their absence in the Angry Penguins period (with the exception of Bergner), their importance in the work of Boyd and Drysdale. They could not have any place in the abstract art that followed the war, if we except the oblique connection with Fairweather and Tuckson. They naturally reappear in the politically and socially concerned imagery from the seventies onwards, but then it is as the victims of injustice that must be righted. The success of Aboriginal art, however, allowed the Aborigines once again to occupy something like the symbolic place they had in colonial art and again in the art of Boyd and Drysdale, as the representatives of a natural belonging in this land, the bearers of an essential knowledge of Australia.

This rehabilitation led to various confusions, like the declaration, in the Bicentennial year 1988, that an ensemble of Aboriginal paintings was something like the Parthenon of Australia. There is no doubt that this assimilation was motivated by genuine enthusiasm and good-will, but it risks trivializing both terms of the comparison; each arises out of a past and has consequences for a future that are extremely complex and profoundly different. Aboriginal culture is not our culture – neither in the sense that we own it nor that we belong to it. We are often forced to recognize the foreignness even of cultures that are close to our own; but nothing is more foreign to our every habit of mind, value and custom than Aboriginal culture. The fact that we can appreciate the beauty of Aboriginal art is an immense testimony to the fraternity of the human race and to the power of art to reach deep into the heart, and to glimpse what lies beyond the limits of culture. But we should beware of thinking that we *understand* Aboriginal art in anything like the way we understand our own. That is why Aboriginal art has had, practically speaking, no effect on contemporary Australian art; it can only – once again – stand for an experience of belonging that is the antithesis of our own sense of homelessness, and which for us remains a dream.

TIMELINE (durations indicated are approximate)

1800 **1850** **190**

Groups, Movements and Styles

Early Colonial (from 1788)

High Colonial

Heidelberg School

Influential Artists

Duterrau, Benjamin	**Lewin**, John	**Buvelot**, Louis	**Longstaff**, John
Earle, Augustus	**Lycett**, Joseph	**Chevalier**, Nicholas	**McCubbin**, Frederick
Evans, G. W.	**Martens**, Conrad	**Conder**, Charles	**Roberts**, Tom
Glover, John		**Davies**, David	**Streeton**, Arthur
		Fox, Emanuel Phillips	**Strutt**, William
		Guérard, Eugène von	**Sutherland**, Jane
		Long, Sydney	**Withers**, Walter

Important Events

1770 • Cook discovers the east coast of Australia
 • Aboriginal population probably under 500,000
1787 • The First Fleet sails from England, 13 May
1788 • Captain Phillip raises Union Jack at Sydney Cove, 26 January
1801 • Matthew Flinders circumnavigates continent (1801–03)
1803 • Settlement of Van Diemen's Land (Tasmania)
1807 • Abolition of the slave trade in the British Empire
1810 • Lachlan Macquarie becomes Governor (1810–21)
1815 • Road built across Blue Mountains
1817 • Macquarie first uses the name 'Australia' in official correspondence
1824 • Colony of Brisbane founded as a convict town
1827 • Hobart Mechanics Institute founded
1829 • Perth founded as a free town (later accepted convicts because of inadequate immigration)
1833 • Sydney Mechanics' Institute founded (by 1851 MIs in every capital)
1835 • Melbourne begins as a village
1836 • Adelaide founded as a free town with ambitious urban layout
1837 • Canadian rebellion provokes movement to self-govt of colonies
1838 • Massacre of Aborigines at Myall Creek; seven Europeans tried and hanged
 • Melbourne cricket club founded
1840 • Transportation of convicts to NSW ends
1841 • Economic depression begins (ends 1843)
1843 • Legislative Council established in NSW
1847 • Society for the Promotion of Fine Arts founded under presidency of Sir Charles Nicholson; first exhib. at the Australian Library, Sydney, in June

1850 • Foundation of the University of Sydney
 • Total European population of Australia around 405,000
 • Principal colonies invited to draft constitutions for self-govt
 • First railways built
1851 • Gold discovered in Victoria; gold rush in NSW and Victoria
 • Victoria separates from NSW
1854 • Eureka Revolt in Ballarat
1859 • Queensland becomes an independent colony
 • Foundation of the Sydney Mechanics' School of Arts (now the National Art School)
1863 • Fine Arts Commission, Melbourne, establish prize of £200 for purchase of a painting by an artist resident in Australia
1865 • Fine Arts Commission prize awarded to Chevalier for *The Buffalo Ranges*
1868 • Transportation of convicts ends with last arrival in Western Australia; a total of 163,000 convicts had come to the colonies
1870 • National Gallery School founded
1874 • Marcus Clarke, *For the Term of his Natural Life*
1877 • Australia's population exceeds 2 million
1880 • Sydney *Bulletin* founded
1887 • First National Gallery School Travelling Scholarship
1889 • '9 by 5' exhib., Melbourne
1891 • Womanhood Suffrage League founded in Sydney
1893 • Financial panic and run on the banks
1894 • Melbourne music conservatorium founded
1895 • 'Banjo' Paterson writes words of 'Waltzing Matilda'
1899 • Australian troops to the Boer War

Groups, Movements and Styles

Post-Heidelberg

Early Modernism

Angry Penguins

Post-War Modernism

Abstraction

Late Modernism

Post-Modernism

Influential Artists

Boyd, Arthur
Cossington Smith, Grace
de Maistre, Roy
Dobell, William
Drysdale, Russell
Gleeson, James
Hester, Joy
Heysen, Hans

Hinder, Frank
Hoff, Rayner
Lambert, George
Lindsay, Lionel
Lindsay, Norman
Nolan, Sidney
Preston, Margaret
Tucker, Albert
Wakelin, Roland

Booth, Peter
Brack, John
Burn, Ian
Fairweather, Ian
Henson, Bill
Hickey, Dale
Klippel, Robert

Lynn, Elwyn
Olsen, John
Parr, Mike
Tillers, Imants
Tuckson, Tony
Unsworth, Ken
Williams, Fred

Important Events

1901 • Federation of six states to form the Commonwealth of Australia
 • Sarah Miles Franklin, *My Brilliant Career*
1904 • Federal law enforces the arbitration of industrial disputes
1914 • First World War (1914–18)
1915 • ANZAC landing at Gallipoli
1916 • *Art in Australia* launched by Sydney Ure Smith (edits it until 1938)
1919 • Raymond Hollis Longford directs *The Sentimental Bloke*
1927 • Federal capital moves from Melbourne to Canberra
1932 • Opening of Sydney Harbour Bridge
 • Australian Broadcasting Commission (ABC) established
1934 • William Moore, *Story of Australian Art*
1937 • Formation of Australian Academy of Art
1938 • Formation of the Contemporary Art Society
1939 • Melbourne *Herald* exhib. (*French and British Contemporary Art*)
 • Second World War (1939–45); Australian troops sent to the Mediterranean
 • Radio Australia begins broadcasting overseas
 • 'Exhibition I', Sydney
1942 • Japanese bomb Darwin
1945 • Bernard Smith, *Place, Taste and Tradition*
1946 • Mass European migration launched
1947 • The Contemporary Art Society, Victoria, suspends activities
1949 • Robert Menzies becomes PM (1949–66)

1950 • Australian troops to the Korean War (1950–53)
1956 • Olympic Games held in Melbourne
1959 • The 'Antipodean' exhib., Melbourne
1960 • 'Australian Aboriginal Art' exhib., Sydney and state galleries
1962 • Australian troops to the Vietnam War (1962–72)
 • Bernard Smith, *Australian Painting*
1963 • *Art and Australia* founded
 • Tate Gallery exhib. of Australian Art, London
1966 • Census counts *c*. 80,000 Australians of half- or full Aboriginal ancestry
1968 • 'The Field' exhib., Melbourne
1972 • Gough Whitlam leads Labor Party to victory (PM, 1972–75)
1973 • Opening of the Sydney Opera House
 • Patrick White wins the Nobel Prize for Literature
 • First Biennale of Sydney
1975 • Malcolm Fraser wins a landslide for the Liberals
 • Peter Weir directs *Picnic at Hanging Rock*
1976 • Fed. Govt grants Aborigines large areas of land
1981 • First Australian Perspecta exhib., Sydney
1982 • National Gallery opened in Canberra
1983 • Fraser defeated by Bob Hawke (Labor, 1983–91)
1984 • 'Futur★Fall' conference at Sydney University
1985 • Ayers Rock (Uluru) returned to Aborigines
 • 'Golden Summers – Heidelberg and Beyond' exhib., toured Australia
1988 • 'Terra Australis: The Furthest Shore' exhib., Sydney
 • 'The Great Australian Art Exhibition 1788–1988', toured Australia
1991 • Paul Keating deposes Hawke as Labor PM (1991–96)
 • Museum of Contemporary Art opened
1992 • Mabo Case: High Court finds Native Title was not extinguished by arrival of British in 1788
1994 • Native Title Act
1996 • Keating defeated by John Howard (Liberal)
1997 • Wik Case: High Court finds Native Title not necessarily extinguished by pastoral leases

Select Bibliography

General histories and reference works

Blainey, Geoffrey, *A Shorter History of Australia*, Melbourne: Mandarin, 1995

Burn, Ian, *Dialogue: Writings in Art History*, Sydney: Allen and Unwin, 1991

Flannery, Tim, *The Future Eaters: An Ecological History of the Australasian Lands and Peoples*, Melbourne: Reed Books, 1994

Hughes, Robert, *The Art of Australia*, Harmondsworth and Melbourne: Penguin, 1966, rev. ed. 1970, reprinted 1987

Kerr, Joan, ed., *The Dictionary of Australian Artists, Painters, Sketchers, Photographers and Engravers to 1870*, Melbourne: Oxford University Press, 1992

McCulloch, Alan, *The Encyclopedia of Australian Art*, rev. ed. Susan McCulloch, Sydney: Allen and Unwin, 1994

Sayers, Andrew, *Drawing in Australia: Drawings, Water-colours, Pastels and Collages from the 1770s to the 1980s*, Canberra: Australian National Gallery, and Melbourne: Oxford University Press, 1989

Smith, Bernard, *The Antipodean Manifesto: Essays in Art and History*, Melbourne: Oxford University Press, 1976; ed., *Concerning Contemporary Art: The Power Lectures 1968–1973*, Oxford: Clarendon Press, 1975; ed., *Documents on Art and Taste in Australia, the Colonial Period, 1770–1914*, Melbourne: Oxford University Press, 1975, reprinted 1990; *European Vision and the South Pacific*, New Haven, Conn., and London: Yale University Press, 1985, and Sydney: Harper & Row, 1984; *Place, Taste and Tradition: a Study of Australian Art since 1788*, 1st ed. Sydney: Ure Smith, 1945, and Melbourne: Oxford University Press, 2nd ed. 1979, reprinted 1988; *The Spectre of Truganini* (the 1980 Boyer Lectures), Sydney: The Australian Broadcasting Commission, 1980; and Terry Smith,

Australian Painting 1788–1990, Melbourne: Oxford University Press, 1st ed. 1962, 2nd ed. 1971, 3rd ed. 1991 [the three additional chapters on painting since 1970 were written by T. Smith for the 1991 edition]

White, Richard, *Inventing Australia: Images and Identity 1688–1980*, Sydney: George Allen and Unwin, 1981

Studies of particular periods

Bonyhady, Tim, *Images in Opposition: Australian Landscape Painting 1801–1890*, Melbourne: Oxford University Press, 1985, reprinted 1991

Burn, Ian, *National Life and Landscape: Australian Painting 1900–1940*, Sydney: Bay Books, 1990

Catalano, Gary, *The Years of Hope: Australian Art and Criticism 1959–1968*, Melbourne: Oxford University Press, 1981

Eagle, Mary, *Australian Modern Painting Between the Wars 1914–1939*, Sydney: Bay Books, 1989

Haese, Richard, *Rebels and Precursors: The Revolutionary Years of Australian Art*, Melbourne: Allen Lane, 1981

Heathcote, Christopher, *A Quiet Revolution, the Rise of Australian Art 1946–1968*, Melbourne: The Text Publishing Company, 1995

Radford, Ron, and J. Hylton, *Australian Colonial Art 1800–1900*, Adelaide: Art Gallery of South Australia, 1995

Taylor, Paul, ed., *Anything Goes: Art in Australia 1970–1980*, Melbourne: Art & Text, 1984

Topliss, Helen, *The Artists' Camps: 'Plein air' Painting in Australia*, Melbourne: Hedley, 1992

Exhibition catalogues

Clark, Jane and B. Whitelaw, *Golden Summers: Heidelberg and Beyond*, Melbourne: International Cultural

Corporation of Australia and National Gallery of Victoria, 1985

Dixon, Christine, and T. Smith, *Aspects of Australian Figurative Painting 1942–1962: Dreams, Fears and Desires*, Sydney: Power Institute, 1984

Hansen, David, *The Face of Australia*, Sydney: Australian Bicentennial Authority, 1988

Harris, Max, et al., *Angry Penguins and Realist Painting in Melbourne in the 1940s*, London: South Bank Centre, 1988

Merewether, Charles, *Art and Social Commitment: an End to the City of Dreams, 1931–1948*, Sydney: Art Gallery of New South Wales, 1984

Thomas, Daniel, ed., *Creating Australia: 200 Years of Art, 1788–1988*, Sydney: International Cultural Corporation of Australia, and Adelaide: Art Gallery of South Australia, 1988

Apart from the many monographic catalogues on individual artists, the catalogues of regular survey exhibitions are useful material for the most recent decades:
Biennale of Sydney, published by the Biennale of Sydney (1973, '76, '79, '82, '84, '86, '88, '90, '92, etc.); Australian Perspecta, published by the Art Gallery of New South Wales (1981, '83, '85, '87, '89, '91, etc.); Australian Sculpture Triennial, held at the National Gallery of Victoria from 1984 (1981, '84, '87, '90, '93, etc.)

Art periodicals

Art in Australia (1916–42); *Art and Australia* (1st vol. 1963); *Art & Text* (1st vol. 1981); *Artlink* (1st vol. 1981); *Australian Art Monthly* (1st vol. 1987); *The Sydney Review* (1988–96). In addition, important critical discussions appear in such newspapers as *The Sydney Morning Herald*, *The Age*, *The Australian*, *The Bulletin* and *The Australian Financial Review*

List of Illustrations

Measurements are given in centimetres, followed by inches, height before width before depth

Cover Arthur Boyd *Flood Receding in Winter Evening* 1981 (detail). Oil on canvas 122 × 152.5 (48 × 60). Private collection, Melbourne. Photo: The Art Gallery of New South Wales, Sydney
Frontispiece (detail) and **115** Russell Drysdale *The Rabbiters* 1947. Oil on canvas 75.4 × 100.8 (29¼ × 39¼). National Gallery

of Victoria, Melbourne. Purchased 1947
1 Port Jackson Painter *A Native Going to Fish with a Torch and Flambeau while his Wife and Children are Boiling Fish for their Supper c.* 1795. Watercolour 26.7 × 42.6 (10½ × 16¼). The Natural History Museum Picture Library, London
2 George Raper *Gum-Plant and Kangooroo of New Holland* 1789. Ink and watercolour 46 × 32.5 (18¼ × 12⅞). The Natural History Museum Picture Library, London
3 John Lewin *Two Kangaroos in Landscape*

1819. Watercolour 39.5 × 56.5 (15½ × 22¼). National Library of Australia, Canberra. Rex Nan Kivell Collection
4 William Blake after Thomas Watling *A View of the Town of Sydney in the Colony of New South Wales* 1802. Aquatint, engraving, hand coloured on paper 24 × 41.5 (9½ × 16¼). Art Gallery of South Australia, Adelaide. South Australian Government Grant 1987
5 John Lewin *Fish Catch and Dawes Point, Sydney Harbour c.* 1813. Oil on canvas

86.5 × 113 (34 × 44½). Art Gallery of South Australia, Adelaide. Gift of the Art Gallery of South Australia Foundation and S. A. Brewing Holdings Ltd on the occasion of the Company's Centenary 1988
6 Augustus Earle *A Bivouac of Travellers in a Cabbage-Tree Forest c.* 1838. Oil on canvas 118 × 82 (46½ × 32¼). National Library of Australia, Canberra. Rex Nan Kivell Collection
7 George Raper *View of the East Side of Sydney Cove, Port Jackson c.* 1790. Ink and watercolour 31.7 × 47.4 (12½ × 18⅝). The Natural History Museum Picture Library, London
8 G. W. Evans *Blighton Farm* 1810. Watercolour on paper 18.6 × 26.6 (7⅜ × 10½). Reproduced by permission of the National Gallery of Australia, Canberra
9 Joseph Lycett *Raby, a Farm Belonging to Alexander Riley Esq c.* 1820. Watercolour on paper 20.9 × 24.8 (8¼ × 9¾). Reproduced by permission of the National Gallery of Australia, Canberra
10 John Glover *My Harvest Home* 1835. Oil on canvas 76.2 × 113.9 (30 × 44⅞). Tasmanian Museum and Art Gallery, Hobart
11 John Glover *A View of the Artist's House and Garden, in Mills Plains, Van Diemen's Land* 1835. Oil on canvas 76.4 × 114.4 (30 × 45). Art Gallery of South Australia, Adelaide. Morgan Thomas Bequest Fund 1951
12 Eugène von Guérard *North-East View from the Northern Top of Mount Kosciusko* 1863. Oil on canvas 66.5 × 116.8 (26⅛ × 46). Reproduced by permission of the National Gallery of Australia, Canberra
13 Eugène von Guérard *Stony Rises, Lake Corangamite* 1857. Oil on canvas 71.2 × 86.4 (28 × 34). Art Gallery of South Australia, Adelaide. Purchased with assistance of the Utah Foundation through the Art Gallery of South Australia Foundation 1981
14 William Strutt *Black Thursday, February 6th, 1851* 1862–64. Oil on canvas 106.7 × 342.9 (42 × 135). La Trobe Picture Collection, State Library of Victoria, Melbourne. Purchased with State Government funds 1954
15 Benjamin Duterrau *The Conciliation* 1840. Oil on canvas 12.1m × 17m (39.7 ft × 55.8 ft). Tasmanian Museum and Art Gallery, Hobart
16 Benjamin Duterrau *(left) The Manner of Straightening a Spear and (right) Cheerfulness* 1835. Oil on plaster, each 33 × 26 (13 × 10¼). Royal Society of Tasmania
17 Benjamin Law *Bust of Trucaninny, Wife of Woureddy* 1835. Painted plaster cast 56 × 42.5 × 25.7 (22 × 16¾ × 10⅛). Reproduced by permission of the National Gallery of Australia, Canberra
18 Benjamin Law *Bust of Woureddy, an Aboriginal Chief of Van Diemen's Land* 1836. Painted plaster cast 75 × 48.4 × 27 (29½ × 19 × 10⅝). Reproduced by permission of the National Gallery of Australia, Canberra
19 Augustus Earle *Wentworth Falls c.* 1830. Oil on canvas 71 × 83.2 (28 × 32¾). National Library of Australia, Canberra. Rex Nan Kivell Collection
20 Augustus Earle *Natives of New South Wales as seen in the Streets of Sydney* from *Views in*

New South Wales and Van Diemen's Land 1830. Lithograph, hand coloured with watercolour on paper 28 × 38.6 (11 × 15¼). Art Gallery of South Australia, Adelaide. J. C. Earl Bequest Fund 1994
21 Conrad Martens *Fall of the Quarrooille (FitzRoy Falls), near Throsby Park, Bong Bong* 1836. Watercolour 43.5 × 63.2 (17⅛ × 24⅞). Private collection
22 Eugène von Guérard *Koort Koort-Nong Homestead, near Camperdown, Victoria* 1860. Oil on canvas 50.8 × 83.9 (20 × 33). National Library of Australia, Canberra. Rex Nan Kivell Collection
23 John Glover *A Corrobory of Natives in Mills Plains* 1832. Oil on canvas board 56.5 × 71.4 (22¼ × 28⅛). Art Gallery of South Australia, Adelaide. Morgan Thomas Bequest Fund 1951
24 Nicholas Chevalier *The Buffalo Ranges* 1864. Oil on canvas 132.8 × 183.7 (52¼ × 72⅜). National Gallery of Victoria, Melbourne. Purchased 1864
25 Nicholas Chevalier *Mount Arapiles and the Mitre Rock* 1863. Oil on canvas 77.5 × 120.6 (30½ × 47½). Reproduced by permission of the National Gallery of Australia, Canberra
26 Thomas Clark *Falls on the Wannon* 1870. Oil on canvas 92 × 138 (36¼ × 54⅜). National Gallery of Victoria, Melbourne. Felton Bequest 1973
27 W. C. Piguenit *The Flood in the Darling* 1890. Oil on canvas 122.5 × 199.3 (48¼ × 78½). The Art Gallery of New South Wales, Sydney
28 William Strutt *Bushrangers, Victoria, Australia, 1852* 1887. Oil on canvas 75.7 × 156.6 (29⅞ × 61⅝). The University of Melbourne Art Collection. Gift of the Russell and Mab Grimwade Bequest 1973
29 John Longstaff *Breaking the News* 1887. Oil on canvas 109.7 × 152.8 (43⅛ × 60⅛). Collection Art Gallery of Western Australia, Perth. Acquired with funds from the Hackett Bequest 1933
30 Abram Louis Buvelot *Upper Falls on the Wannon c.* 1872. Oil on canvas on composition board 66.9 × 50.4 (26⅜ × 19⅞). Art Gallery of South Australia, Adelaide. M. J. M. Carter Collection
31 Isaac Whitehead *Gippsland c.* 1870. Oil on canvas 99 × 132.1 (39 × 52). National Library of Australia, Canberra. Rex Nan Kivell Collection
32 Abram Louis Buvelot *Summer Afternoon, Templestowe* 1866. Oil on canvas 76.6 × 118.9 (30⅛ × 46⅞). National Gallery of Victoria, Melbourne. Purchased 1869
33 Abram Louis Buvelot *Waterpool near Coleraine (Sunset)* 1869. Oil on canvas 107.4 × 153 (42¼ × 60¼). National Gallery of Victoria, Melbourne. Purchased 1870
34 Charles Conder *Under a Southern Sun* 1890. Oil on canvas 71.5 × 35.5 (28⅛ × 14). Reproduced by permission of the National Gallery of Australia, Canberra. Gift of Mary Meyer in memory of her husband Dr Felix Meyer 1975
35 Arthur Streeton *The Selector's Hut: Whelan on the Log* 1890. Oil on canvas 76.7 × 51.2 (30⅛ × 20⅛). Reproduced by permission of the National Gallery of Australia, Canberra

36 Tom Roberts *The Artists' Camp c.* 1886. Oil on canvas 46 × 60.9 (18⅛ × 24). National Gallery of Victoria, Melbourne. Felton Bequest 1943
37 Tom Roberts *The Sunny South c.* 1887. Oil on canvas 30.8 × 61.4 (12⅛ × 24⅛). National Gallery of Victoria, Melbourne. Felton Bequest 1940
38 Charles Conder *A Holiday at Mentone* 1888. Oil on canvas 46.2 × 60.8 (18¼ × 24). Art Gallery of South Australia, Adelaide. South Australian Government Grant with the assistance of Bond Corporation Holdings Ltd through the Art Gallery of South Australian Foundation to mark the Gallery's Centenary 1981
39 Tom Roberts *Allegro con brio: Bourke Street, West c.* 1886. Oil on canvas 51.2 × 76.7 (20⅛ × 30¼). National Library of Australia, Canberra
40 Arthur Streeton *The Railway Station, Redfern* 1893. Oil on canvas 40.8 × 61 (16 × 24). The Art Gallery of New South Wales, Sydney. Gift of Lady Denison 1942
41 Charles Conder *The Departure of the Orient – Circular Quay* 1888. Oil on canvas 45.1 × 50.1 (17¾ × 19¾). The Art Gallery of New South Wales, Sydney
42 Tom Roberts *Woodsplitters* 1886. Oil on canvas 61.4 × 92.3 (24⅛ × 36⅜). Collection of Ballarat Fine Art Gallery. Bequest of J. R. Hartley 1961
43 Arthur Streeton *Golden Summer, Eaglemont* 1889. Oil on canvas 81.3 × 152.6 (32 × 60). Reproduced by permission of the National Gallery of Australia, Canberra
44 Charles Conder *How We Lost Poor Flossie* 1889. Oil on wood 25 × 9.2 (9⅞ × 3⅝). Art Gallery of South Australia, Adelaide. Elder Bequest Fund 1899
45 Tom Roberts *Impression* 1888. Oil on wood panel 11 × 18.8 (4⅜ × 7⅜). National Gallery of Victoria, Melbourne. Purchased 1955
46 Arthur Streeton *Impression for 'Golden Summer'* 1888. Oil on canvas mounted on composition board 29.6 × 58.7 (11⅝ × 23⅛). Benalla Art Gallery Collection, Victoria. Ledger Gift
47 Tom Roberts *Shearing the Rams* 1890. Oil on canvas on composition board 122.4 × 183.3 (48⅛ × 72⅛). National Gallery of Victoria, Melbourne. Felton Bequest 1932
48 Tom Roberts *A Break-Away!* 1891. Oil on canvas 137.2 × 168.1 (54 × 66¼). Art Gallery of South Australia, Adelaide. Elder Bequest Fund 1899
49 Arthur Streeton *Fire's On (Lapstone Tunnel)* 1891. Oil on canvas 183.8 × 122.5 (72⅜ × 48¼). The Art Gallery of New South Wales, Sydney
50 Tom Roberts *Bailed Up* 1895–1927. Oil on canvas 134.5 × 182.8 (53 × 72). The Art Gallery of New South Wales, Sydney
51 Arthur Streeton *The Purple Noon's Transparent Might* 1896. Oil on canvas 123 × 123 (48½ × 48½). National Gallery of Victoria, Melbourne. Purchased 1896
52 David Davies *Moonrise* 1894. Oil on canvas 119.8 × 150.4 (47¼ × 59¼). National Gallery of Victoria, Melbourne. Purchased 1895

53 Jane Sutherland *Children Playing in a Paddock c.* 1895. Oil on canvas 41 × 61 (16⅛ × 24). Art Gallery of South Australia, Adelaide. South Australian Government Grant 1979

54 Walter Withers *Early Morning, Heidelberg* 1898. Oil on canvas on composition board 45 × 91.7 (17¾ × 36⅛). Art Gallery of South Australia, Adelaide. Elder Bequest Fund 1899

55 Emanuel Phillips Fox *Moonrise, Heidelberg* 1900. Oil on canvas 76.3 × 126.5 (30 × 50). National Gallery of Victoria, Melbourne. Purchased 1948

56 Emanuel Phillips Fox *The Convalescent* 1890. Oil on canvas 97.5 × 78.5 (38⅜ × 31). The Holmes à Court Collection, courtesy of Heytesbury

57 Sydney Long *Spirit of the Plains* 1897. Oil on canvas on wood 62 × 131.4 (24⅜ × 51¾). Reproduced by permission, from the collection of the Queensland Art Gallery, Brisbane. Gift of William Howard-Smith in memory of his grandfather, Ormond Charles Smith

58 George Lambert *Across the Black Soil Plains* 1899. Oil on canvas 91.6 × 305.5 (36 × 120¼). The Art Gallery of New South Wales, Sydney

59 Frederick McCubbin *Down on his Luck* 1889. Oil on canvas 114.5 × 152.8 (45 × 60⅛). Collection Art Gallery of Western Australia, Perth

60 Frederick McCubbin *The Pioneer* 1904. Oil on canvas triptych, left panel 222.5 × 86 (87⅝ × 33¾), centre panel 224.7 × 122.5 (88½ × 48¼), right panel 223.5 × 85.7 (88 × 33¾). National Gallery of Victoria, Melbourne. Felton Bequest 1906

61 Elioth Gruner *Spring Frost* 1919. Oil on canvas 131 × 178.7 (51⅝ × 70⅜). The Art Gallery of New South Wales, Sydney. Gift of F. G. White 1939

62 Hans Heysen *Red Gold* 1913. Oil on canvas 127.6 × 172.1 (50¼ × 67¾). Art Gallery of South Australia, Adelaide. Gift of the Rt. Hon. Sir Charles Booth 1913

63 Hans Heysen *A Lord of the Bush* 1908. Oil on canvas 134 × 103 (52¾ × 40½). National Gallery of Victoria, Melbourne. Felton Bequest 1908

64 Jessie Traill *Beautiful Victims* 1914. Etching on yellowed oriental paper on cardboard 70.1 × 49.3 (27⅝ × 19½). Reproduced by permission, from the collection of the Queensland Art Gallery, Brisbane. Purchased 1961

65 Sydney Long *By Tranquil Waters* 1894. Oil on canvas 111.1 × 183.7 (43¾ × 72⅜). The Art Gallery of New South Wales, Sydney

66 Sydney Long *Pan* 1898. Oil on canvas 108.6 × 177.8 (42¾ × 70). The Art Gallery of New South Wales, Sydney. Gift of J. R. McGregor 1943

67 Lionel Lindsay *Pan* 1910. Sepia aquatint 8.2 × 15.1 (3¼ × 6). Dixson Library, State Library of New South Wales, Sydney

68 Norman Lindsay *Pollice Verso* 1904. Pen and indian ink 47.5 × 60.5 (18¾ × 23⅞). National Gallery of Victoria, Melbourne. Felton Bequest 1907

69 Rupert Bunny *Summertime c.* 1907. Oil on canvas 248.9 × 298.5 (98 × 117½). The Art Gallery of New South Wales, Sydney

70 George Lambert *A Sergeant of the Light Horse in Palestine* 1920. Oil on canvas 77 × 62 (30¼ × 24⅜). National Gallery of Victoria, Melbourne. Felton Bequest 1921

71 Rayner Hoff *Idyll (Love and Life)* 1924–26. Marble 94 × 48 × 11 (37 × 18⅞ × 4¾). The Art Gallery of New South Wales, Sydney. Gift of Howard Hinton 1926

72 Napier Waller *The Pastoral Pursuits of Australia* 1927 (detail). Oil on canvas 160 × 430 (63 × 169¼). Art Gallery of South Australia, Adelaide. Gift of James and Diana Ramsay Fund 1987

73 Arthur Murch *Beach Idyll* 1930. Tempera on canvas on plywood 35.5 × 59.1 (14 × 23¼). The Art Gallery of New South Wales, Sydney. Visual Arts Board, Australia Council, Contemporary Art Purchase Grant 1975

74 Charles Meere *Australian Beach Pattern* 1940. Oil on canvas 91.5 × 122 (36 × 48). The Art Gallery of New South Wales, Sydney

75 Max Dupain *Sunbaker* 1937. Gelatin silver photograph 38.3 × 43.7 (15 × 17¼). The Art Gallery of New South Wales, Sydney

76 Arthur Streeton *The Land of the Golden Fleece* 1926. Oil on canvas 49.8 × 75.4 (19⅝ × 29⅝). National Gallery of Victoria, Melbourne. Bequeathed by W. C. C. Cain 1950

77 George Lambert *The Squatter's Daughter* 1923–24. Oil on canvas 61.4 × 91.2 (24⅛ × 36). Reproduced by permission of the National Gallery of Australia, Canberra

78 Grace Cossington Smith *The Sock Knitter* 1915. Oil on canvas 61.6 × 50.7 (24¼ × 20). The Art Gallery of New South Wales, Sydney

79 Roland Wakelin *Down the Hill to Berry's Bay* 1916. Oil on canvas on hardboard 68 × 122 (26¾ × 48). The Art Gallery of New South Wales, Sydney

80 Roy de Maistre *Rhythmic Composition in Yellow Green Minor* 1919. Oil on paperboard 86.3 × 116.2 (34 × 45¾). The Art Gallery of New South Wales, Sydney

81 Margaret Preston *Implement Blue* 1927. Oil on canvas on paperboard 42.5 × 43 (16¾ × 16⅞). The Art Gallery of New South Wales, Sydney. Gift of the artist 1960

82 Dorrit Black *The Olive Plantation* 1946. Oil on canvas 63.5 × 86.5 (25 × 34). Art Gallery of South Australia, Adelaide. Bequest of the artist 1952

83 Ethel Spowers *The Works, Yallourn* 1933. Hand-coloured linocut on oriental tissue paper 15.7 × 34.8 (6⅛ × 13¾). Reproduced by permission of the National Gallery of Australia, Canberra

84 Jessie Traill *Building the Harbour Bridge IV: The Ant's Progress, November 1929* 1929. Etching on paper 40.4 × 24.8 (16 × 9¾). Art Gallery of South Australia, Adelaide. David Murray Bequest Fund 1932

85 Grace Cossington Smith *Eastern Road, Turramurra c.* 1926. Watercolour on paperboard 40.6 × 33 (16 × 13). Reproduced by permission of the National Gallery of Australia, Canberra. Gift of Mervyn Horton 1984

86 Grace Cossington Smith *The Bridge In-Curve c.* 1930. Tempera on cardboard 83.6 × 111.8 (33 × 44). National Gallery of

Victoria, Melbourne. Gift of the National Gallery Society of Victoria 1967

87 Grace Cossington Smith *Interior with Wardrobe Mirror* 1955. Oil on canvas on paperboard 91.4 × 73.7 (36 × 29). The Art Gallery of New South Wales, Sydney

88 Margaret Preston *Flannel Flowers* 1928. Hand-coloured woodblock print on paper 24.6 × 24.9 (9⅝ × 9⅞). Reproduced by permission of the National Gallery of Australia, Canberra

89 Margaret Preston *Aboriginal Landscape* 1941. Oil on canvas 40 × 52 (15¾ × 20½). Art Gallery of South Australia, Adelaide. D. & J. T. Mortlock Bequest Fund 1982

90 Clarice Beckett *Sandringham Beach c.* 1933. Oil on canvas 55.8 × 50.9 (22 × 20). Reproduced by permission of the National Gallery of Australia, Canberra

91 Sam Atyeo *Organized Line to Yellow* 1934. Oil on canvas 68 × 48 (26¾ × 18⅞). Reproduced by permission of the National Gallery of Australia, Canberra

92 Yosl Bergner *Aborigines in Fitzroy* 1941. Oil on board 62 × 49.5 (24⅜ × 19½). Art Gallery of South Australia, Adelaide. South Australian Government Grant 1978

93 Albert Tucker *Spring in Fitzroy* 1941. Oil on paper on cardboard 56 × 43.4 (22 × 17). Reproduced by permission of the National Gallery of Australia, Canberra. Gift of the artist 1982

94 Albert Tucker *Futile City* 1940. Oil on cardboard 45 × 54.5 (17¾ × 21½). Collection Museum of Modern Art at Heide, Melbourne. Purchased from John and Sunday Reed 1980

95 Albert Tucker *Image of Modern Evil 24* 1945. Oil on composition board 64.8 × 53.5 (25½ × 21). Reproduced by permission of the National Gallery of Australia, Canberra. Gift of the artist 1981

96 Sidney Nolan *Boy and the Moon c.* 1940. Oil on canvas, mounted on board 73.3 × 88.2 (28⅞ × 34¾). Reproduced by permission of the National Gallery of Australia, Canberra

97 Sidney Nolan *Kiata c.* 1943. Enamel on composition board 60.9 × 91.7 (24 × 36⅛). Reproduced by permission of the National Gallery of Australia, Canberra

98 Sidney Nolan *Ned Kelly* 1946. Enamel on composition board 90.8 × 121.5 (35¾ × 47⅞). Reproduced by permission of the National Gallery of Australia, Canberra. Gift of Sunday Reed 1977

99 Sidney Nolan *Fraser Island* 1947. Ripolin enamel on hardboard 77.4 × 105.4 (30½ × 41½). Private collection

100 Sidney Nolan *Mrs Fraser* 1947. Ripolin enamel on hardboard 66.2 × 107 (26 × 42⅛). Reproduced by permission, from the collection of the Queensland Art Gallery, Brisbane. Purchased 1995 with a special allocation from the Queensland Government. Celebrating the Queensland Art Gallery's Centenary 1895–1995

101 Arthur Boyd *The Brown Room* 1943. Oil on cotton gauze on composition board 63.1 × 75.2 (24⅞ × 29⅝). Reproduced by permission of the National Gallery of Australia, Canberra. The Arthur Boyd Gift 1975

102 Arthur Boyd *The Weathercock* 1944. Oil

on muslin on board 61.4 × 73.8 (24⅛ × 29).
National Gallery of Victoria, Melbourne.
Purchased through The Art Foundation of
Victoria with the assistance of the Shell
Company of Australia, Founder Benefactor
1988
103 Arthur Boyd *Melbourne Burning*
1946–47. Oil and tempera on canvas on
board 90.2 × 100.5 (35½ × 39½). The Holmes
à Court Collection, courtesy of Heytesbury
104 Arthur Boyd *The Mockers* 1945. Oil on
canvas on hardboard 84.5 × 103 (33¼ × 40½).
The Art Gallery of New South Wales,
Sydney
105 Arthur Boyd *The Expulsion* 1947–48.
Oil on hardboard 99.5 × 119.6 (39⅛ × 47).
The Art Gallery of New South Wales,
Sydney
106 Arthur Boyd *The Boat Builders, Eden,
New South Wales* 1948. Oil and tempera on
composition board 85.6 × 101.7 (33¼ × 40).
Reproduced by permission of the National
Gallery of Australia, Canberra
107 Joy Hester *Face (with Crossbar)* c. 1947–48.
Ink on paper 30.5 × 24 (12 × 9½). Collection
Museum of Modern Art at Heide, Melbourne.
Bequest of Sunday and John Reed 1982.
© Fern Smith and Perrigrine Smith. Photo
John Brash
108 John Perceval *Boy with Cat* 1943. Oil on
composition board 58.8 × 43.2 (23⅛ × 17).
Reproduced by permission of the National
Gallery of Australia, Canberra
109 John Perceval *The Merry-Go-Round*
1944. Oil on canvas on cardboard 63.3 × 41.3
(25 × 16¼). Reproduced by permission of the
National Gallery of Australia, Canberra
110 William Dobell, study for the portrait
of *Joshua Smith* 1943. Oil on hardboard
35.9 × 25.7 (14⅛ × 10⅛). Collection Lady
Mary Fairfax
111 William Dobell *The Red Lady* c. 1937.
Oil on canvas 76.9 × 66.1 (30¼ × 26).
Reproduced by permission of the National
Gallery of Australia, Canberra
112 James Gleeson *We Inhabit the Corrosive
Littoral of Habit* 1940. Oil on canvas 40.7 ×
51.1 (16 × 20⅛). National Gallery of Victoria,
Melbourne. Anonymous gift 1941
113 James Gleeson *The Citadel* 1945. Oil on
composition board 182.5 × 122 (71⅞ × 48).
Reproduced by permission of the National
Gallery of Australia, Canberra
114 Russell Drysdale *Man Feeding his Dogs*
1941. Oil on canvas 51.2 × 61.4 (20⅛ × 24⅛).
Reproduced by permission, from the
collection of the Queensland Art Gallery,
Brisbane. Gift of C. F. Viner-Hall 1961
115 see frontispiece
116 Russell Drysdale *Woman in a Landscape*
1949. Oil on canvas mounted on
composition board 101 × 66.3 (39¾ × 26⅛).
Art Gallery of South Australia, Adelaide.
South Australian Government Grant 1949
117 Donald Friend *An Exotic Garden Viewed
at Different Levels* 1957. Oil and mixed media
on two doors with glass panels, each door
183 × 45 (72 × 17¾). The Art Gallery of New
South Wales, Sydney
118 David Strachan *Lovers and Shell*
c. 1945–46. Oil on canvas 35.7 × 55.8
(14 × 22). Collection of Ballarat Fine Art
Gallery. L. J. Wilson Bequest Fund 1972

119 David Strachan *Batterie de Cuisine* 1956.
Oil on hardboard 73 × 91.8 (28¾ × 36¼).
The Art Gallery of New South Wales,
Sydney. Gift of Lane Cove Art Society 1973
120 Russell Drysdale *Mullaloonah Tank* 1953.
Oil on canvas 123 × 183.4 (48⅜ × 72¼). Art
Gallery of South Australia, Adelaide. South
Australian Government Grant 1953
121 Russell Drysdale *Ceremony at the Rockface*
1963. Oil on canvas 127.3 × 102 (50⅛ ×
40⅛). Reproduced by permission of the
National Gallery of Australia, Canberra. Gift
of Godfrey Phillips International, courtesy
of the Arts Council of Australia 1980
122 Arthur Boyd *Half-Caste Child* 1957. Oil
and tempera on canvas 150 × 177.5 (59 × 70).
JGL Investments, Melbourne
123 Arthur Boyd *Shearers Playing for the Bride*
1957. Oil and tempera on canvas 150.1 ×
175.7 (59 × 69¼). National Gallery of Victoria,
Melbourne. Gift of Tristan Buesst 1958
124 Arthur Boyd *Clay and Rockface at
Bundanon* 1981. Oil on canvas 86 × 59
(33⅞ × 23¼). Joseph Brown Collection
125 Godfrey Miller *Still Life with Musical
Instruments* 1963. Pen and ink and oil on
canvas 65.5 × 83 (25¾ × 32⅝). National
Gallery of Victoria, Melbourne. Felton
Bequest 1963
126 Frank Hinder *Subway Wynyard* 1948.
Tempera on hardboard 22.9 × 19 (9 × 7½).
The Art Gallery of New South Wales,
Sydney
127 Ralph Balson *Painting No. 9* 1959.
Enamel on hardboard 137 × 137 (53⅞ × 53⅞).
The Art Gallery of New South Wales,
Sydney
128 Elwyn Lynn *Four Burnt Paddocks* 1987.
Mixed media on canvas 153 × 203 (60¼ ×
79⅞). The University of New South Wales,
Sydney
129 Roger Kemp *The Cross* 1968. Synthetic
polymer paint on composition board
183 × 137.5 (72 × 54⅛). Monash University
Collection, Melbourne. Photo Terence
Bogue
130 Charles Blackman *Suite of Paintings* 1960.
Oil on hardboard 122 × 183 (48 × 72).
Collection Art Gallery of Western Australia,
Perth
131 Robert Dickerson *The Tired Man* 1956.
Enamel on composition board 137.6 × 152.8
(54⅛ × 60⅛). National Gallery of Victoria,
Melbourne. Purchased 1957
132 John Brack *Collins Street, 5pm* 1956. Oil
on canvas 114.8 × 162.8 (45¼ × 64). National
Gallery of Victoria, Melbourne. Purchased
1956
133 Frank Hodgkinson *Time of the Last
Cicada* 1963. Oil on canvas laid on board
183 × 365.5 (72 × 144). The University of
New South Wales Union, Sydney
134 Ian Fairweather *Monastery* 1961.
Synthetic polymer paint, tempera on
cardboard 144 × 185.5 (56¾ × 73).
Reproduced by permission of the National
Gallery of Australia, Canberra. © Estate of
Ian Fairweather 1997. All rights reserved
DACS
135 Tony Tuckson *Black, Grey, White* 1970.
Acrylic and enamel on hardboard, two
panels, each 213.5 × 244 (84 × 96). The
Chartwell Collection, Waikato Museum

and Art Gallery, Hamilton, New Zealand
136 Fred Williams *Upwey Landscape II* 1965.
Oil on canvas 183.2 × 147.6 (72⅛ × 58⅛).
Reproduced by permission of the National
Gallery of Australia, Canberra
137 Lloyd Rees *Illawarra Pastoral* 1961. Oil on
canvas 89.2 × 117.2 (35⅛ × 46⅛). Collection
Art Gallery of Western Australia, Perth
138 John Coburn *Curtain of the Sun* 1971.
Wool tapestry by Pinton Frères at Aubusson,
France 8.23 m × 15.85 m (27 × 52 ft). Sydney
Opera House Trust
139 Colin Lanceley *Glad Family Picnic*
1961–62. Oil on hardboard 122 × 183
(48 × 72). The Art Gallery of New South
Wales, Sydney. Bequest of Lucy Swanton
1982. © DACS 1997
140 Gareth Sansom *The Blue Masked
Transvestite* 1964. Oil and enamel on
hardboard 167.5 × 136.6 (66 × 53¼).
Collection Art Gallery of Western
Australia, Perth
141 Jeffrey Smart *Cahill Expressway* 1962. Oil
on plywood 80 × 109 (31½ × 42⅞). National
Gallery of Victoria, Melbourne. Purchased
1963
142 Michael Johnson *Window One* 1969.
Synthetic polymer paint on shaped canvas
229 × 198.5 (90⅛ × 78⅛). National Gallery of
Victoria, Melbourne. Purchased with
Admission Funds 1986
143 Alun Leach-Jones *Noumenon XXXII,
Red Square* 1969. Synthetic polymer paint
on canvas 168.5 × 168.5 (66⅜ × 66⅜).
Reproduced by permission of the National
Gallery of Australia, Canberra
144 Robert Rooney *Kind-Hearted-Kitchen
Garden II* 1967. Synthetic polymer paint on
canvas 167.9 × 168.1 (66 × 66⅛). Reproduced
by permission of the National Gallery of
Australia, Canberra
145 Keith Looby *With the Death of the Talking
Mural* 1988. Oil on canvas 274 × 257 (107⅞ ×
101⅛). Ray Hughes Gallery, Sydney
146 Inge King *Planet* 1976–77. Stainless steel
53.5 × 55.1 × 18 (21 × 21¾ × 7⅛) . The Art
Gallery of New South Wales, Sydney
147 Clement Meadmore *Virginia* 1970.
Corten steel 3.56m × 14.02m × 6.09m
(12 ft × 46 ft × 20 ft). Reproduced by
permission of the National Gallery of
Australia, Canberra
148 Robert Klippel *Opus 655* 1987–88.
Bronze 321 × 170 (126⅜ × 66⅞). The Art
Gallery of New South Wales, Sydney.
Bicentennial gift of The Art Gallery Society
of New South Wales 1988
149 Ron Robertson-Swann *Elvira Madigan*
1971. Steel 179 × 487 × 195 (70½ × 191¾
× 76¾). Reproduced by permission,
from the collection of the Queensland
Art Gallery, Brisbane. Purchased 1986
150 Ken Unsworth *Suspended Stone Circle II*
1984. 103 river stones, wire, diameter 11m
(36 ft). The Art Gallery of New South Wales,
Sydney
151 Mike Parr *Integration 3 (Leg Spiral)* 1975.
Performance at 54 Holmwood Street, South
Newtown, Sydney. Courtesy of the artist and
Sherman Galleries, Sydney
152 Ian Burn using one of the mirrors of
1–6 Glass/Mirror Piece 1967 to shave. The
Estate of the Late Ian Burn

221

153 Ian Burn *1–6 Glass/Mirror Piece* 1967. First mirror with one sheet of glass over it, second mirror with two sheets of glass over it, to the sixth mirror with six pieces of glass over it. The Estate of the Late Ian Burn

154 Dale Hickey *90 White Walls* 1970. Black-and-white photographs and ink on cardboard in hand-made box, each sheet 8 × 15.9 (3⅛ × 6¼); box closed 9.5 × 18.4 × 15.1 (3¾ × 7¼ × 6). National Gallery of Victoria, Melbourne. Gift of Bruce Pollard 1980

155 Ponch Hawkes *Sheila and Janie* from the *Our Mums and Us* series 1976. Gelatin silver photograph 17.8 × 12.6 (7 × 5). Reproduced by permission of the National Gallery of Australia, Canberra

156 Vivienne Binns *Mothers' Memories, Others' Memories* from the Blacktown Community project 1980. Postcard rack, enamel on steel, nylon line 90.4 × 27 (35⅝ × 10⅝). Reproduced by permission of the National Gallery of Australia, Canberra. Gift of the Philip Morris Arts Grant 1982. © DACS 1997

157 Brett Whiteley *Self Portrait in the Studio* 1976. Oil, collage, hair on canvas 200.5 × 259 (79 × 102). The Art Gallery of New South Wales, Sydney

158 Imants Tillers *Pataphysical Man* 1984. Charcoal, spp, pencil on 168 canvas boards 305 × 532 (120⅛ × 209½). The Art Gallery of New South Wales, Sydney. Ewan Murray-Will Bequest Fund 1985

159 Imants Tillers *Conversations with the Bride* 1974–75. Gouache, spp, paper on aluminium, 112 stands, each painting 12.7 × 18.3 (5 × 7¼). The Art Gallery of New South Wales, Sydney

160 Imants Tillers *Kangaroo Blank* 1988. Synthetic polymer paint, gouache, oilstick on 78 canvas boards 213 × 196 (83⅞ × 77⅛). Courtesy the artist and Sherman Galleries, Sydney

161 Lindy Lee *Heartbeat and Duration* 1992. Synthetic polymer paint on photocopies 174.6 × 126.6 (68¾ × 49⅞). Reproduced by permission of the National Gallery of Australia, Canberra. Courtesy Roslyn Oxley9 Gallery, Paddington, NSW

162 Anne Zahalka *The Bathers* 1989–90. Photograph, image 74 × 85 (29⅛ × 33½). The Art Gallery of New South Wales, Sydney. Hallmark Cards Australian Photography Collection Fund 1990

163 Fiona Hall *Inferno, Canto XIII: The Forest of the Suicides* from the *Illustrations to Dante's Divine Comedy* series 1988. Polaroid photo 50 × 61.5 (19⅝ × 24¼). Art Gallery of South Australia, Adelaide. Maude Vizard-Wholohan Art Prize Purchase Award 1990

164 Bill Henson *Untitled 1983–84*. Triptych photograph, each panel 102 × 74 (40⅛ × 29⅛). Courtesy Roslyn Oxley9 Gallery, Paddington, NSW

165 Peter Booth *Painting 1971*. Synthetic polymer paint on canvas 245 × 184.5 (96½ × 72⅝). National Gallery of Victoria, Melbourne. Purchased 1971

166 Peter Booth *Painting 1982*. Oil on canvas 197.7 × 274 (77⅞ × 107⅞). Art Gallery of South Australia, Adelaide. A. M. Ragless Bequest Fund 1983

167 Peter Booth *Painting 1977*. Oil on canvas 182.5 × 304 (71⅞ × 119⅝). National Gallery of Victoria, Melbourne. Gift of the artist in memory of Les Hawkins 1978

168 Peter Booth *Winter 1993*. Oil on canvas 203 × 396 (79⅞ × 156). Collection the artist. Photo Deutscher Fine Art, Malvern, Victoria

169 Mike Parr, two etchings from *12 Untitled Self-Portraits (Set 1)* series 1989. Etching on copper 108 × 78 (42½ × 30¾). Courtesy the artist and Sherman Galleries, Sydney. Photo Gary Sommerfeld

170 Susan Norrie *Fruitful Corsage, Bridal Bouquet, Lingering Veils* 1983. Oil on canvas,

each panel 182 × 121 (71⅝ × 47⅝). The Art Gallery of New South Wales, Sydney. Henry Salkauskas Contemporary Art Purchase Fund 1983

171 Allan Mitelman *Untitled 1993–94*. Oil on canvas 183 × 153 (72 × 60¼). Private collection. Courtesy the artist and Sherman Galleries, Sydney

172 Rosalie Gascoigne *Monaro* 1989. Sawn and split soft drink crates on plywood 130.5 × 465 (51⅛ × 183). Collection Art Gallery of Western Australia, Perth. © DACS 1997

173 Robert Hunter *Untitled* 1992. Acrylic on plywood 122 × 244 (48 × 96⅛). Photo courtesy Annadale Galleries, Sydney

174 Hossein Valamanesh *Untouchable* 1984. Wood, ceramic, bamboo, sand, black hessian, oil burner 15 × 500 × 500 (5⅞ × 197 × 197). Collection the artist. Courtesy the artist and Sherman Galleries, Sydney

175 Jan Senbergs *Sticht's Smelters, Penghana 2* 1982. Synthetic polymer paint on canvas 167.6 × 244.1 (66 × 96⅛). Collection Geelong Art Gallery. Purchased with the assistance of the Clatex Victorian Government Art Fund 1983

176 Simone Mangos *Tölling Läuten* installation at Künstlerhaus Bethanien, Berlin, May 1989, showing *(left)* morning view and *(right)* evening view. Rubble, suspended platform, pulley, steel cable. Courtesy the artist. Photo Tim Marshall

177 Simone Mangos *Sounding* installation at the Bond Store, Eighth Biennale of Sydney, April 1990. Chalk, doorway 250 × 250 (98⅜ × 98⅜), one piece of chalk 9 × 9 × 1 (3½ × 3½ × ⅜), overall dimensions undefined. Courtesy the artist. Photo Tim Marshall

178 Aida Tomescu *Seria Unu I, II, III, IV* 1993. Liftground aquatint 121 × 80 (47⅝ × 31½). Courtesy Coventry Gallery, Sydney. Photo Paul Green